modern
MOSAIC

W9-BOO-691

A FIREFLY BOOK

Published by Firefly Books Ltd. 2003

Copyright © 2003 Quintet Publishing Limited

All rights reserved. No part of this publication may be reproduced,
stored in a retrieval system, or transmitted in any form or by any means,
electronic, mechanical, photocopying, recording, or otherwise,
without the permission of the copyright owner.

First printing

National Library of Canada Cataloguing in Publication Data
Hunkin, Tessa, 1954-
Modern Mosaic: inspiration from the 20th century / Tessa Hunkin

Includes bibliographical references and index.
ISBN 1-55297-703-X (bound) ISBN 1-55297-701-3 (pbk)
1. Mosaics. 2. Mosaics—Technique. I. Title.

NA3750.H85 2003 738.5 C2002-905357-9

Publisher Cataloging-in-Publication Data (U.S)
(Library of Congress Standards)

Hunkin, Tessa.
Modern Mosaic: inspiration from the 20th century / Tessa Hunkin
.—1st ed.
[144] p. : ill. : col. photos. ; cm.

Includes bibliographical references and index.
Summary: Mosaic techniques, materials and projects for home and
garden inspired by the work of contemporary mosaic artists
and famous mosaics from around the world.

ISBN 1-55297-703-X (bound)
ISBN 1-55297-701-3 (pbk)
1. Mosaics—Technique. 2. 3. I. Title.
751.4/ 8 21 NA3750.H86 2003

Published in Canada in 2003 by
Firefly Books Ltd.
3680 Victoria Park Avenue
Toronto, Ontario, M2H 3K1

Published in the United States in 2003 by
Firefly Books (U.S.) Inc.
P.O. Box 1338, Ellicott Station
Buffalo, New York 14205

MODM

This book was designed and produced by
Quintet Publishing Limited
6 Blundell Street
London N7 9BH

Senior Project Editor: Corinne Masciocchi
Editor: Anna Bennett
Photographer: Ian Garlick
Art Director: Sharanjit Dhol
Design: James Lawrence
Creative Director: Richard Dewing
Publisher: Oliver Salzmann

Manufactured in London by Documedia
Printed in China by Leefung-Asco Printers Trading Ltd

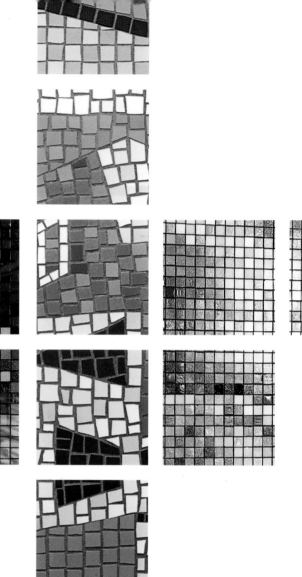

Acknowledgments

I would like to thank the following people who helped make this book.
Decorative wall tiles (Project 3) by Nichole Sleet
Cityscape floor panel and Tonal Composition (Projects 2 and 9) by Jo Thorpe

I would also like to extend my thanks to Marek Rodgers,
Miranda Symington, Emma Biggs, James Postgate, Adam Curtis,
and Tim Hunkin for their help and advice.

modern
MOSAIC

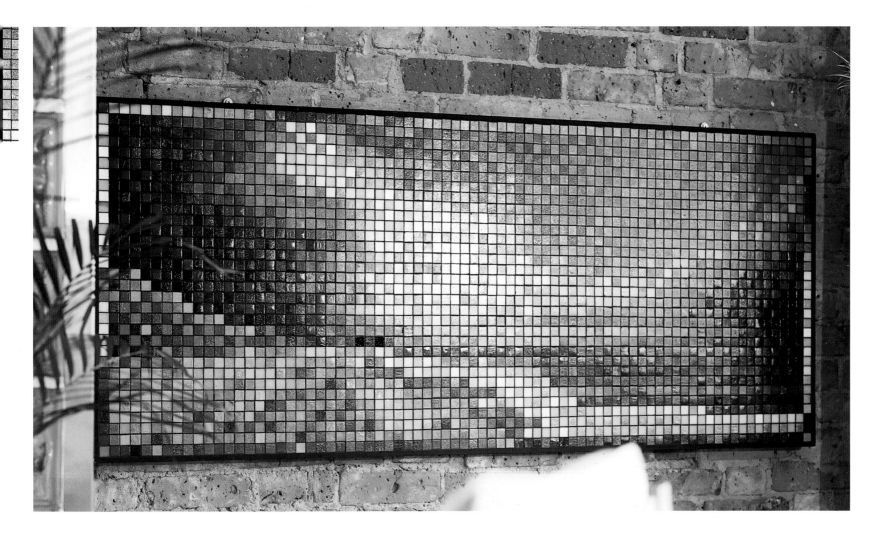

Inspiration from the 20th century

TESSA HUNKIN

FIREFLY BOOKS

contents

introduction

MOSAIC IS AN ART FORM ASSOCIATED MORE WITH ANTIQUITY THAN WITH THE MODERN AGE, BUT THERE IS A CONTINUOUS HISTORICAL TRADITION THAT CAN BE TRACED FROM CLASSICAL GREECE TO THE PRESENT DAY. ITS POPULARITY HAS SOMETIMES FALTERED OVER THE CENTURIES BUT THERE HAS BEEN A MARKED REVIVAL OF INTEREST IN RECENT YEARS. THIS BOOK CONCENTRATES ON 20TH-CENTURY DEVELOPMENTS AND THEIR RELATIONSHIP TO MOVEMENTS IN THE MAINSTREAM OF PAINTING AND SCULPTURE. AS WELL AS DESCRIBING MODERN MOSAICS AND OTHER WORKS THAT HAVE RELEVANCE TO MOSAIC DESIGN, THE BOOK ALSO CONTAINS ALL THE TECHNICAL INFORMATION YOU NEED TO MAKE YOUR OWN MOSAICS FOLLOWING A SERIES OF STEP-BY-STEP PROJECTS.

Mosaics, unlike works executed in paint or fresco, have an inherent durability, and numerous examples have survived. The earliest known mosaics were made from pebbles, and the illustration below shows a floor made in Gordium (Asia Minor) in the eighth century B.C. Although it is one of the very oldest mosaic pavements in existence, the freely executed interlocking patterns have a remarkably modern look.

The historical tradition

Mosaic developed across the Roman Empire as a popular method of decorating floors and a distinctive style emerged that combined patterns with representational panels. This approach incorporated many stylistic variations. The mosaics of Rome itself and its northern empire favored patterns based on geometry, while the North African border designs are more organic, based on plants and other natural forms. The representational panels usually show figures

▲ *Pavement from Via Ardeatina*, **Rome, mid-first century** B.C.
An overall geometric structure is decorated here with a bewildering variety of patterns. Representational motifs are also integrated into the design and the whole floor demonstrates the increasing preoccupation with geometry and pattern in Roman Italy.

◄ *Pebble mosaic*, **Gordium, eighth century** B.C.
The drawing shows a reconstruction of the surviving fragments. The juxtaposition of so many different geometric patterns and the way they merge into each other gives the overall design a liveliness and interest sometimes lost in later, more regular arrangements.

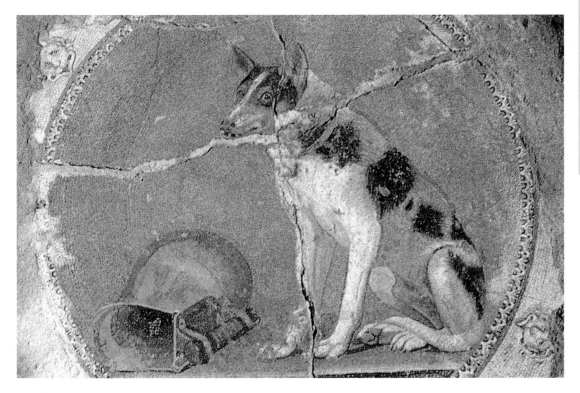

◀ ***Dog and overturned bronze vessel**, Alexandria, late third to early second century* B.C.
The panel would have been the centerpiece of a larger floor and shows the extraordinary degree of technical skill possessed by the mosaicists of Alexandria at this early date. The startling degree of realism is achieved through use of tiny tesserae, and the illusionism of the dog is accentuated by contrast with the completely plain, flat background.

and animals set against a plain, neutral background so as to read clearly on the horizontal floor plane. Pictorial panels from the Eastern Roman Empire, however, are often structured around a realistic background, with elements of perspective and depth that create a curious confusion when viewed from a standing position. The decorative borders would usually be laid *in situ* but, as the representational centerpieces became increasingly elaborate, they were made off-site in the workshop. Known as "emblema," these panels sometimes achieved an extraordinarily high level of realism. Many examples of such panels, showing theatrical scenes, were found in Pompeii. The Vatican Museum houses a collection of these very fine pieces, sometimes made using very minute tesserae. Illustrated above is an example from Hellenistic Alexandria that shows a seated dog, executed in hyper-real detail, that strikes our modern eyes as having an almost photographic quality.

This striking contrast between illusionistic and decorative designs in classical mosaic becomes less significant in Byzantine and medieval examples. The transition from late Roman to early Christian was a continuous process, and the very earliest Christian mosaics, such as those in Santa Costanza in Rome, dating from the fourth century A.D.,

look very like contemporary pagan mosaic. Classical motifs of cherubs and vines are depicted against a pale background in the traditional Roman way. By the sixth century A.D., however, the great church mosaics of Ravenna had acquired a distinctive style. The faces are still executed with a realism that is close in style to the paintings on mummy casings found in Roman Egypt, and there are likenesses of contemporary bishops and courtiers. The compositions, however, have become very stylized, and the backgrounds and draperies are treated in a flat, decorative way. Champions of the classical world have interpreted this as a decline into a more primitive form of picture-making, influenced increasingly by local popular traditions as the civilizing power of the Roman Empire began to fail. It is a transformation, however, that can equally be read in terms of the expression of a new, revolutionary view of the world. The early Christians had suffered terrible persecutions in the real world, and their faith had survived by encouraging its followers to concentrate on a spiritual inner world and its continuation after death. In this context, accurate representations of the real world were completely irrelevant and the purpose of Christian art was to convey the glory of the invisible world of the spirit. Byzantine artists used techniques from traditional popular art because they wanted to make their message

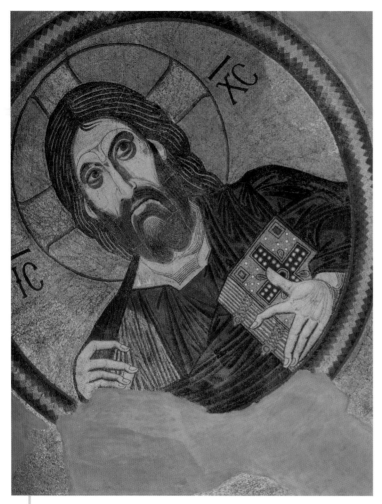

▲ **Christ Pantokrator, Daphni, c. 1100.**
This powerful portrait of Christ is located in the dome of the church, occupying the central focal point in accordance with the codified system of decoration developed in the Eastern church. Within these rules there was still great scope for individual interpretation as can be seen in this uniquely expressive work.

decoration were invented, and it is believed that early stained glass was made from melting down the tesserae of ruined ancient mosaics. As medieval Christian art developed it became more decorative and less naturalistic, a process that can clearly be seen in the Italian mosaics of the Middle Ages. The late 13th-century *Coronation of the Virgin* by Gaddo Gaddi in Florence Cathedral is an example from the very end of the medieval period. A small work mounted over a doorway, it is easily missed among the more famous splendors of Florence but it reveals an astonishing balance between genuinely expressive representation and a sensuous display of pattern and stylized form. The surface is interwoven with gold, which links all the different patterns together, and the animals representing the evangelists are flattened to form shapes that interlock in the

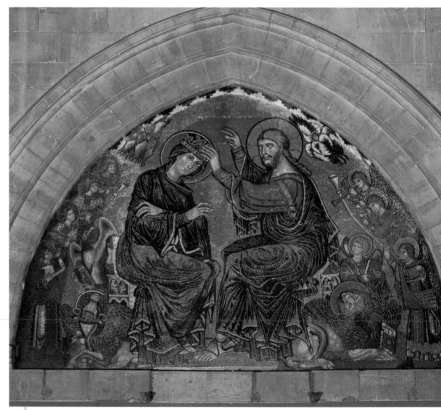

▲ **The Coronation of the Virgin, Gaddo Gaddi, Florence Cathedral, late 13th century.**
The treatment of the subject in this lunette illustrates the extreme stylization practiced by artists in the late Middle Ages. The flatness of the surface is emphasized by the liberal use of gold in the figures as well as the background, and the whole piece is a fusion of representation and abstract pattern.

popular, but they also employed a sophisticated vocabulary of sumptuous materials and color, combined with dramatic stylization. Meaning and execution are fused into a single, powerful didactic purpose. The face of the Pantokrator at Daphni, Attica, is idealized but not sentimentalized, the exaggerated features (the piercing eyes and elongated nose) communicating an awe-inspiring strength and resolve.

The development of mosaic in the Middle Ages was largely confined to Italy, where craft skills were handed down from generation to generation. In Northern Europe other forms of

design. Admiration for these formal characteristics, however, betrays a distinctly modern sensibility. In Chapter 2, the achievement of a similar balance is discussed in the context of Matisse's work, and many other modern artists, including Roger Fry and Picasso, turned to medieval and Byzantine art as a source of inspiration for expressive stylization.

In its own time, the work of the Italian painter Gaddi and his contemporaries, including Cimabue, in Pisa, Padua, and Florence, marked the final flourishing of the medieval tradition. By the end of the 14th century there was even some confusion as to the meaning of the word mosaic. Due to a shortage of qualified craftsmen, the repair to the damaged mosaics in St. Mark's basilica, Venice, caused by a fire in 1419, was very much impeded.

Not only had fresco taken over as the dominant technique for decorating church walls, but a cultural revolution had also taken place. The Italian Renaissance signaled a return to classical values and a fascination with accurate depictions of the real world. Illusionism, achieved through developing the laws of perspective, was to dominate the visual arts until the 19th century. Painting and sculpture were art forms that lent themselves to this kind of realism and were distinguished as fine arts, in a superior category to the decorative arts. Mosaics continued to be made in Italy but their aim was to imitate oil painting, and some of the 18th-century examples, for example in St. Peter's in Rome, do so with extraordinary, if slightly pointless, technical facility. The history of mosaic, from the Renaissance on, becomes a small part of the broader histories of fine art and architecture. Although mosaic itself became increasingly marginalized when it eventually made its brief reappearance in the mainstream at the start of the 20th century, it was as part of a revival of decorative art in general.

Craft and the salvation of industrial society

By the mid-19th century the enormous optimism in the guaranteed fruits of industrial progress was beginning to fade. British manufacturing, despite its head start, was undermined by foreign competition partly because its products were poorly designed. Henry Cole who was responsible for the Great Exhibition of 1851 which displayed wares from all over the world, aimed to educate a new

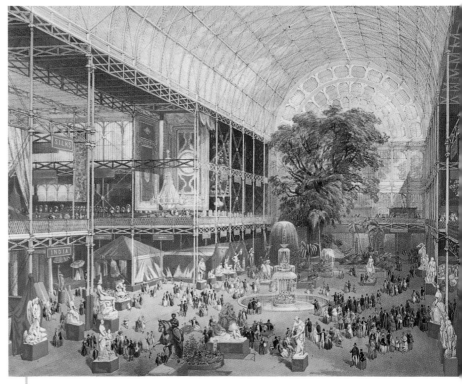

▲ **The Great Exhibition, 1851.**
The revolutionary glass and iron building that housed the exhibition (Joseph Paxton's Crystal Palace), was a great success. Not only was it delivered on time and within budget, but it also inspired future generations of modernist architects. In contrast, the exhibits were almost all examples of High Victorian decorative excess.

generation of designers who could collaborate with industry. The idea of an exhibition to show off the fruits of industry originated in France where the first such show had been held by the Marquis d'Avèze in Paris in 1798. The Great Exhibition was inspired by the French Industrial Exposition of 1844 and was deemed a great success. The French won the majority of the prizes and the dominant style of all the manufactured exhibits, whether made in Europe, Russia, or America, was an elaborate "Frenchified" Classicism. France had a reputation for style and taste that dated back to medieval times, and the new manufacturing industries hoped that an imitation of 18th-century French goods would be a short-cut to guaranteed good design. Although popular with the general public, most artists were horrified by the vulgarity of the work on show, and there was a profound crisis in the decorative arts as they tried to adjust to the new realities of mass-production.

The most radical critic of all was John Ruskin, whose despair at the coarseness of 19th-century mechanical ornament led him to look back at the Middle Ages and analyze why medieval decoration was so much more beautiful and inspiring. His argument was partly based on his assumption that medieval society was morally superior and therefore produced better art, but he also asserted that it was the individuality of the craftsman's touch that made the sculpture and ornament of the Middle Ages inherently beautiful. He believed that machine-made things would always be ugly, and that only hand-made objects were of any value. This fundamentally esthetic analysis had profound implications for the organization of society, and Ruskin expressed his ideas in powerful, persuasive rhetoric:

> "There is dreaming enough, and earthiness enough, and sensuality enough in human existence, without overturning the few glowing moments of it into mechanisation; and since our life must be at best a vapour that appears for a little time and then vanishes away, let it at least appear as a cloud in the height of heaven, not as the thick darkness that broods over the blast of the Furnace, and the rolling of the Wheel."
> (*The Seven Lamps of Architecture; The Lamp of Life*, 1849).

Ruskin's ideas, however, were enormously influential. He was a friend of the American critic Charles Eliot Norton who became the first Professor of Fine Arts at Harvard University and whose ideas, expressed in a large output of books and essays, were based on Ruskin's philosophy. As a member of the educated Boston elite, Norton believed that America's culture was dangerously impoverished by industrial progress and that the solution would be a return to the older European values proposed by Ruskin. Perhaps most important of all, however, was Ruskin's influence on the young William Morris. Morris was interested in architecture and painting but he also believed that artists should become involved in the decorative arts, and that the distinction between the arts should be dissolved so that applied art and architecture could be integrated into a single artistic expression, as they were in the great Gothic cathedrals.

Central to Morris's philosophy was the belief that good design could only be achieved by an intimate knowledge of materials, acquired through the process of making. This led Morris to a profound respect for vernacular objects made by craftsmen with a simplicity derived from their knowledge and experience of materials and techniques.

► *A contemporary of William Morris,* **John Ruskin** (1819–1900) *was one of the most prominent artists, poets, philosophers, and art critics of Victorian England. Together with Morris, he was the primary proponent of the Arts and Crafts Movement of the 1860s.*

Morris's reputation now rests largely on the exceptional sophistication and beauty of his own designs. He believed it would be "dishonest" to copy medieval designs and chose instead to draw inspiration from nature, in accordance with Ruskin's theories. In this context, his textiles and wallpapers seem surprisingly formal but they are a highly original and harmonious mix of simplification and complexity, and proof of their remarkable quality is their continued popularity today. It seems hard to believe that there was a time when it was seriously imagined that craft could change the world, but toward the end of the 19th century this idea was embraced with enthusiasm, particularly in America. The leader of the American Arts and Crafts Movement, Gustav Stickley, was inspired by a meeting with the architect Charles Voysey, and subsequently set up the Craftsman Workshops in Syracuse, New York, in 1899. Two years later he started a magazine called *The Craftsman* with the avowed purpose of promoting Morris's ideas. The furniture and furnishings he designed were solidly made out of good materials and had a simplicity that was clearly influenced by traditional American furniture. Stickley is said to have created the first truly American furniture. The Craftsman Workshops proved to be very successful, providing the growing bourgeois class with a distinct identity that did not emulate the decadent luxury of the aristocratic rich nor completely abandon the simplicity of pioneer life. Stickley showed his products in furniture showrooms across the country and also sold by mail order, not unlike

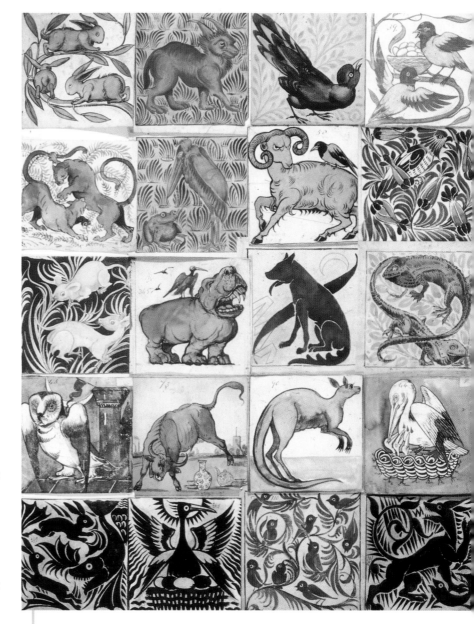

◀ **Frontispiece to a book produced by the Roycroft Press.**
Elbert Hubbard's books were a household name across America. It was a brief meeting with William Morris in 1895 that influenced Hubbard and set the style for his printed materials.

the Swedish IKEA stores that can be found around the world today. This scale of enterprise, and the affordable prices that were essential to its success, were possible because although the objects were designed in an Arts and Crafts style they were actually mass-produced.

Another craft business that displayed this distinctive American compromise with commerce was Elbert Hubbard's Roycroft Shops in East Aurora, New York. Hubbard set up his own printing business in 1894, primarily to produce his own books of homespun wisdom. He quickly expanded into bookbinding and then furniture, and set up a community where the craftsmen lived and worked together. Hubbard's writings were extremely popular and visitors began to arrive at East Aurora to meet the author and witness the experiment in living. A hotel was built, the Roycroft Inn, and furnished in a medieval style. The community had become a kind of Arts and Crafts theme park that promoted and marketed the goods that were manufactured to meet the ever-increasing demand.

Another of Morris's followers was William de Morgan who was trained as a stained-glass maker and started working for Morris's firm but soon set up independently to make ceramics. He experimented with glazes and lustre, initially on factory-made tiles and pots and later on ceramics of his own making. He studied Persian originals and

▲ **William de Morgan, Designs for six inch tiles, 1870s–80s.**
The design shows de Morgan's great skill at simplifying natural forms into decorative compositions. They vary in the degree of their stylization, with some creatures, such as the bull, described in pictorial style, and others, such as the phoenix, flattened to form an almost abstract pattern.

explored ancient techniques to reproduce their intensely beautiful colors. He produced almost perfect copies of these originals as well as his own distinctive designs incorporating lively birds and animals that were simplified and flattened into elegant pictorial symbols.

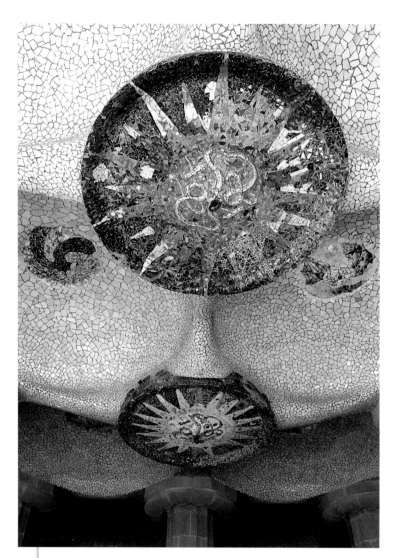

▲ **Antonio Gaudí and Josep Maria Jujol, ceiling boss, Parc Güell.**
The innovative use of broken ceramic mosaic as an element of architectural decoration has been enormously influential in the 20th century. The irregular shapes of the pieces and the free use of color and pattern revolutionized the medium and gave expression to the modern sensibility.

There was an appetite for a new decorative art to replace the tedium of Classicism, and the new movements of Art Nouveau in France and Jugendstil in Germany began to emerge. Decorative art and architecture were combined to an unprecedented degree and for the first time since the Middle Ages mosaic became an important means of expression. As we shall see in Chapter 4, the Spanish architect Antonio Gaudí produced buildings in Barcelona that were a fusion of organic forms and Catalan tradition. His fascination with the

natural form and curvilinear forms is very much evident in Parc Güell where Gaudí draws inspiration from forests and animals to create an inimitable Art Nouveau masterpiece. Highlights of the park include the Serpentine bench and Sala Hispostila with its 84 mosaiced columns.

In Belgium, which was a relatively new and increasingly successful modern state, Art Nouveau flourished as an expression of bourgeois confidence. One of the most striking examples of a completely unified design of interior and exterior, form and decoration, is to be found in the Hôtel Tassel in Brussels. Designed in 1892 by Victor Horta for a professor of descriptive geometry, its deceptive façade is a relatively sober composition of stone, glass, and steel but the interior is full of curling metalwork, painted decoration, and soaring glass roofs. All this is accompanied by a series of intricate and swirling mosaic floors, whose designs spread from one space to another expressing the new idea of flowing, interpenetrating spaces. Also in Brussels is the Stoclet House, designed by the architect Josef Hoffman and decorated with a mosaic frieze by artist Gustav Klimt. Both Klimt and Hoffman were Austrians, and Vienna was an important center for the new style. There are large pots decorated with mosaic flourishes outside the Secession building in Vienna designed by Josef Maria Olbrich, and ornate wall mosaics in the extraordinary church of St. Leopold am Steinhof, designed by Otto Wagner.

This extraordinary outbreak of architectural decoration revitalised the craft of mosaic. The Italian firm of Angelo Orsoni was set up in Venice in 1888 and they exhibited their beautiful range of colored and metallic tesserae at the Universal Exhibition in Paris in 1889. The sample board was greeted with such enthusiasm that it was regarded as a work of art in its own right. The company was subsequently involved in the decoration of many great Art Nouveau projects, including the Church of the Sacré Coeur and the Opéra, both in Paris. Mosaic was not just used in the great set-piece buildings designed by important architects, but also in fashionable restaurants and cafés, such as the magnificent gold ceiling of the Criterion Grill in London and the smalti wall panels of the Caffè Camparino in Milan.

These extreme outbursts of decoration were regarded by Morris's followers as a "strange decorative disease" and design theory

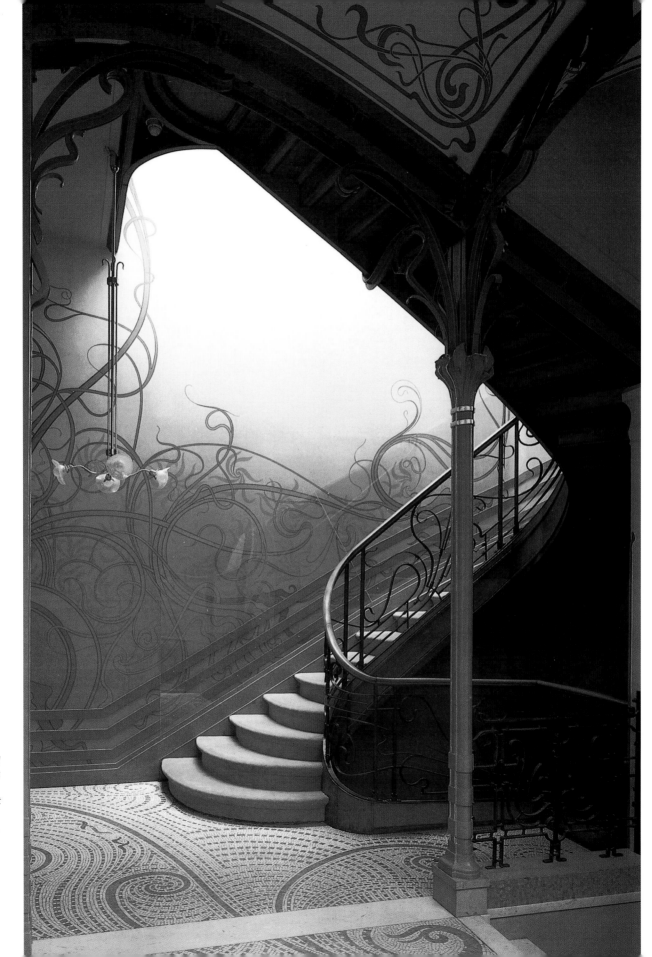

▶ **Victor Horta, Hotel Tassel, Brussels, 1892.**
The mosaic floor demonstrates how appropriate a medium mosaic was for the execution of swirling organic designs. The very limited colors and the use of dotted lines gives the design a lightness of touch that complements the elegance of the metal work and wall paintings.

▲ One of Ruskin's disciples, **William Morris** (1834–1896) was an important theorist of Arts and Crafts philosophy, championing the fusion of designing and making against the mechanical processes of industry. He also practiced what he preached through Morris & Co., the firm he set up to produce stained glass, wallpaper, furniture, and many other decorative objects.

▶ **William Morris,** *Bird,* **1878.**
Morris's patterns, for both wallpaper and fabrics, show a masterful command of the underlying rhythm of ornament, layering different plant forms and motifs in a complex but satisfying harmony. He believed that patterns should have meanings and contain clear pictorial elements, criticizing abstract and geometric patterns as a waste of opportunity.

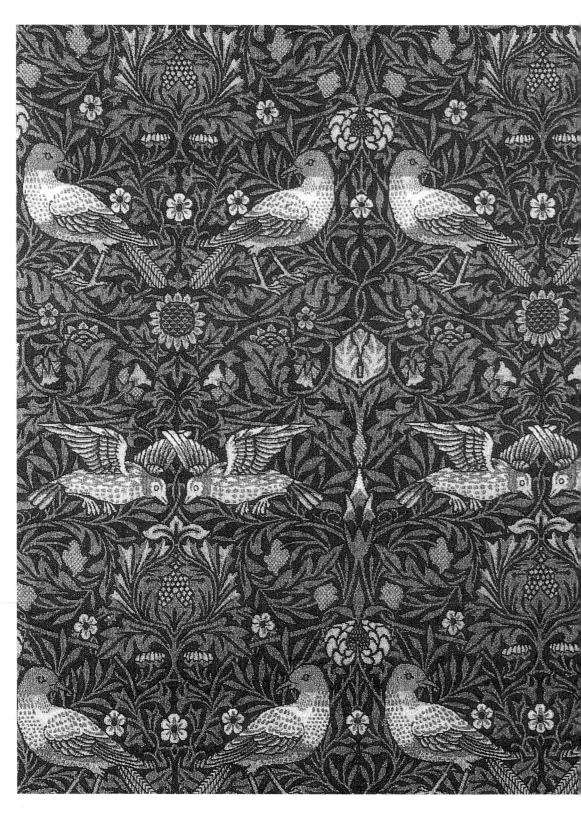

divides into two distinct strands in the early 20th century. The plain, vernacular English style was much studied by other nations. Equally, the ornate continental style was very popular and examples can be found all over Europe from the Vultural Negru Hotel in Oradea, Romania, to Eero Saarinnen's railway station in Helsinki, Finland.

In America elements were taken from both styles to produce a distinctive eclectic mix. The architects Charles and Henry Greene were trained in St. Louis, Missourri, but their parents had retired to the resort town of Pasadena in California and en route to visit them the brothers came across the Japanese Temple in the World's Colombian Exhibition in Chicago. When they arrived in Pasadena they decided to settle and to design for the wealthy residents of southern California a series of beautiful timber houses that combine craftsman style with inspiration from traditional Japanese architecture. An outstanding example is the Gamble House, lovingly built out of wood and designed in every smallest detail from metalwork to lampshades. The low, ground-hugging plans derived from Japanese buildings, proved enormously influential in the development of the characteristic Californian bungalow. In Chicago, the architect Louis Sullivan was heavily influenced by Art Nouveau decoration. His tall structures, built of steel and glass, were technically innovative and unlike any other buildings elsewhere, and his ornamental style, while deriving from

European models, was also unique. The organic forms are highly stylized and intensely observed in fine detail with strong geometric elements and a strict symmetry of composition.

The Art Nouveau influence is also visible in some of the Prairie School architects such as George Washington Maher. He followed a system he called "motif rhythm theory" where each project could be identified by a particular motif which he repeated in different materials and locations throughout the house. An example is the King-Nash House of 1901 in Washington Boulevard, Chicago, where the motif is a stylized thistle. In one room it appears as a vivid glass mosaic around the fireplace. Frank Lloyd Wright was both a member of the Prairie school and a founder member of the Chicago Arts and Crafts Society. Like the Greene brothers, he was also influenced by Japanese architecture. His interpretation of these ideas was influenced by his open enthusiasm for mechanisation which he believed would open the way for a new style of architecture and design. The decorative windows, fabrics, and rugs that he designed are inspired by natural forms but they have none of the swirling movement associated with Art Nouveau. Instead they are stylized into geometric patterns that echo the geometry of the architecture and which, for the first time, have a look that anticipates the "machine esthetic" of Modernism.

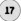

17

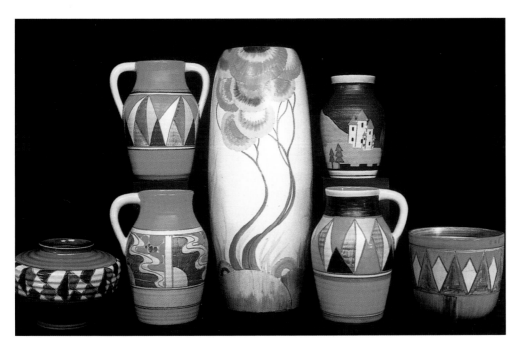

◀ **Art Nouveau vases, 1930s.**
A collection of the highly decorative pottery by Clarice Cliff, the early 20th-century English potter. Simple forms are jazzed up with the use of daring and bold color combinations.

The nostalgic medievalism at the heart of Arts and Crafts thinking was an attempt to halt an inevitable historical process and was doomed to failure. The movement had thrived for as long as it did, however, because it also contained elements of genuinely radical thought that would be absorbed into Modernism. The ideas of utility, of form following function, and of truth to materials, are all central to the Arts and Crafts philosophy. The assumption that these qualities were unique to hand-made objects could not be sustained but they proved enormously influential in architecture and all other fields of design, including mosaic. Furthermore, their interpretation of "truth to nature" introduced the idea that patterns or decorations using stylized forms were more "honest" than elaborate realistic illusionism because the reality of the surface and the materials used should be expressed truthfully and not disguised.

The decline of craft

By the beginning of the 20th century, there were serious challenges facing the Arts and Crafts Movement. The curious alliance between handicrafts and decorative art that had seemed so fundamental to Ruskin and Morris was beginning to break up. The last significant craft company to flourish, called the Omega workshops, was strongly influenced by these ideas and produced work that was very different from its predecessors. It employed artists from the Bloomsbury Group, including Vanessa Bell and Duncan Grant. Most of the objects produced by the Omega artists were clearly excuses to experiment with painting. There was no interest in craft skills and most items were factory made and bought in for decoration. Even so, Omega objects acquired a reputation for falling to bits or losing their painted finishes. Bell and Grant designed and made some mosaics using broken ceramics in a free, unstructured style and, remarkably, some examples at Charleston House have survived.

The outbreak of World War I brought many difficulties for the Omega workshops with both raw materials and customers being hard to find. Industry and production everywhere were disrupted by the new priorities of war. America was drawn into the conflict, and the craft companies found it hard to continue in the new political climate. Gustav Stickley was declared bankrupt in 1915 and in the same year Elbert Hubbard and his wife were lost on the *Lusitania* when she was sunk by a German submarine in the Atlantic.

The demise of decoration

In Europe the devastation of the war would allow the radical new ideas of the avant-garde to take root. The mania for rampant decoration that permeated pre-war Europe had bred an equally extreme counter-reaction. In 1909 an Austrian architect called Adolf Loos and another young German architect, Walter Gropius, began designing buildings that were completely plain and unadorned, rejecting even ordinary construction details such as pitched roofs and gutters on the grounds that they were visually too fussy. These buildings are shocking in their plainness, and seemed to mark an abrupt discontinuity in the development of design. Mosaic, being an integral part of a building's walls or floors, is a decorative medium unique for its close association with architecture, and this rejection of ornament was more damaging to the craft of mosaic than to any other art form.

The Bauhaus, a school of design in Germany, became very influential in the dissemination of this new philosophy. When it was founded in 1919 by Walter Gropius, the Bauhaus offered courses that were designed to teach a combination of theoretical and practical craft-based skills. Gradually the emphasis shifted further toward designing and making prototypes of objects that could be mass-produced.

The idea of the designer as an important element in the manufacturing process was beginning to emerge. The buildings that inspired the machine esthetic had arisen from practical rather than visual considerations but, despite the rhetoric of Modernism, it was the functional "look" that was the source of inspiration, more than functionalism itself. Design was still an essential process in the production of beautiful things but designers were now wedded to a new austere esthetic of plainness and elegance, a kind of stripped-down Classicism.

Although sometimes inconvenient for the people who lived in, or used, products designed according to the new esthetic, they were generally popular with the manufacturers who made them. The simplicity and absence of ornament made them easy to produce, and their association with a superior esthetic sensibility meant they could be expensive to buy. It was the beginning of the correlation between designer labels and inflated price tags.

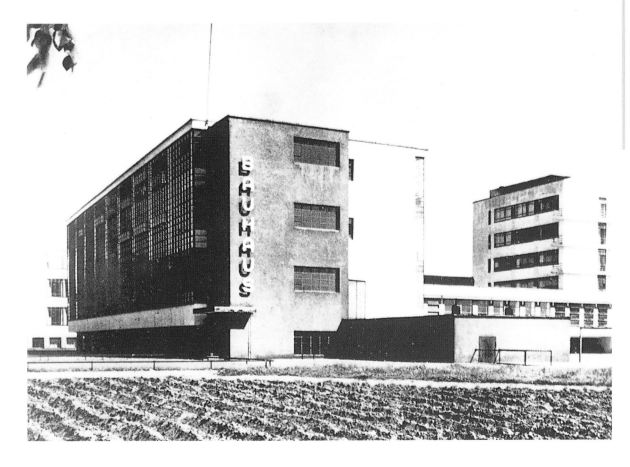

The survivors

As we shall see in Chapter 3, Modernism and the International style did not take off in America until after World War II, and in the 1920s designers were enthusiastically developing their own contemporary decorative style. They followed the direction proposed by Frank Lloyd Wright and American Art Deco is a style of geometric and repeating patterns expressing a confident modernity that could be easily produced by machines. The Chrysler building in New York is one of the finest examples of this bold decorative style which rejected hand-made details in favor of glossy surfaces and perfect geometry. The Empire State Building is another example but although it was finished in 1931 it was not fully occupied until the 1960s. The Wall Street crash of 1929 plunged America into an economic depression that would last for a decade.

Decoration was an unaffordable luxury, and a new style called Streamline Moderne was developed that was much plainer and sleeker. It was envisioned as a style of the future and as a way of helping people look forward optimistically to better times ahead. It was also much cheaper and easier to produce than the complicated, intricate, decorative sunbursts and patterns of Art Deco. In the United States, under the New Deal, the government set up a series of programs to help restart the economy and bring relief to the unemployed. Among these was the Federal Art Project, which helped struggling artists by commissioning both thousands of individual works and also public art projects on progressive themes that would educate and inspire the people. In California in 1935 two mosaic murals were commissioned from Helen and Margaret Brunton to decorate The Old Powerhouse at the University of California, Berkeley, which was being converted into the University Art Gallery. They show allegorical figures depicting the arts of music, painting, sculpture, and dance. The same artists made mosaic murals at Fleishacker (now known as San Francisco) Zoo, which can also still be seen today.

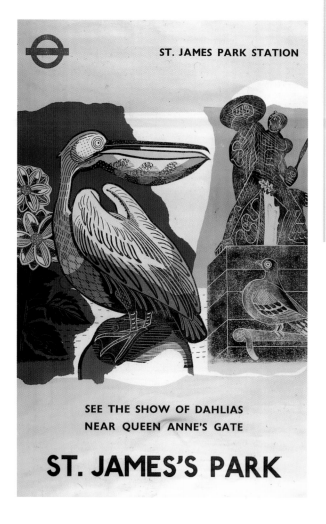

ST. JAMES PARK STATION

SEE THE SHOW OF DAHLIAS
NEAR QUEEN ANNE'S GATE

ST. JAMES'S PARK

◀ **St. James's Park poster, Edward Bawden, 1936.** *As part of his job creating a unified identity or "brand image," for London Underground, Frank Pick commissioned many artists to design posters to display on stations and platforms. His aim was to stimulate people's desire to travel by presenting them with seductive images of exciting destinations.*

The twilight world of craft

Nowadays the decorative arts are largely the preserve of professional designers. The tradition of making things by hand continues to survive but it has become a secluded backwater, detached from the mainstream. In the field of ceramics, potters such as Bernard Leach and Lucy Rie were designer-makers and, along with other artisans such as furniture makers and jewellers, produced work which came to be known as "studio crafts." Artisans who produce domestic items such as pots, furniture, fabrics, jewellery, and rugs can still find a market for their carefully produced objects. It is, however, hard to compete with the avalanche of cheaper mass-produced goods, where labor costs are much lower. In order to defend contemporary crafts against these pressures, organizations like the American Crafts Council, the Canadian Crafts Federation, the Australian Craft Council, and the Crafts Council in Britain promote craft as a high-minded and serious activity, and attempt to restore its declining status by imposing rigorous standards of taste and quality.

▼ **Eric Ravilious, Boat Race designs for Wedgwood, c. 1938.** *Of the many designs for Wedgwood, these were the ones Ravilious was most pleased with. He enjoyed the collaboration with industry but was sometimes disappointed to find that it was his most conventional designs that were always chosen for production.*

The legacy of Morris and his seriousness about decorative art left a lingering fondness for the applied arts that softened the impact of the machine esthetic. However, the widespread separation of design and manufacture was an indisputable fact, and the idea that designers should collaborate with industry was gaining in importance. English artists retained an interest in decorative art and the period between the two world wars saw some extremely successful examples of artists becoming involved in designing products, posters, and books. One example is the graphic work supplied by artists such as Edward Bawden for the London Underground posters; another the exquisite designs made in the 1930s by Eric Ravilious for Wedgwood, the fine china company founded in 1759.

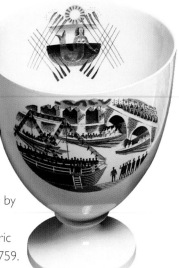

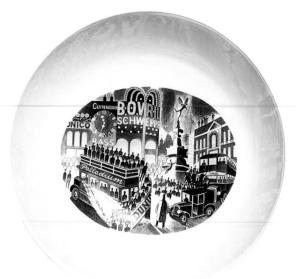

Mosaic in the 20th century

Many of the decorative arts and crafts such as block printing, joinery, weaving, and even embroidery have been able to adapt themselves to modern production techniques, and designers have become a part of the new industries. Mosaic, however, because of its inherent interdependence with architecture, did not flourish in the atmosphere of Modernism. Nevertheless, some interesting mosaics have triumphed over the prohibition of decorated buildings, and it is the aim of this book to place these works in the context of developments within the mainstream of painting and sculpture. It is also the intention to show how many of the experiments in the fine arts have potential relevance to mosaic, and how many possibilities there are to explore in the relatively unfrequented territory of modern mosaic.

As well as the modernist scorn for applied decoration, another reason for the limited quantity of mosaic produced in the 20th century is that it is a process that has largely resisted industrial techniques. Some mechanization was introduced with the invention of vitreous glass tiles in the 1930s, which allowed colored glass to be poured into a mold to form small tiles. These tiles were then stuck onto a paper facing, to be sold in square sheets, as they are to this day. In this way mosaic could be fixed over large areas much more quickly, and by the 1960s it had become a popular material for lining swimming pools and cladding office buildings. These plain expanses of color were compatible with the modern architectural esthetic but more intricate, cut-piece work was impossible to mechanize and remained a rare and expensive choice of finish.

Another reason for the scarcity of modern mosaic is that it has always been closely associated with a single geographical location: Italy. The skills of Italian mosaicists, who have monopolized the craft since Byzantine times, are closely guarded. Most of the craftsmen, originally from the province of Friuli, north of Venice, traveled and set up mosaic companies all over the world. These traditional mosaic companies increasingly found themselves fixing acres of single-color sheets in subways and skyscrapers without any opportunities to exercise their traditional mosaic skills. The American mosaicist Joseph Young described this phenomenon in his book, *Mosaics: Principles and Practice*, published in 1963:

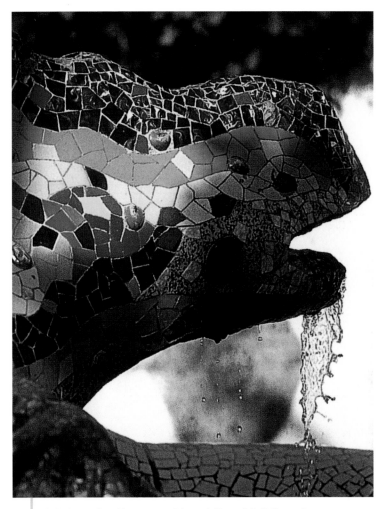

▲ **Antonio Gaudí, mosaiced lizard, Parc Güell, Barcelona.**
This brightly colored lizard adorns one of the fountains of Parc Güell. It is a fine example of 20th-century mosaics used in sculpture.

"From concert hall foyers to hotel bathrooms, the antiseptic white of thousands of tile installations moved through the growing cities of America like a giant glacier. Machine-made imitations of mosaic became so inexpensive they wound up gracing tenement house entrances."

There were, however, important exceptions to this general trend and it is, not surprisingly, in Italy that mosaic has flourished best in the 20th century. In the 1920s two new schools of mosaic had been set up in Spilimbergo and Ravenna, in addition to the long-established

workshops at the Vatican and Salviati's in Venice. These schools continued to train mosaicists in the traditional mosaic techniques and in the arts of restoration and conservation. There is also a group of Italian mosaic artists, associated with these establishments, who have been making and exhibiting contemporary mosaics since the 1950s. They share a preoccupation with texture, working with a combination of smalti and rough marble, and often using very subtle tonal effects combined with spidery lines to recreate the spontaneously lively effects of painting. Lucio Orsoni, from the family of the famous Orsoni mosaic company in Venice, has established a reputation as a modern mosaic artist, creating striking geometric works following Op Art principles, a 20th-century movement in which artists sought to create the illusion of movement and depth from a flat surface. Felice Nittolo is another Italian artist who uses mosaic to give surface and pattern to his three-dimensional pieces. Mosaic is still frequently used to decorate churches in Italy and there is an interesting example of an ambitious scheme, covering most of the interior, in the cathedral of Benevento, Campagnia. The Church of Saint Anthony in Taranto, Puglia, also contains a magnificent series of mosaics by Ferrucio Ferrazzi. Another important site for 20th-century mosaics in Italy is the resort of Albissola, where a number of different artists have contributed to an enormous pavement called the Passeggiata degli Artisti, including Lucio Fontana and Giuseppe Capocrossi. Finally there is the Tarot Garden near Grosseto in Tuscany by the French artist Niki de Saint Phalle, which is discussed in Chapter 4.

In other parts of Europe there have also been adventurous experiments in mosaic. In France several important artists collaborated with mosaicists and had striking works produced from their designs. At the Fernand Léger Museum in Biot in the south of France there is a series of large and striking mosaic murals designed by Léger. Utilizing his characteristically restricted palette and strong graphic style, the panels have a lively surface created by the texture of the marble and glass mosaic. Close by in Nice, the Chagall Museum houses another mosaic, based on a design by Marc Chagall and executed by Leno Melano. It is an extraordinarily delicate rendering of line and wash effects, achieved by using smalti in an almost impressionistic way, with subtle mixes of tones and colors. There is a mosaic designed by Georges Braque at the bottom of a pool at the Fondation Maeght in St. Paul de Vence, as well as another wall mosaic by Chagall. At Menton on the Côte d'Azur there are two pebble mosaics designed by Jean

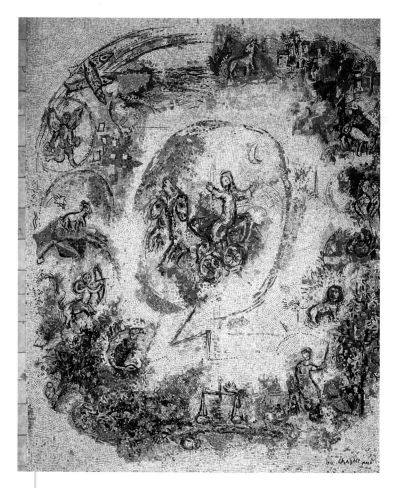

▲ **Marc Chagall, *Le Prophète Elie*, Chagall Museum, Nice, 1970.**
This is a sensitive rendering of the artist's painting style in mosaic by Leno Melano. Smalti are used with great care and precision to mimic the effects of watercolor washes and graphic lines.

Cocteau using his elegant graphic style in simple black and white compositions.

In the United States the mosaics of Jeanne Reynal are discussed in Chapter 3, and there are other important works designed by artists and executed by others, such as the mosaic mural in the lobby of 711 Third Avenue, New York, designed by Hans Hoffman and made by Foscato. The 1960s was a time when many public buildings had walls decorated with large scale mosaic designs. Edmund Lewandowski completed a series of impressive commissions in and around Milwaukee. Joseph Young was working in California on commissions

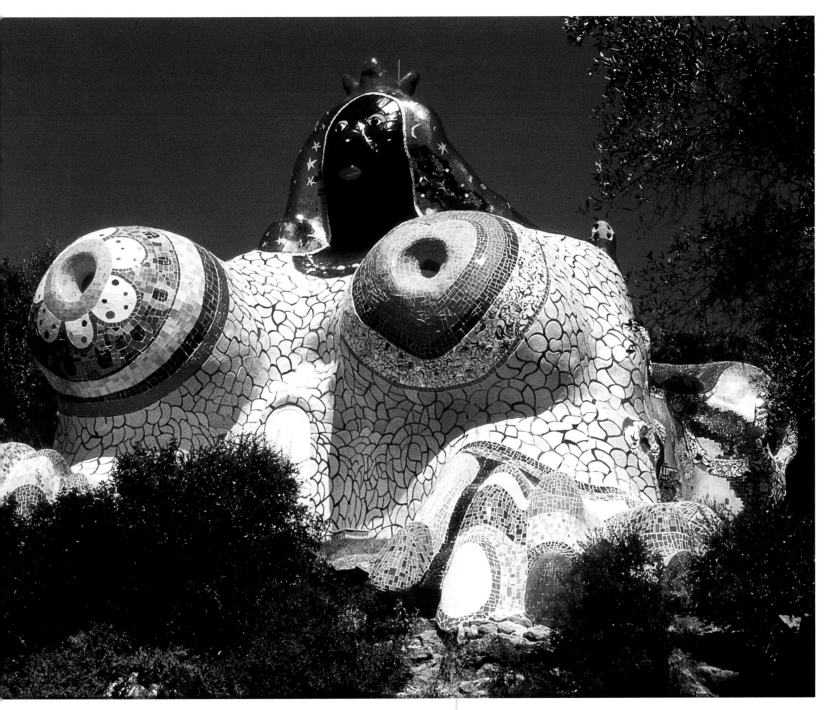

▲ **Niki de Saint Phalle, Tarot Garden, Tuscany.**
This huge figure represents the Empress or Great Goddess, Queen of the Sky.
There are rooms inside where the artists sometimes lived and where the workers
took their coffee breaks. Although she died in 2002, de Saint Phalle's spirit
lives on in her entertaining web site at www.nikidesaintphalle.com.

including the Stock exchange offices in Santa Barbara and the Los Angeles County Hall of Records.

In Canada, Lionel and Patricia Thomas designed large works for the University of British Columbia and for the Public Library, both in Vancouver. A different tradition was represented by the designs of Ben Shahn, for instance his mosaic of Sacco and Vanzetti at Syracuse University. This powerful work shows three scenes from the life and death of two Italian anarchists who were wrongfully executed for a murder and robbery they did not commit, and who became heroes of the American left. Shahn was an artist who worked in many different media, including graphic design and photography, but he was always guided by his sense of social commitment. He had collaborated with the Mexican artist Diego Rivera, whose political murals, both in Mexico and America, had a very strong influence on the tradition of public art in America. The works commissioned by the Federal Arts Project in the 1930s were part of the same movement. The recently completed mosaic mural at San Francisco Airport called *Waiting*, by Mike Mandel and Larry Sultan, demonstrates that the genre is still continuing. It is taken from a photograph of ordinary people waiting at the arrivals barrier, but it is at such a huge scale it elevates its characters to the heroic status of The Common People.

In Mexico City, on the university campus, there is a series of enormous mosaics designed by different artists including Francisco Eppens and Juan O'Gorman. These powerful pieces combine traditional Aztec symbols with a contemporary political message. Their didactic purpose is similar to the many large-scale mosaics executed in the former Soviet Union and clearly owe a debt to the work of Rivera. Before embarking on the monumental rectangular block that is the University Library, O'Gorman experimented on lively three-dimensional mythical creatures at his home in the Pedregal. He was a great admirer of Gaudí but also of the outsider artist Raymond Isidor.

In Britain various artists have experimented with mosaic. The pop artist Alan Jones designed an enormous six-armed figure covered in mosaic, now in Goodwood Sculpture Park, and Andrew Logan has produced a large number of mirror-clad sculptures. Matt Collishaw is currently working on a series of giant monochrome images in pixelated mosaic. More conservative examples can be found in London's Westminster Cathedral.

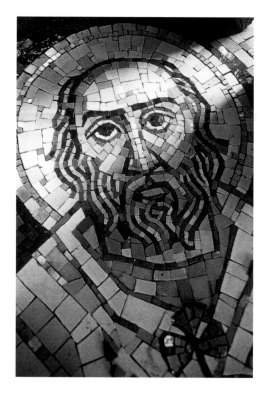

▶ **Trevor Caley, *St. Patrick*, Westminster Cathedral, 1999.** *Executed in an interesting combination of smalti and ceramic, this panel shows a very human version of St. Patrick. The face shows a Byzantine influence but the figure and background are resolutely contemporary.*

The revival of interest

Italian mosaicists working abroad found that there was a steadily declining demand for their skill, and some of the old firms closed down. By the 1980s even mosaic cladding was out of fashion as it began to drop off 1960s buildings. A growing disillusionment with uninspiring and sub-standard modern architecture during the 1980s fuelled a renewed interest in the architecture of the past. There was a new mania for architectural restoration and pastiche, and a new appetite for decoration. Surfaces were scumbled, rag-rolled, stenciled, and distressed, and mosaic began to be rediscovered. At first it was used by designers to add a touch of visual interest in otherwise plain interiors, such as the fashionable crustacea bars at Terence Conran's restaurants Quaglino's and the Coq d'Argent. With materials readily available, this trend quickly spread to the home where mosaic has become in vogue. The very reasons that had led to its decline earlier in the century now contributed to its renewed popularity. There was no ready-made industrial equivalent so every hand-made mosaic had a unique quality that could also be tailor-made to suit individual locations. Even now, when some of the decorative excesses of the 1980s seem over-fussy, mosaic is still a popular material. It provides a

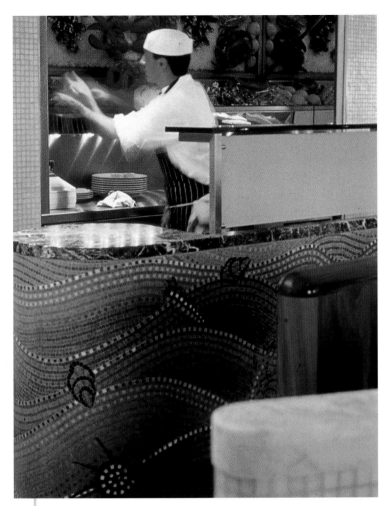

▲ **Mosaic Workshop, *Crustacea Bar*, Coq d'Argent, London, 1998.**
In the 1990s Terence Conran opened a series of restaurants in London with the
intention of making eating out both a memorable and affordable experience.
The interiors were modern but with glitzy touches to convey a sense of glamor,
and mosaic, with its rich colors and texture, was often used to suggest a
restrained opulence.

practical way of introducing color and decoration into the home, and can be used to create strikingly contemporary effects.

Mosaic has acquired a new modernity through its visual affinity with digital imagery. The process of building up pictures using repeated small units of changing tone and color is common to mosaic and pixelated computer images. These new fractured pictures have inspired American photorealists such as Chuck Close to produce complex and sophisticated paintings. Using the same basic idea, a computer program has been devised by fellow countryman Robert Silvers which can categorize images according to their overall tone and assemble them together to form readable pictures. These "photomosaics" have a complexity of content that would be impossible for the human hand to create and an appearance that is fascinating although inhuman.

The future of mosaic craft

Making mosaics in the 21st century may seem like an unusual activity. There are so many equally practical wall and floor materials available to buy, and so many easier and quicker ways of decorating the home. The popularity of making things by hand has declined dramatically in the face of increased mechanization. It may be that this is an inevitable process that will soon lead to the final extinction of craft activities. The once-believed observation that objects made by machines could only ever be ugly seems patently absurd in an age that worships beautiful and ever neater and smaller electronic gadgets. Perhaps we shall soon grow out of the idea that hand-made things have an irreplaceable kind of beauty and move on to a vision of a machine-made Utopia.

The argument against this prediction is that there is something naturally satisfying and pleasurable in the process of designing and making beautiful things by hand. Although it can be difficult and slow, the combined use of mind, eye, and body is, for many people, strangely fulfilling. In his book *The Sense of Order*, the art historian Ernst Gombrich suggests that we are programmed to order experience into predictable patterns, which we can then ignore until alerted to a possible danger by deviations or interruptions. There is therefore a point of balance or equilibrium between monotony and chaos to which all humans will respond: "Delight lies somewhere between boredom and confusion." There is a direct correlation between this way of perceiving things and the physical process of making things. It is satisfying to find an easy rhythm of working and then to interrupt or change it at intervals to avoid boredom. This means that hand-made things appeal to us on a very basic perceptual level, and that designing by making will always remain a successful way of creating objects that please the eye.

The very fact that there is still a lot of interest in mosaic shows that hand-made objects are not extinct yet. There is real pleasure to be derived from inventing and making mosaic, and I hope this book will encourage people to enjoy that process to the full.

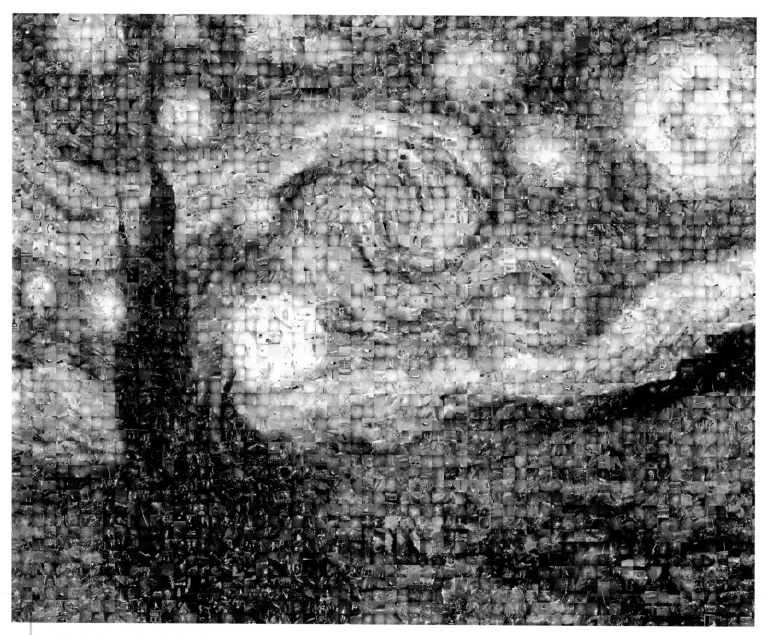

▲ Robert Silvers, *Starry Night*, Photomosaic, 1997.
In this example, pictures of slightly different sizes and proportions have been used against a dark background giving a livelier surface than the perfect grid. Photographs of suitable subjects have been selected with images from space flight forming the sky, and satellite photographs of the Earth forming the land.

▶ Robert Silvers, *Owl*, Photomosaic, 1997.
The program that creates these images is very sophisticated and can read changes in tone across a single image as well as the overall average. The resulting pictures do not, therefore, have distinctly jagged edges and shapes, such as the owl's eyes and ears, that do not fit the rectangular module, can be described with clarity.

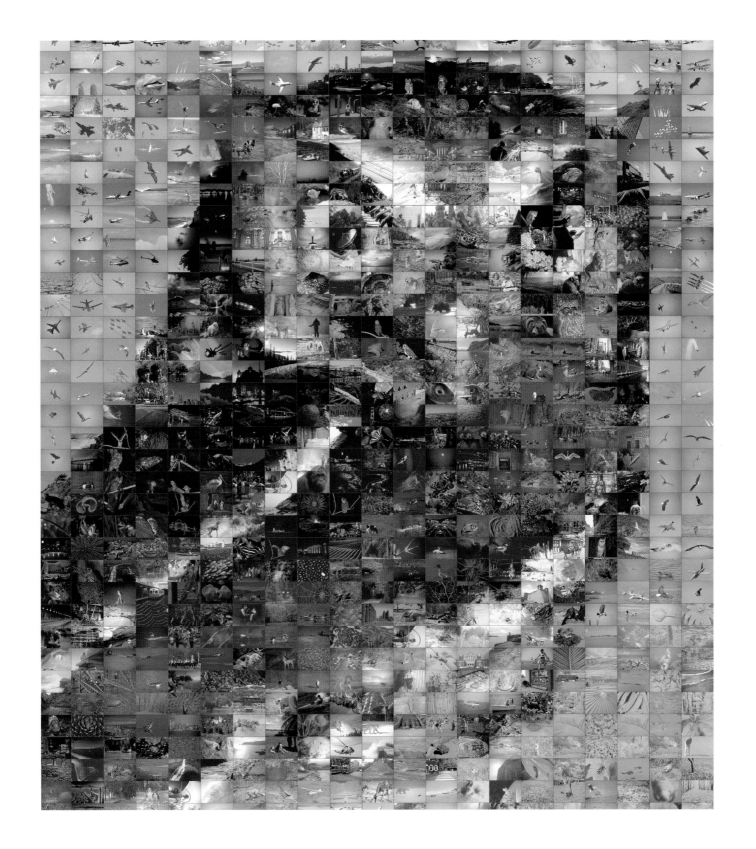

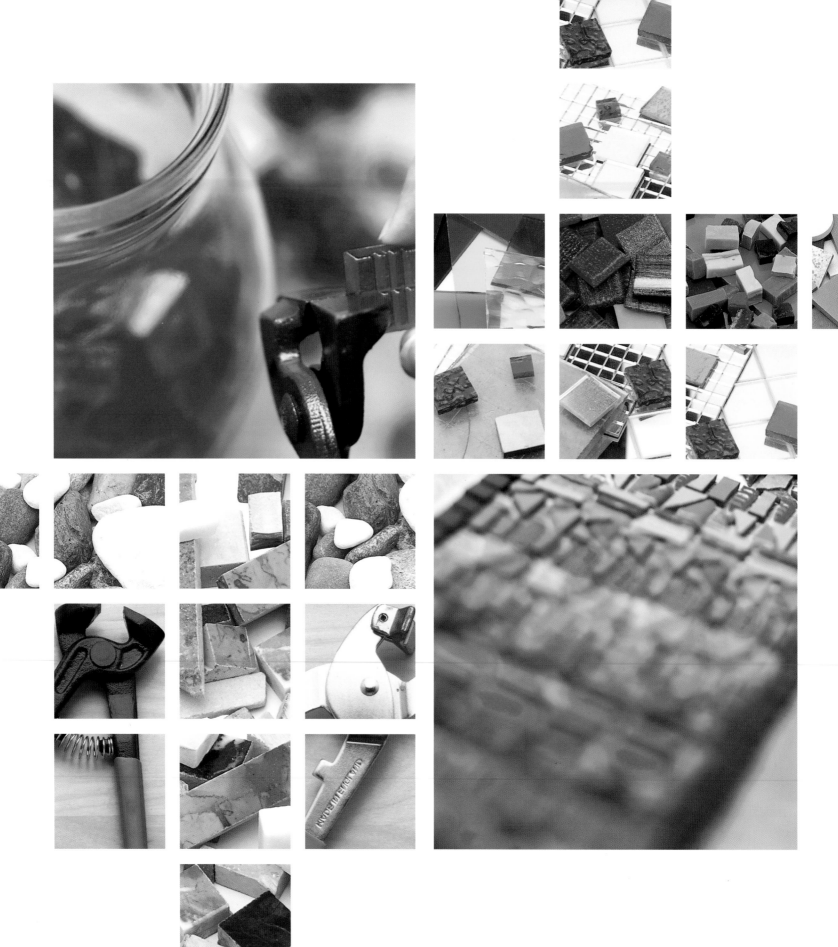

materials, tools, and techniques

THIS CHAPTER PROVIDES A GUIDE TO MATERIALS AND TOOLS COMMONLY USED IN MAKING MOSAICS. IT ALSO GIVES STEP-BY-STEP DESCRIPTIONS FOR THE TWO MOST USEFUL TECHNIQUES OF FIXING MOSAIC—THE DIRECT AND INDIRECT METHODS. THIS WILL PROVIDE A BASIC UNDERSTANDING OF THE PROCESSES INVOLVED, AND VARIATIONS AND WRITTEN TECHNICAL ADVICE ARE CONTAINED IN THE INDIVIDUAL PROJECTS. IT IS IMPORTANT TO CHOOSE COMPATIBLE MOSAIC AND BACKING MATERIALS AND TO USE THE RIGHT ADHESIVE ACCORDING TO THE LOCATION AND FUNCTION OF THE FINISHED PIECE. BEYOND THESE FUNDAMENTAL PRACTICAL CONSIDERATIONS, HOWEVER, THERE IS ALWAYS SCOPE FOR EXPERIMENTATION. INNOVATING WITH NEW MATERIALS AND APPROACHES IS AN IMPORTANT ASPECT OF THE MODERN IDIOM AND IS ENCOURAGED AS LONG AS THE BASIC REQUIREMENTS OF FIRM FIXING TO A RIGID BASE ARE ACHIEVED.

materials

Mosaics can be made using any material that comes in small pieces or that can be easily broken or cut. Paper mosaics can be made using collage techniques, and even small pieces of fabric can be assembled in a mosaic effect. In the 1950s and 1960s it was fashionable to experiment with a wide range of surprising materials, such as seeds, nuts, bark, and wood. Traditionally, however, mosaic has been made of harder materials, such as stone, glass, and ceramic, which are easy to cut because of their small size, and produce durable and hard-wearing surfaces.

glass
Vitreous glass

This is one of the most readily available mosaic materials and it offers a wide range of both subtle and bright colors. The tiles are of a uniform size, ¾ × ¾ × ⅛-inch (20 × 20 × 4-mm) thick, and are manufactured in molds that give a flat face and a ridged back to provide a key for the adhesive. They are generally opaque and colored uniformly throughout, and are also supplied on paper-faced sheets of 15 × 15 tiles. There is a range of colors called "gemme," which is shot through with a gold vein. Both ordinary and double-wheeled tile nippers can be used for cutting, and care should always be taken sweeping up the splinters because they can be sharp.

Smalti

These are enameled glass tesserae, made in a vast range of colors following a process developed in Roman times. A mixture of silica and potash or soda is heated with particular elements, such as copper and lead, according to special recipes that produce different colors. The mixture is poured out to form flat plates, like pizza bases, and cooled gradually. The plates are then usually cut up into rectangles ½ × ⅓ inch (1.5 × 1 cm) that have uneven surfaces on the front and back faces. Smalti are remarkable for the intensity of their colors, which makes them highly suitable for architectural work over large areas to be viewed from a great distance. The irregularity of the surface, however, makes smalti impractical in areas that must be kept clean, and the labor-intensive process of manufacture also makes them an expensive material to buy. Smalti can be cut with tile nippers; double-wheeled nippers are particularly effective and reduce wastage.

Gold, silver, and mirror

Traditionally, gold and silver mosaics are made by laying metallic leaf over glass and then protecting the surface with a further layer of very thin glass. The backing glass is green and blue and these reverse faces have a depth and shine that can also be used very effectively. Slightly cheaper metallic tiles are also available with a clear glass face and a protective coat of varnish on the back. Mirror tiles with plain and sandblasted finishes can also be used, although the silvering will not last forever in exterior locations and may be affected over time by chemical reactions with cement-based adhesives. Mirror tiles also come on fabric- and plastic-backed sheets for covering larger internal areas. All these tiles can be cut with nippers although more accurate cuts may be achieved by scoring with a glass cutter first.

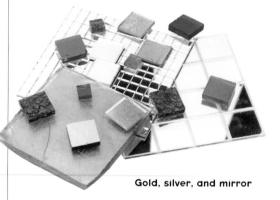
Gold, silver, and mirror

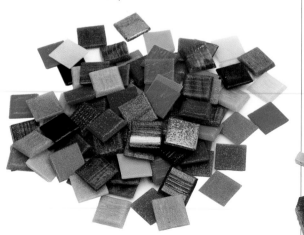
Vitreous glass

Smalti

Stained glass

Sheets of colored glass can be cut into mosaic pieces by cutting strips with a glass cutter and then nipping across with tile nippers. They will be thinner than tesserae made of vitreous glass—about $\frac{1}{16}$ inch (2 mm)—and the appearance of translucent glass will be altered by the adhesive and backing material. It is therefore a particularly suitable material for translucent panels on glass backings.

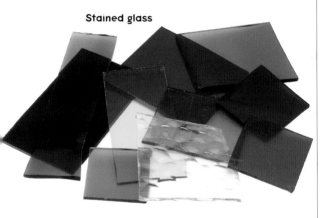

Stained glass

ceramic
Unglazed ceramic

These tiles are manufactured in two sizes, approximately 1 x 1 inch (2.5 x 2.5 cm) and $\frac{3}{4}$ x $\frac{3}{4}$ inch (2 x 2 cm), and are available in a range of muted, earthy tones. They are identical on back and front faces, making them ideal for working in the indirect method and they also have crisp, square edges that lend themselves to cut-piece work. Tile nippers cut them easily, although paler colors may be more likely to shatter. For larger areas the tiles are available on paper-faced sheets.

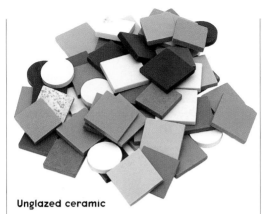

Unglazed ceramic

Glazed ceramic

Glazed mosaic tiles are available in a variety of sizes and are usually sold on mesh-backed sheets. They can be peeled off and used individually, and can be cut using tile nippers. The edges are often slightly rounded and have a variation in the glaze that can stand out in cut-piece work. The color will only be on the face of the tile, making the reverse method difficult, and the range of available colors is limited. A wider range is available in larger glazed tiles, which can easily be cut down into strips with a tile cutter and then nipped across and into shapes with tile nippers. Not all glazed tiles will be frostproof.

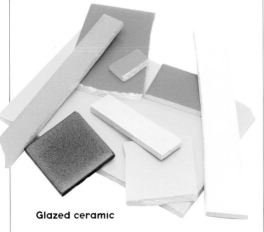

Glazed ceramic

marble and stone
Marble

Marble tesserae can be cut to any size although $\frac{1}{2}$ x $\frac{1}{2}$ inch (1.5 x 1.5 cm) cubes are easy to work with and are therefore the ones most often used. They are cut down from $\frac{1}{3}$-inch (1-cm) thick polished marble tiles on a wet saw and have a polished face and a saw-cut face, either of which can be used. The unpolished face will be much less intense in color and may have slight diagonal markings from the saw-blade. It is also possible to split the cubes, revealing a rough inner face with a crystalline surface. This is called riven marble and can be used on wall mosaics. Marble can be cut with tile nippers; long-handled nippers give greater leverage and are easier to use. The hammer and hardie can also be used to cut saw-cut rods down into cubes and to split and shape them.

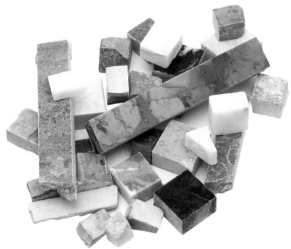

Marble

Pebbles

Pebbles can be easily collected from beaches and rivers or bought in selected colors such as white and green. White pebbles are soft and can be cut but are not suitable for areas of heavy wear.

Pebbles

Stone

A few other stones, such as limestone, are soft enough to cut and shape by hand but most stone can only be cut on the wet-saw and used in whole cubes.

Stone

found objects

Broken china and tiles

These materials can be smashed into irregular shapes by wrapping them in a towel and hitting them with a hammer, or they can be cut down and shaped with tile nippers. It is easier to work with pieces of similar thickness or at least in areas of equal height if you are planning to grout the mosaic.

Broken china and tiles

Other materials

A few suggestions are: shells, marbles, beads, buttons, metal nuts, rivets, type blocks, typewriter keys, thimbles, coins, bottle tops, washers.

Other materials

drawing equipment

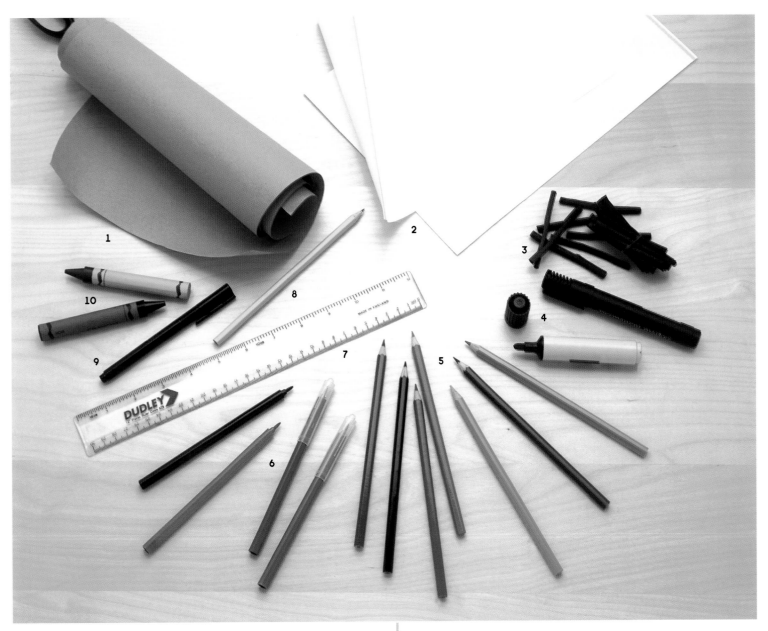

▲ **For drawing**

1 *brown paper*
2 *acetate sheets*
3 *charcoal*
4 *marker pens*
5 *colored pencils*

6 *felt-tip pens*
7 *ruler*
8 *pencil*
9 *pen*
10 *crayons*

tools
mosaic cutting and fixing tools

Hammer and hardie

A mosaic hammer has a flat tungsten tip at each end, and a hardie is like a chisel embedded in a solid stand such as a tree trunk or a flowerpot filled with cement. The mosaic piece is held on top of the hardie along the line of the desired cut and the hammer brought down parallel to the hardie. This is the traditional method of cutting marble mosaic.

Tile cutters

These tools have a scoring wheel and a snapper for breaking the tiles. Larger versions are available with a fixed bed and a rail along which the scoring wheel runs. They are used when working with tiles larger than 1-inch (2.5-cm) square to cut strips of the required size. These can then be cut across with nippers to form squares and rectangles. They can also be used on small tiles to cut triangles because the scoring encourages the tiles to break more neatly from point to point.

Tile nippers

This is the essential tool for all mosaic cutting. The tungsten-tipped blades can be used on all but the hardest mosaic materials for both cutting and shaping. Long-handled nippers give greater leverage when cutting hard materials such as marble, and double-hinged cutters will cut even harder stones and thick ceramic floor tiles. Double-wheeled nippers are good at cutting thin strips of vitreous tile and for cutting smalti.

► **For cutting**
1 *hacksaw*
2 *mosaic hammer*
3 *double-wheeled nippers*
4 *wire cutters*
5 *long-handled nippers*
6 *tile nippers*
7 *tile cutter*
8 *scissors*
9 *craft knife*
10 *surform*

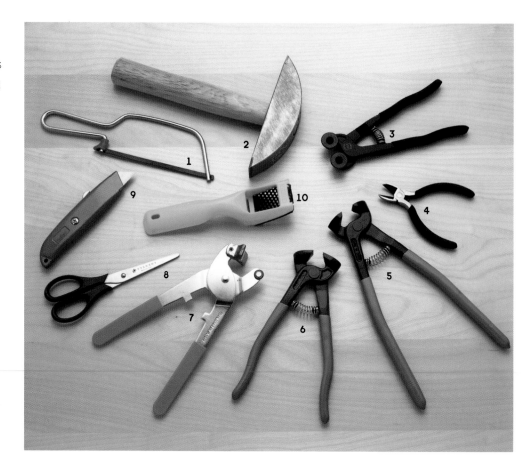

Grouting tools

The small adhesive spreaders have a flat side, which is useful for applying grout to small pieces. Larger areas can be grouted using a squeegee or a flat bed trowel. For three-dimensional objects or fiddly areas the human hand is the best tool, protected in surgical rubber gloves.

Plasterer's small tool

This little trowel can be used to apply adhesive to flat and curved surfaces when using the direct method. It is also useful for covering areas that the trowel cannot reach using the indirect method.

Tiler's sponges

These sponges have a particularly close density that helps to pick up surplus grout and makes the job of cleaning the surface easier.

Trowels

Small-notched trowels are used for applying cement-based adhesive for mosaic work. The small notches (approximately $1/8$ inch / 3 mm) mean that most of the surface is covered in adhesive and even very small pieces should be in contact with the fixing bed. Small plastic spreaders are useful for small pieces, while the large trowels are essential for larger areas.

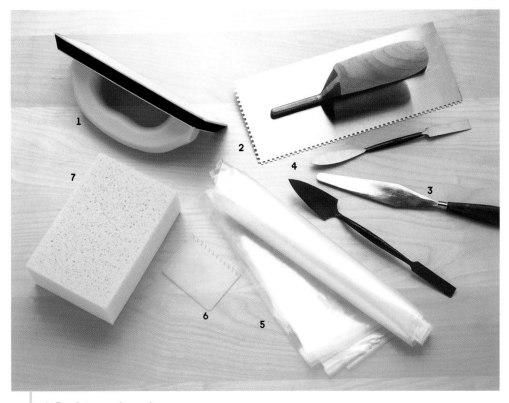

▲ **For fixing and grouting**
1 *grouting float*
2 *notched trowel*
3 *palette knife*
4 *plasterer's small tools*
5 *polyethylene sheeting*
6 *plastic spreader*
7 *sponge*

▶ **For framing and hanging**
1 *hammer*
2 *small screwdrivers*
3 *large screwdriver*
4 *copper strip*
5 *picture wire*
6 *D-rings*
7 *copper hardboard pins*

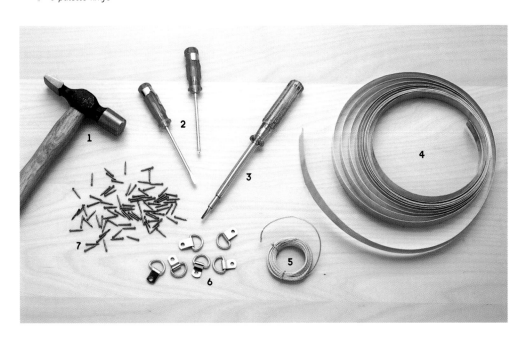

other useful tools and equipment

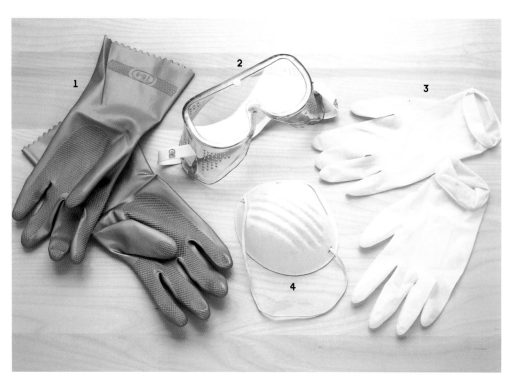

◀ **For protection**
1 *rubber gloves*
2 *protective eyewear*
3 *surgical gloves*
4 *face mask*

Face masks

Large amounts of cutting of any material will create a lot of dust, and it is advisable to avoid breathing it in by wearing a protective mask.

Protective eyewear

Small slivers can fly upward during cutting, so eyes should be protected by glasses or safety goggles.

Rubber and surgical gloves

Cement products can irritate the skin, so fixing with cement-based adhesive and grouting should be carried out wearing rubber gloves. Surgical gloves are more closely fitting and allow for more dexterity.

▲ **Setting tray**
A moulded, plastic tray or jig for setting vitreous glass tiles in a regular grid with even spacings between the tiles.

backing materials

Glass

Mosaic materials can be stuck to sheets of glass or glass objects using silicone glue.

Mesh

Mosaic materials can be stuck to nylon mesh before being fixed with cement-based adhesive to a wall, panel, or floor. You can use PVA glue for interior pieces or an aliphatic wood glue for exterior work, and you will need to place a sheet of plastic under the mesh to prevent the glue from sticking to the work surface. Aluminum mesh can be used to form a base for three-dimensional pieces. It should be covered in a layer of adhesive and allowed to dry before you start to apply any mosaic.

Plaster and plasterboard

These surfaces are suitable for use in dry internal areas and should be primed with a dilute solution of PVA before fixing with cement-based adhesive. On painted surfaces the bond will be between the paint and the adhesive, so it is essential that the paint adhere thoroughly to the plaster.

Sand and cement screeds and renders

These are ideal surfaces to fix mosaic on to either walls or floors using cement-based adhesives. The surface should be as flat as possible because any irregularities will be visible on the surface of the mosaic. The sand and cement mixes should be completely dry before fixing the mosaic to prevent salts coming up through the joints.

Terracotta

This should be primed with dilute PVA before using a cement-based adhesive for sticking.

Timber

For interior panels in dry areas MDF (medium-density fiberboard) is a good stable backing material. The thickness of the board should be determined by its overall size so that it is stiff enough not to bend; $\frac{1}{3}$ inch (1 cm) is recommended for boards up to 35 inches (90 cm) square. Very large boards may need diagonal bracing on the back to keep them flat and to avoid making them impossibly thick and heavy. For exterior locations you must use an exterior-grade board, which can be either MDF or plywood. The edges of a mosaic board will be vulnerable and it is recommended that some kind of timber or metal frame be used. Because timber is a material that expands and contracts according to temperature and humidity, it is important for larger panels to use an adhesive with some flexibility—silicone or cement-based adhesives containing a flexible additive are suitable. For exterior panels a highly flexible adhesive is required.

Other surfaces

Any rigid surface can be covered in mosaic but objects that bend, such as plastic furniture, are not suitable. Adhesive manufacturers' instructions should be consulted for specific requirements.

▲ **Backing surfaces**
1 *aluminum insect mesh*
2 *hardboard*
3 *nylon mesh*
4 *MDF*

adhesives and grouts

Cement-based adhesives

These are proprietary tiling adhesives based on traditional sand and cement but containing additives to improve adhesion and workability. Powder-based products that are mixed with water give greater flexibility in consistency for different applications and will last indefinitely. Different products will vary in their precise characteristics and the labels should always be read with care and manufacturers contacted in case of doubt.

Cement-based grouts

Cement-based grouts are proprietary products that are a weak, sandy mix designed to fill the joints between the tiles while allowing some movement without cracking. They are generally available in a limited range of colors including white, gray, ivory, and black but some manufacturers produce a greater range of colors. Sometimes fine powder grouts are recommended for narrow joints but they can be difficult to clean off and the coarser wide-joint grouts are easier to use.

Epoxy grout

This is a two-part product that forms a genuinely waterproof joint. It is quite difficult to clean off the surface, particularly in mosaics where there are many joints, and should be considered only when essential for reasons of hygiene or impermeability.

PVA and wood glue

Propylene vinyl acetate (PVA) is a white liquid glue. The water-soluble variety, often sold as school glue, is used in a dilute form to stick tiles to paper in the indirect method. The permanent variety, including wood glue, can be used to stick pieces directly to a timber background. A waterproof version is also available but it is waterproof only when added to, or used with, cement and should not be used as an exterior adhesive. Aliphatic wood glue is available in an exterior grade for the outdoors.

Silicone

Available in small tubes or cartridges for mastic guns, this glue is highly flexible and can be used both indoors and out. It comes in a translucent form, described as clear, which can be used on glass for translucent panels. Because it is very sticky and dries quickly it is important not to get it on the face of the tiles.

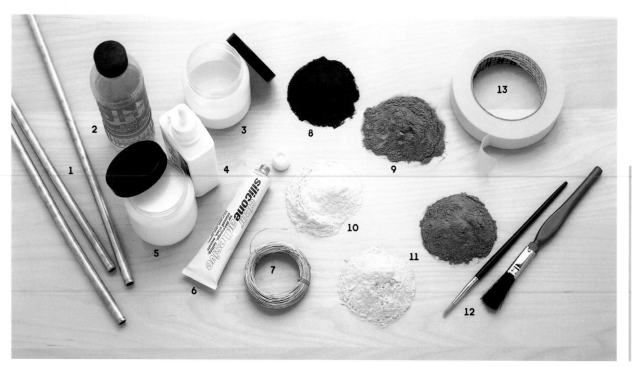

◀ **Adhesives and materials**
1 *copper tube*
2 *linseed oil*
3 *aliphatic wood glue*
4 *white craft glue*
5 *water-soluble PVA*
6 *silicone glue*
7 *wire*
8 *black grout*
9 *gray grout*
10 *white grout*
11 *cement-based adhesives*
12 *paintbrushes*
13 *masking tape*

Choosing grout colors

The color of the grout will radically affect the appearance of the finished piece so it should be chosen with care.

White grout This will give a mosaic a fresh, clean look and is often a good choice if white tiles have been used. It can also be a suitable choice in bathrooms where freshness and cleanliness are attractive but in other situations the association with bathroom tiling may be inappropriate. White grout will unite areas of white mosaic while darker areas will be very broken up. This will reduce the intensity of the colors and should be avoided if strong color effects are desired.

Gray grout This is a practical choice for floors as it will not show the dirt. In mosaics with a strong contrast between dark and light, such as black and white designs, a gray grout will be a mid-tone that breaks up the light and dark areas equally, creating a balanced effect. Grays can also be used successfully with pale and mid-tone mosaics where the grout is a similar tone to the colors used and therefore blends them together. As with white, gray will tend to deaden the intensity of bright, strong colors.

Black and dark gray grouts A very dark grout will darken the overall appearance of the mosaic but it will bring out the intensity and vibrancy of the colors. It is a good choice for plain areas of single bright colors and for designs with a generally dark background, creating a unified field against which the foreground can be read. Dark grout can stain very pale colors and should be cleaned off as quickly as possible.

White grout

Gray grout

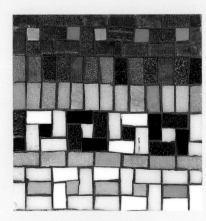
Dark gray grout

basic techniques

Cutting

Vitreous glass and ceramic tiles are cut with tile nippers by placing the nippers at the edge of the tile and squeezing gently. The angle at which the nippers are placed will determine the angle of the cut. Tiles can also be nibbled away to form circles or to straighten up uneven cuts. Remember that cuts do not have to be perfectly straight—some variety in shape and size will give the mosaic its hand-made quality. Marble is easier to cut if the nippers are placed across the tile rather than at the edge. Marble and stone mosaic can be cut using the hammer and hardie. When striking the stone with the hammer try to avoid hitting the hardie underneath because this will blunt it.

▲ **Cutting using tile nippers**
Tile nippers are used to cut both vitreous glass and ceramic tiles. For safety, protective goggles should be worn at all times and fingers kept well away from the nippers.

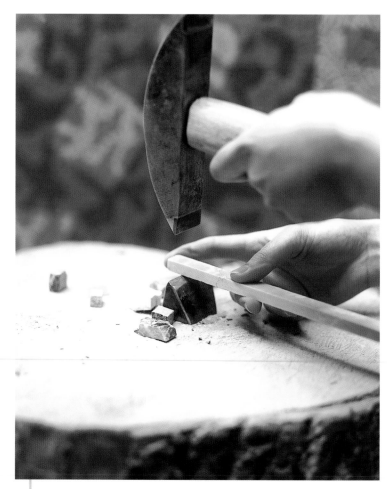

▲ **Cutting using a hammer and hardie**
Because marble and stone are thicker than tiles, a sharp hammer and hardie are often the best tools for cutting. You should never use a conventional hammer as marble is prone to bruising if not handled properly.

fixing

Direct Method

This method of fixing is when the tiles are glued directly to the backing surface. The adhesive used can be cement-based, PVA, or silicone depending on the particular application, and it is a method that is suitable for all types of mosaic and backing materials.

It is the most straightforward technique to use as you will be able to see exactly how the finished mosaic will look as you progress. It is a good method to choose if you want to create a textured surface but it can, however, be difficult to achieve a perfectly flat finish and you also have to be careful to plan out your work in some detail before starting to stick. It is the most practical technique for all three-dimensional and sculptural work.

1 Sketching the design
Start by outlining your design. The design must be drawn onto the backing surface. It can be traced from a drawing using tracing paper or a light box.

2 Laying out the tiles and selecting the colors
Tiles can be laid loose, right side up, onto the design before sticking. You need to have worked out in advance the main principles of what you are going to do as alterations can be difficult and messy. In this piece the features are arranged and the tiles cut before gluing.

3 Sticking down the tiles
The adhesive should be applied thinly over a small area with a palette knife. All glues will skin over when exposed to the air so it is important not to spread more than you can cover to ensure this doesn't happen.

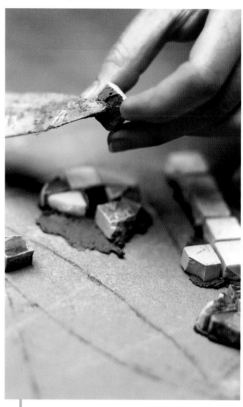

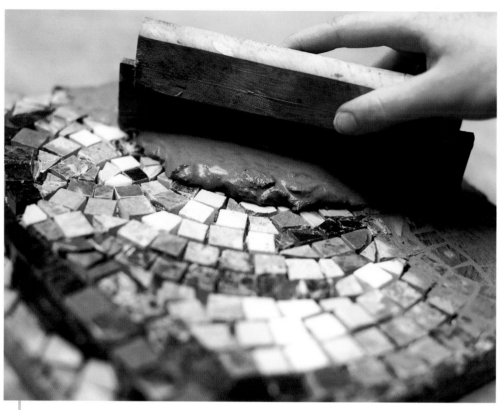

4 Leveling the surface
As some materials will be thinner than others, they will need to be built up to the overall level by applying a little extra adhesive directly onto the back of the tile. Once the features are in position the rest of the face and the background can be filled in.

5 Grouting the mosaic
When all the pieces are stuck down and the adhesive is dry, the mosaic can be grouted. Spread grout all over the face of the mosaic using a spreader or your hands protected by rubber gloves. Work the grout into the joints, eliminating air bubbles.

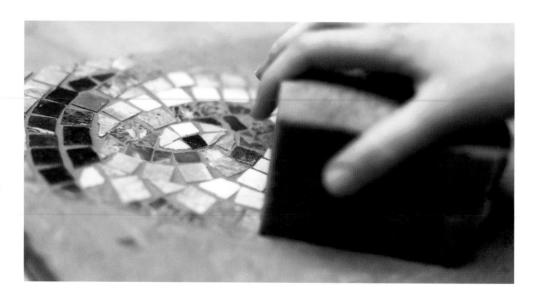

6 Sponging down the surface
While the grout is still wet, clean off the surface with a damp sponge. Rinse the sponge regularly and squeeze it so that it is as dry as possible. Pass it lightly across the mosaic at a diagonal angle to the joints. Never use the dirty side of the sponge as this will merely smear the grout back on again. Instead keep turning to a clean face, rinse thoroughly, and repeat.

7 Cleaning the surface
Once the excess grout has been removed and the grout is dry, you can clean off any residue left on the surface with a clean, dry cloth.

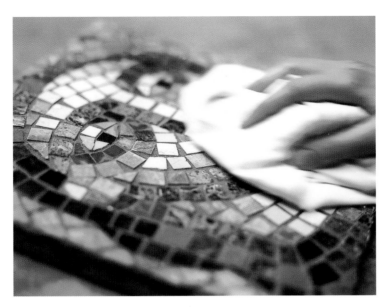

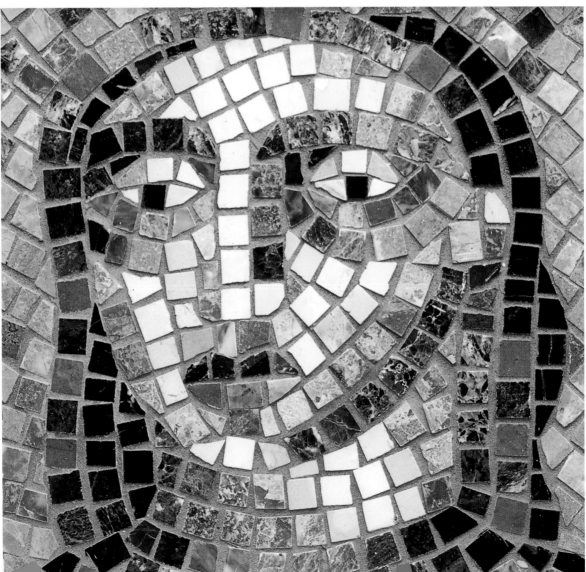

Indirect Method

This technique, sometimes called the reverse method, is when the design is reversed and drawn on to brown paper and the pieces stuck upside down with a water-soluble glue to the paper. The mosaic can then be turned over into an adhesive bed and the paper soaked off the face. The indirect method allows alterations to be made easily while the mosaic is still on the paper and also allows work to be carried out comfortably on a bench or table even if it is destined for a ceiling, floor, or vertical wall panel.

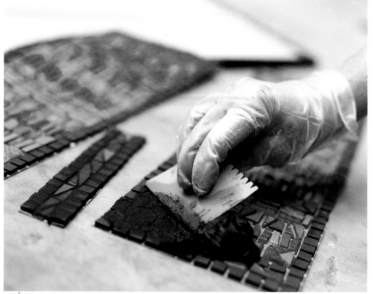

2 Pre-grouting the mosaic
When all the tiles are stuck and the glue is dry, the mosaic should be pre-grouted. Grout is spread across the back of the piece and pushed into the joints. Wear surgical gloves to do this.

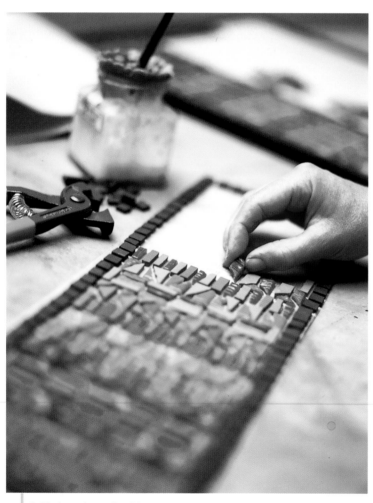

1 Sticking down the tiles
Apply water-soluble glue to a small area of paper with a small brush. Wallpaper paste, or flour and water paste can be used, as well as water-soluble PVA. Too much glue will make the paper too wet and it will wrinkle and buckle. Stick the tiles face-down. Matte ceramic tiles will be the same on both sides but vitreous glass must be stuck with the ridges facing upward. Because glazed tiles have different colored backs they are not suitable for use with this method.

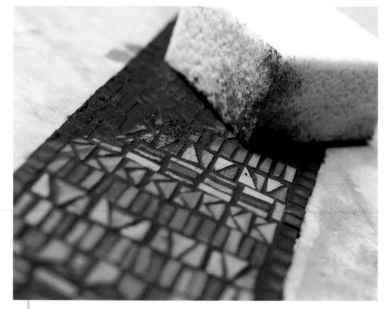

3 Cleaning the surface
The backs of the tiles are then sponged clean, leaving the grout only in the joints. As with ordinary grouting, squeeze the sponge as dry as possible and pass a clean face lightly across the surface, turning the sponge with every pass and rinsing when all faces have been used.

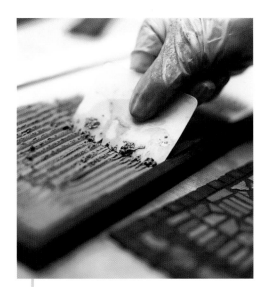 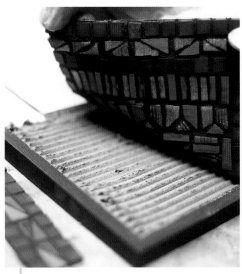 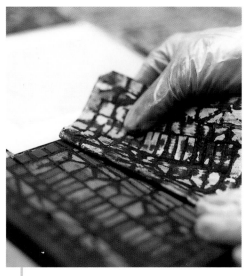

4 Applying the adhesive
Cement-based adhesive should then be applied to the backing using a small-notched trowel to ensure an even bed.

5 Fixing the mosaic
The paper-faced mosaic can now be turned into the adhesive. It should be handled with care as it is fragile at this stage and pre-grouted sections should not be left unattended for more than 15 minutes because the damp grout will start to dissolve the glue. Large mosaics should be cut into sections that can be handled easily (about 17³/₄ inches / 45 cm square).

6 Peeling away the paper
Before the grout dries (within 30 to 40 minutes depending on temperature), the paper should be wetted with a sponge. The glue will take 10 to 15 minutes to dissolve and then the paper should be carefully peeled away. Pull the paper back along the mosaic rather than upward and away from it to avoid lifting the pieces out of the adhesive.

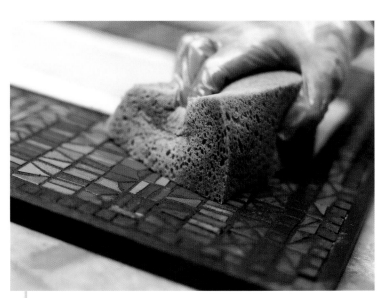 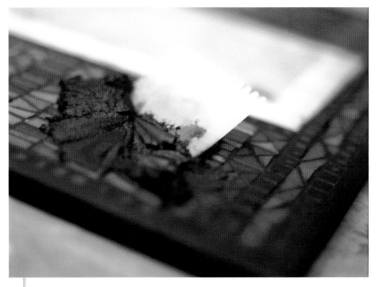

7 Wiping away excess grout
You will see that some grout will have bled through on to the face of the mosaic, and so the surface must be sponged before the grout dries. Remember that the adhesive bed is still wet so do not attempt to clean perfectly at this stage.

8 Regrouting the surface of the mosaic
When the adhesive is dry (consult the manufacturer's instructions for drying times), the mosaic can be regrouted. Cover the face of the mosaic with grout and work in with a spreader (or use your hands, protected by rubber gloves) to fill any low joints or holes. Sponge the surface clean as before with a clean, damp sponge. When the grout is dry give the piece a final clean with a dry cloth.

representation

FOR THE FIRST TIME IN THE HISTORY OF ART, THE MODERN AGE HAS SEEN A DISTINCTION BETWEEN REPRESENTATIONAL AND ABSTRACT ART. THE TWO APPROACHES APPEAR TO BE RADICALLY DIFFERENT BUT BOTH DEMONSTRATE AN INCREASING CONCERN WITH FORMAL PROPERTIES OF SHAPE AND COLOR COMBINED WITH THE EXPRESSION OF EMOTIONAL CONTENT. THE GENERAL MOVEMENT AWAY FROM REALISM AND NARRATIVE LIBERATED PAINTING FROM ITS TRADITIONAL CONSTRAINTS AND OPENED UP A NEW VOCABULARY THAT WAS AS MUCH ABOUT PAINT AND PAINTING AS IT WAS ABOUT ANY SUBJECT MATTER IN THE NEW WORLD. THIS CONCERN WITH EXPRESSIVE STYLIZATION HAD MUCH IN COMMON WITH THE GREAT MOSAIC WORKS OF THE BYZANTINE AND MEDIEVAL PERIODS, AND 20TH-CENTURY MOSAIC BOTH CONTINUED THIS TRADITION AND EXPLORED NEW FORMS AND APPROACHES.

From the Renaissance until the invention of photography in the 19th century the visual arts were primarily concerned with the representation of the real world. The picture frame acted like a window frame, the edge of an aperture through which the viewer could see into another place. The creation of this illusion was accepted as the essential purpose of all art and the techniques and skills of the artists were developed toward this end. In the modern age this fundamental idea began to be questioned, and even within the field of representational painting the assumptions of illusionism were constantly challenged.

Artists became preoccupied with new subjects and other ways of filling the picture frame, and two separate and sometimes contradictory approaches began to emerge: One was to find ways of depicting the hidden significance, or symbolic meaning, behind superficial appearances, and the other was to incorporate the vocabulary of painting—the forms, colors, and lines—into the content. Sometimes these two ideas are fused, with the formal properties used

▼ **Edouard Manet,** *Olympia,* **1863.**
It is hard now to realize how shocking Manet's paintings were to their contemporary audience. Not only did they portray the courtesans and prostitutes of the Paris demi-monde, they did so in a style stripped of all the romantic gestures and allegories of traditional art.

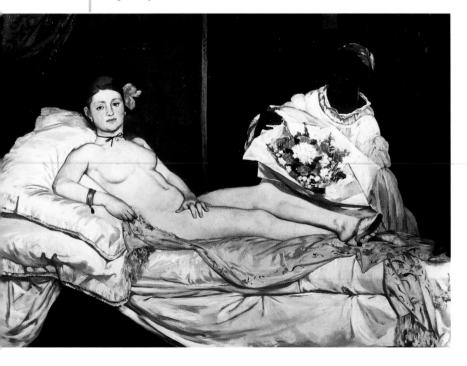

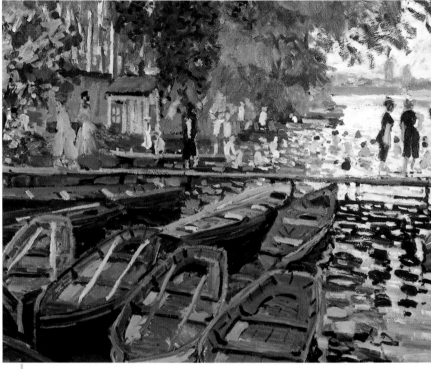

▲ **Claude Monet,** *Bathing at La Grenouillère,* **1869.**
Monet's free style of painting was not intended as a retreat from realism but rather as a way of creating an image that was more true to the painter's experience. He was able to express both his perception of the sunlit scene, and the activity of painting it.

as a new emotional language, and sometimes artists abandoned recognizable imagery altogether and turned to abstraction. The history of representational art can be read as a dynamic dialog between romantic expressionist symbolism and cool esthetic formalism. One other factor is significant in the development of modern art, namely a preoccupation with subjects from the contemporary world. Most painting before Impressionism was concerned with religious or historical subjects but Edouard Manet and his followers turned their detached gaze on everyday scenes and people. The impassive subjects of Manet's paintings gaze out at the viewer in the same way as the saints and martyrs do in Byzantine mosaics. While the Byzantine faces are filled with didactic meaning, conveying their confident message of faith, Manet's courtesans appear simply to be who they are, namely people of their time.

Manet was deeply involved with the art of the past, and some of his paintings referred directly to works by previous masters, such as

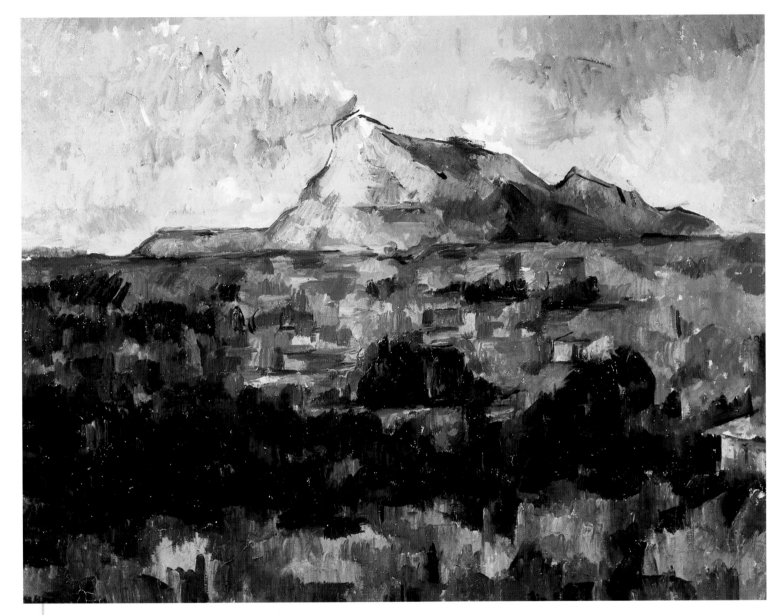

▲ **Paul Cézanne, *Montagne Sainte Victoire*, 1904–06.**
Cézanne worked slowly and was not interested in the transient impressions of a particular moment. Instead, his studied compositions express an almost monumental solidity carefully assembled from blocks of shimmering color.

Velázquez and Goya. Claude Monet, by contrast, was inspired by his observations of nature and in particular the behavior of light and shadow. In his painting of *La Grenouillère*, the scene is broken up into individual dabs of color that convey the dappled sunlight and wind-rippled water. The individual brush strokes are clearly obvious and make the statement that this is a painting and not an illusion. The idea that the human eye can interpret this fractured image is also fundamental to the practice of mosaic, and the Impressionists' experiments with juxtaposing dabs of color are full of potential inspiration for mosaic techniques. Both Monet and Georges Seurat were influenced by scientific theories of color and use the pairing of complementary colors to create shimmering effects. Other painters, such as Paul Cézanne and Paul Gauguin, felt this approach was too cold and distant. Cézanne developed a similarly fractured technique

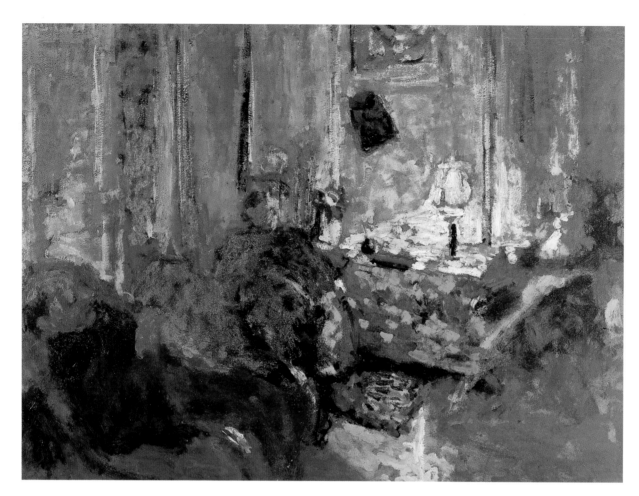

◄ **Edouard Vuillard,**
Interior with Madame
Vuillard, **1893**.
One of many interiors
painted by Vuillard, this
shows a room bathed in
artificial light. The
patterned surfaces and
falling light are all
conveyed by individual
brush strokes and the
figure blends harmoniously
into the background
expressing the peaceful
calm of the domestic
scene.

but his aim was to distill the essence of his subjects, rather than merely record the physical sensations they produced on the eye. Gauguin pursued a different approach to stylization, using line and areas of flat color inspired by primitive art. He believed that different formal elements had emotional qualities: "All five senses, on which a multiplicity of things have impressed themselves in such a way as to be indelible, communicate directly with the brain. From this fact I conclude that there are lines which are noble, others which are misleading, etc., the straight line creates infinity, a curve limits creation, not to speak of the fatality of numbers. Have we talked enough about the numbers three and seven? Colors, though less diverse than lines, are nevertheless more explanatory by virtue of their power over the eye. There are tonalities which are noble and others which are vulgar, harmonies which are calm or consoling, and others which are exciting because of their boldness." (From a letter to Emile Schuffenecker, 1885.)

Gauguin articulated the symbolic, expressionist belief that paintings could communicate a deep and mystical reality associated with dreams and the subconscious. These ideas, already explored by the more traditional Symbolists such as Gustave Moreau and Odilon Redon, were to have a powerful influence on a group of French painters who called themselves the Nabis. Edouard Vuillard was a member of this group, although his paintings are also clearly influenced by Monet's techniques. Vuillard's work combines a fascination with surface and painterly effects with a distinctive emotional mood. He takes the flickering dabs of paint that Monet used to suggest sunlight and landscape and applies them to intimate interior scenes. Project 1, The Dressmaker's Shop (see page 57), is based on one of these paintings.

The influence of the Post-Impressionists spread rapidly, and Roger Fry, who was part of the Bloomsbury Group, introduced their work into England. He and Clive Bell wrote at length on the

significance of the new art, suggesting that a special esthetic sensibility was necessary to fully appreciate and understand the true emotional meaning of the works: "… do we not feel that the average businessman would be in every way a more admirable, more respectable being if his imaginative life were not so squalid and incoherent?" (Roger Fry, *An Essay in Esthetics*, 1909)

Artistic or bohemian people now came to be ranked in a separate and somehow superior class whose esthetic sensitivity permeated their attitudes and lifestyles. At the same time as elevating artistic production to new heights of emotional insight and expressive power, they were also able to champion its translation into a decorative style that could be used throughout their lives to express their bohemian natures. Thus the Omega workshops turned out craft objects and created fabrics and hand-painted furniture to accessorize the artistic lifestyle. This blurring of the distinction between high and decorative art produced some of the most remarkable 20th-century mosaics. The chosen medium of expression for the Russian artist Boris Anrep, who was part of the Bloomsbury Group, was mosaic. He is one of the very few artists who made mosaics himself, and who supervised every detail of the execution of larger works. He made domestic pieces as well as major great public commissions for the city of London: the Bank of England, the Tate Gallery, the National Gallery, and Westminster Cathedral. His style is remarkably free, relying on subtle tonal differences in the marble cubes rather than complex cutting. The cubes are set quite far apart, and the detailed areas, such as faces and figures, are executed with economy using very few carefully positioned colors. The resulting mosaics, particularly those in the National Gallery entrance floor, have an immediacy and sense of life that is more usually associated with Roman and Byzantine mosaics. They demonstrate the advantages of using mosaic as an independent visual form, rather than to reproduce in detail works conceived in other media. The little panel made to demonstrate the direct method (see page 43) is inspired by Anrep's work.

Elsewhere in Europe artists were continuing to explore the potential of the fractured image in painting. At the same time as the Post-Impressionist exhibitions were being staged by Roger Fry in 1910 and 1912 in London, the young artists Pablo Picasso and Georges Braque were experimenting with a new way of painting in Paris. Their attempts to record the information gathered by the constant moving

viewpoint were labeled "Cubism." Following a technique initiated by Cézanne and taking it to its very extreme, they divided the canvas up into largely geometric forms painted with tonal gradation and texture. These formed an exploded composite image that was often barely recognizable without reference to the title. These exercises were purely formal investigations of seeing and painting that were devoid of any emotional or symbolic content. The subject matter was consciously selected from mundane everyday objects, even including bits of found material such as wood-grain paper and chair-caning, and the color palette was largely restricted to browns and grays.

These new pictorial methods were very influential in Italy. The Futurists, a group of artists led by Filippo Tommaso Marinetti, had been struggling with the problem of depicting the excitement of the new technological world. They expressed it in breathless prose in the Futurist Manifesto: "We shall sing the nocturnal, vibrating

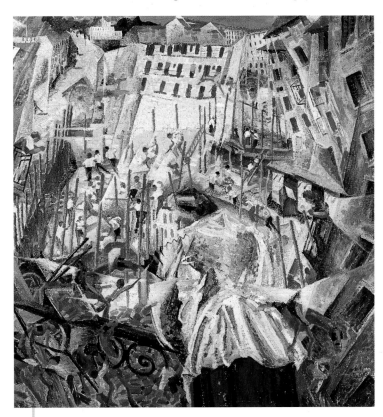

▲ **Umberto Boccioni, *The Street Enters the House*, 1911.**
The image is fractured and distorted to create an impression of dynamism and hectic movement. Vertical lines are tilted at acute angles and brilliant colors are juxtaposed to create fizzing effects, all to convey the excitement of the experience of the modern urban world.

▲ **Gino Severini, *Centrifugal Expansion of Light*, 1914.**
Severini employed an almost pointillist technique in his early futurist paintings, and some of his experiments with color and paint approached total abstraction. This technique of building up images with individual dabs of color bears an obvious relationship to mosaic which he took up later in his career.

which they combined with vivid color to paint scenes of frantic movement, speed, and electric light. Umberto Boccioni painted dramatic townscapes and Gino Severini created a series of increasingly abstracted studies of swirling dancers and incandescent light.

Severini's interest in the use of color led him to an interest in mosaic, which he pursued throughout his artistic career. During the 1930s he turned against the instinctive and emotional methods of Modernism, describing Cézanne's technique as reducing "the painter to the level of a dressmaker or of a designer of lady's head wear." Instead he turned to neoclassicism and developed a rigorous system of harmony based on both mathematical ratios and musical theory. This mental precision is well-suited to mosaic, and his smalti compositions are among the most successful of all 20th-century mosaics. The reaction against Modernism was, however, associated with more sinister ideas about maintaining control over industrial societies expressed in the fascist politics of Hitler and Mussolini. Severini and many other gifted Italian artists worked for Mussolini on grand projects such as the Foro Italico in Rome. Project 5, the Horse Paving Slab (see page 75), is inspired by one of the mosaic pavements there. Fascist art aimed to re-establish continuity with the illusionistic art of the past and to cleanse the world of the infection of the degenerate influence of Modernism. The effect of this in the long term was to strengthen the reputation of Modernism as an expression of liberal values and to discredit all criticisms as politically reactionary and dangerous.

The two great heroes of modern art, Henri Matisse and Pablo Picasso, became powerful icons of contemporary culture. In a humanist and secular age the attributes of genius had acquired particular significance. Artists stood apart from the rest of society but from their positions of exalted isolation, without the bourgeois constraints of lesser mortals, they could reflect back deep inner meanings invisible to the rest of us. Picasso's powerful temperament was a perfect expression of the artist as a wild animal driven by the inseparable forces of desire and creativity. Matisse, in contrast, was contemplative and reclusive, but he believed profoundly in the purpose and significance of art as a purifying and life-enhancing force. He had been a pupil of the Symbolist Gustave Moreau, and he had always believed that painting should be inspired by feeling rather than thought. Only positive, harmonious, and uplifting feelings were suitable material for artistic expression and his paintings depict a calm,

incandescence of arsenal and shipyards, ablaze with violent electric moons, the voracious stations devouring their smoking serpents, the broad-breasted locomotives that paw the grounds of their rails like enormous horses of steel harnessed with tubes, and the smooth flight of the airplanes, their propellers flapping in the wind like flags and seeming to clap approval like an enthusiastic crowd." The fractured style of Cubism allowed them to find an equivalent visual language,

untroubled world suffused with exhilarating color and sheer visual delight. He is sometimes criticised for this narrowness of scope but his work remains extremely popular. As Clive Bell had predicted, art became a kind of secular religion in our society, and Matisse's work offers us a vision of paradise that consoles and comforts us in the way that Madonnas and Nativities comforted previous generations. Matisse's work is equally significant for its experimentation with formal components of painting. His work is governed by flatness: by resisting the illusion of three-dimensional form through shading he reduces all his elements into flat shapes that can be arranged across the canvas. In this way he creates a connection between a flat picture plane and his subject matter, balancing the formal composition of colors and forms with the recognizable but dramatically simplified representations of people and objects. Project 4, the Goldfish Splashback (see page 70), is an attempt to translate this elegant and sophisticated style into mosaic. Picasso was equally adventurous in his distortions and stylized renderings of the human figure, constantly exploring the boundaries between the incomprehensible and the readable, pushing the viewer harder to see both the abstracted forms and the dislocated images. This tension between form and image is full of possibility for the mosaic artist. The medium in itself is powerfully distinctive and cannot be disguised, but the challenge is to unite its characteristic formal qualities in a harmonious balance with a representational image.

There were other developments in modern art that reacted against all this concern with the formal language of painting. The movement known as Dada that sprang up in various cities across Europe during World War I was a radical re-evaluation of what could constitute art. Dadaists were disillusioned by artists seeking to produce objects that were pleasing to the bourgeoisie, and challenged the very idea that works of art should be made by artists. Marcel Duchamp exhibited "ready-mades," manufactured objects such as a urinal and a bottle rack, and Tristan Tzara made poems by cutting up written sentences and reassembling them at random, allowing chance to be the author. There was an inexorable nihilistic logic to Dada, and in 1923 Marcel Duchamp abandoned art altogether in favor of chess. Other artists associated with Dada escaped the cul-de-sac of anti-art by turning their attention to the imagery provided by the subconscious. André Breton used the same random techniques as Tzara but believed they could be used to reveal the topography of our inner lives. In 1924 he wrote the *Surrealist Manifesto*, in the wake

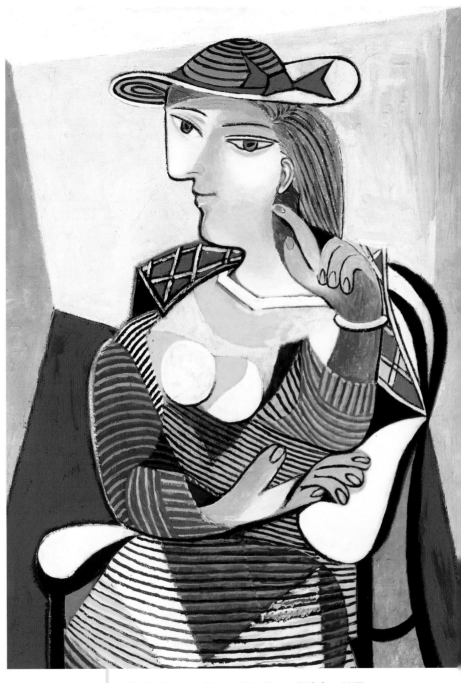

▲ **Pablo Picasso, *Portrait de Marie-Thérèse*, 1937.**
In this portrait, Picasso has flattened out the components of his subject and arranged them on the canvas in a way that is both visually harmonious and expressive of the attitude of grace of the sitter. Even the perspective of the room is distorted to produce balancing shapes rather than an illusion of depth.

of which a group of artists including Max Ernst, Joan Miró, and Giorgio de Chirico began to create strange dreamlike paintings. These works display an unexpected juxtaposition of everyday objects and rely on a highly illusionistic painting style in order to create the desired sense of shock in the viewer. Although the content was concerned with a modern approach to the human psyche, the techniques used, particularly by Salvador Dalí and René Magritte, were conservative and old-fashioned. The potential imagery of Surrealism also turned out to be less extensive than Breton had envisaged, more an offshore island than an undiscovered continent.

Realistic painting appeared to have entirely run out of steam. Photography had developed into an art form, with the tasks of recording the beauties of nature, the character of the human face, and the revealing details of everyday life all being covered by photographers. In the 1950s American abstract painters came to dominate the contemporary art scene, and all forms of representation were viewed as passé. However, in the late 1950s and early 1960s a new movement emerged in Britain and America that focused attention back on the appearance of the real world and that came to be called Pop Art. Artists began to make images of consumer objects and to borrow techniques and styles of representation from advertising and packaging. Their inspiration was partly drawn from Dada, although Marcel Duchamp was horrified at what he regarded as an empty esthetification of his more radical ideas. The central, revitalizing ingredient in the work of the new artists was irony. It became possible to paint the real world again because it was done in the full knowledge that it was an absurd activity. In an age of mechanical graphic reproduction, the hand-made, one-off attributes of art works seemed redundant. Roy Lichtenstein's painting of brush strokes executed in the style of a comic-strip drawing expresses this peculiar dilemma. Andy Warhol made images of multiple mass-produced objects, and then mass-produced his own screen prints in his ironically named *Factory*. The bright, strong images inspired by the icons of popular culture were very popular and easy to reproduce and imitate. They have been imitated in mosaic in Project 3, Decorative Wall Tiles (see page 66).

Far from being the dead end it had seemed, Dada went on to inspire all kinds of new art in the 1970s and 1980s. Their idea that "gestures" could be an art form was elaborated into the mysteries of Performance Art. Indeed, the game of finding unlikely things to be

accepted seriously as art continues to this day. Contemporary artists are difficult to criticise or discuss in esthetic terms, however, because they are protected by a wall of irony. No matter how feeble, imitative, or beautiful a work may be it always seems to represent a knowing comment on some other work or cultural phenomenon. Even aspects of craft have been assimilated, for instance Tracey Emin's appliqué decoration of her tent and Chris Ofili's glass-bead paintings. Making things by hand that are attractive and interesting to look at can still be considered a valid artistic statement so long as these objects can be explained in contemporary art-critical terms as commenting on gender or race or other approved issues.

Artists now work in a dazzlingly wide range of media including video and computers, and photography has emerged as one of the most popular means of expression. Technological advances have meant that photographic images can be infinitely adapted and manipulated and are no longer restricted to being a mere documentary record. Andreas Gursky is one of the most interesting artists using photography to reconfigure the world around us. His photograph of the Chicago Board of Trade encompasses far more information than the human eye could ever see in a single gaze and thus uses the camera to generate an image that is strikingly inhuman. The effect is also curiously mosaic-like, because it is made up of so many different fragments that it exploits the tension between an abstract pattern and a recognizable scene.

The digital systems of creating images in computers and LED screens also have a close affinity with mosaic. Pictures are broken down into a grid of separate squares in exactly the same way as mosaics are made up of tiny separate elements. Much digital art is based on the manipulation of a simple grid: John Simons's *Every Icon*, for example, has a grid of 32 × 32 squares, broken down into even smaller squares. They change from light to dark, in different combinations, one line at a time according to a complex program that would take, literally, an infinite amount of time to complete. Like much digital art, this piece is more interesting conceptually than visually. There is potential for a fertile crossover between mosaic and digital imagery, encompassing the ironic idea of the similarity between the virtual realm and one of the most physical and enduring mediums of all time. Project 6, Digital Landscape: Sole Bay, explores some of these possibilities (see page 79).

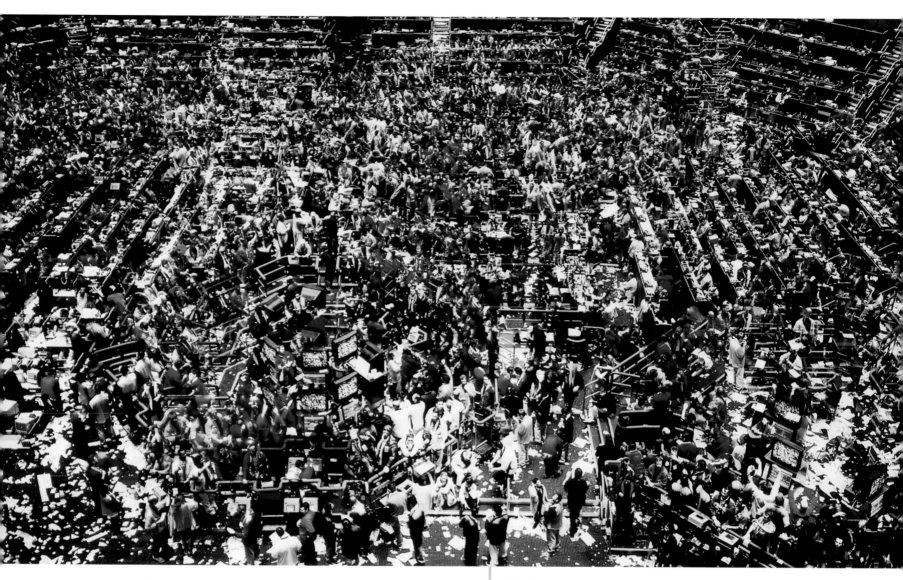

▲ **Andreas Gursky,** *Chicago Board of Trade II,* **1999.**
Gursky's photographs are manipulated with computer technology and therefore represent neither the vision of the human eye nor the simple camera lens. The composite image, without any clear focal point, is both unsettling and fascinating.

Computers and mosaic

It is easy to render any image in pixelated squares using a
computer because there are many programs offering a "mosaic"
effect. In practice it is quite difficult to translate these images
into real mosaic because of the limited range of colors available.
A computer will average the hue and tone across the area of each
square but this process may mean that every square is a slightly
different color. In a vitreous glass mosaic there are only about 120
colors to choose from. Some more sophisticated programs are
available that work from that given palette, for instance
TileCreator (www.tilecreator.com), but they interpret images very
literally, and obviously without any esthetic judgement about the
color combinations proposed. Working by eye, without the aid of
machines, allows the use of the traditional mosaic technique of
using mixes of color to widen the overall color range and to enable
subtle gradations of tone and hue. It is also then possible to make
the mosaic interesting and harmonious in detail as well as making
a striking effect from a distance. This approach has a lot in
common with Impressionist techniques of painting where
combinations of vibrant complementary colors are used to merge
into complex new tones and colors.

 The aim of all mechanical reproduction of images, from
photographic printing to LED screens, is to make the picture as
"realistic" as possible. There is, however, something lively and
interesting about the crude, deconstructing effects of some of
these technologies. For instance, the worlds created in early
computer games were a weirdly stylized place, half flat and half
3-D, and the images on giant LED screens have wild and sometimes
beautiful color distortions. In the same way that mosaic recreates
the world out of fractured pieces, these modern images remind us
that our own perceptions are fragmented and only make sense
due to a process of subconscious mental effort. The idea of
"realism" is, therefore, not an absolute but a concept continually
open to interpretation.

▲ This is a computer pixallated version of the photographs used in
the composition of the seascape in Project 6. The computer has
used far more different tones than are available in mosaic.

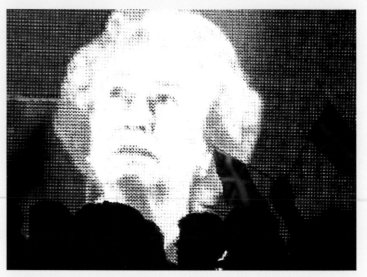

▲ The giant screens used to show moving images at open-air events
are made up of thousands of LED (light emitting diode) bulbs
arranged in a grid. The images are bright and readable from a
distance but close to they also make complex, abstract patterns.

The dressmaker's shop

Inspiration
PROJECT FOR A SCREEN, 1892–93
EDOUARD VUILLARD

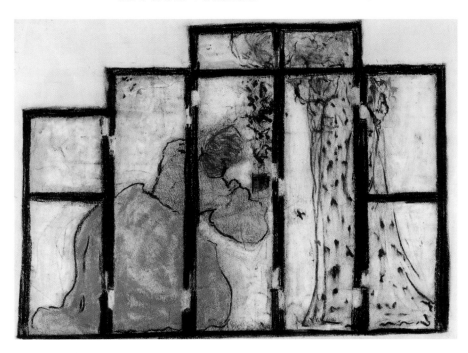

This project is based on a painting called *Project for a Screen*, showing two women examining bolts of fabric. Vuillard belonged to the generation that followed the Impressionists who were dissatisfied with the purely objective preoccupations of Impressionism, wanting to reintroduce deeper and more personal meaning into their work. Pre-eminent amongst these Post-Impressionists was Paul Gauguin, whose stylized and colorful paintings were suffused with symbolic meaning. Although Vuillard professed admiration for Gauguin, his paintings also betray a large debt to the Impressionists. The quiet interior scenes of everyday life were the kind of subject matter championed by Edouard Manet earlier in the century, and the execution, using shimmering dabs of paint to create a fragmented surface, owes a great deal to the work of Claude Monet. Vuillard's unique contribution, however, was his preoccupation with pattern and the way he used the juxtaposition of different patterns to create complex visual effects. His mother, whom he adored, was a corsetière and his uncle and grandfather were textile designers. He was therefore brought up surrounded by fabrics, and this personal experience, combined with a profound affection for his family, gives his paintings an intensity of observation and expression.

The figures almost disappear against the wallpapers and carpets, absorbed into the play of light on surface pattern. Three-dimensional space is collapsed into a flat field of painted marks, anticipating later experiments with complete abstraction.

The use of pattern in Vuillard's work is inspiring to the mosaicist. The small units of mosaic lend themselves to making patterns, and the uniformly fragmented surface is also a feature of all mosaic work. The degree of stylization is sympathetic to the simplification required to represent figures and faces in mosaic, and the curious compositions are arresting and interesting. Many of Vuillard's effects are painterly and cannot be successfully reproduced in mosaic, but his freedom with the medium can be adopted in the appropriate handling of the mosaic. The patterns have been adapted so that they flow naturally and easily in mosaic and recreate the relaxed atmosphere of the original. The color design for this project was drawn referring only to a black and white reproduction so that the selection of colors could be made from the available smalti palette and not compromised by attempts to match or mimic effects in the painting. The project was made in smalti because of the interesting colors available and the lively reflective surface of the material, but it could equally well be made in vitreous glass.

equipment

- pencil and colored pencils
- double-wheeled nippers
- paintbrush
- craft knife
- plasterer's small tool
- notched trowel
- small screwdriver

materials

- drawing paper
- tracing paper
- brown paper
- smalti in various colors
- water-soluble glue
- cement-based adhesive
- framed board 21 x 16 in (55 x 40 cm) internal dimension
- linseed oil

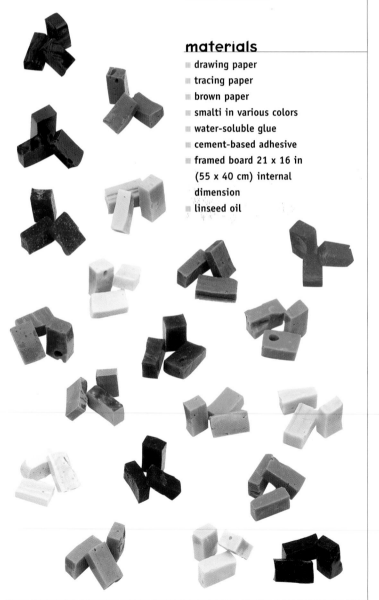

method

1 This project is visually complex and requires some careful planning before starting. The composition is worked out in a line drawing (or see template on page 156) over which a colored drawing is made on layout paper. The colors are chosen with reference to the smalti palette.

2 When the design drawing is complete the basic outlines can be traced on tracing paper and the image enlarged on a photocopier.

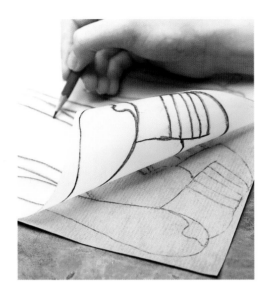 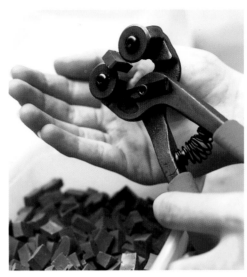 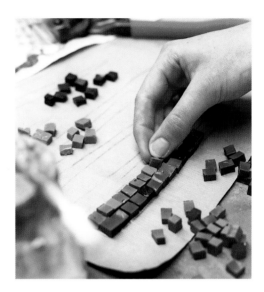

3 Because the indirect method is being used, the image needs to be reversed onto brown paper. This can be done on a light box or by tracing the enlarged image and then turning over the tracing paper before transferring the outlines onto the brown paper.

4 This is quite a small panel so the smalti pieces have been halved to make a smaller unit size. The double-wheeled nippers cut smalti with accuracy and without too much wastage.

5 The pieces can then be stuck to the paper with water-soluble glue. Starting with the figures apply the glue with a paintbrush to a small area of paper and start to build up a pattern, cutting as necessary to fit the drawn outlines.

6 Before completing all the figures fill in some of the background so that you can check if the color balance is working.

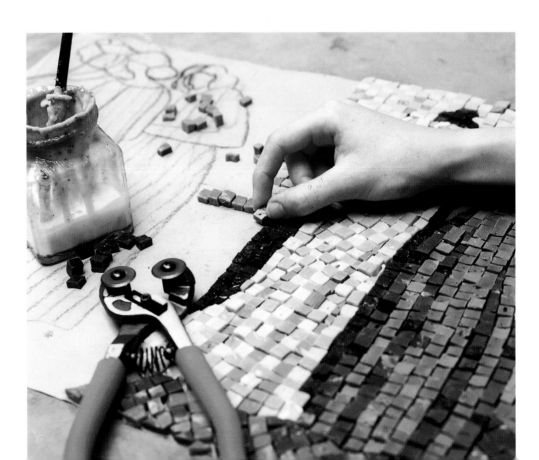

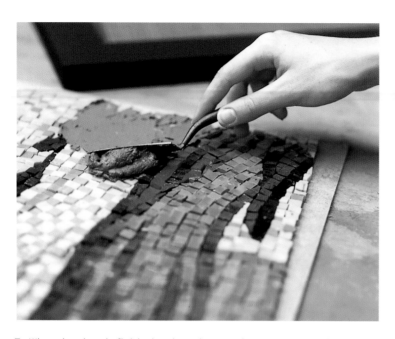

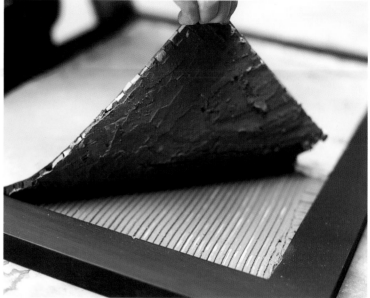

7 When the piece is finished and you have made any necessary alterations you will have to cover the back face with cement-based adhesive before fixing. This is called "buttering the back" and is necessary when fixing uneven materials such as smalti. This process will make the mosaic quite heavy and it is a good idea to divide it into two sections by cutting the paper along a joint line with a craft knife. The adhesive is applied with the plasterer's small tool in a thin layer to even out the irregular surface.

8 Apply cement-based adhesive to the surface of the board with a notched trowel and turn the mosaic section over into the bed. Do not let the adhesive on the back of the section dry out or skin over. Press the mosaic lightly onto the board so that the two wet adhesive surfaces merge.

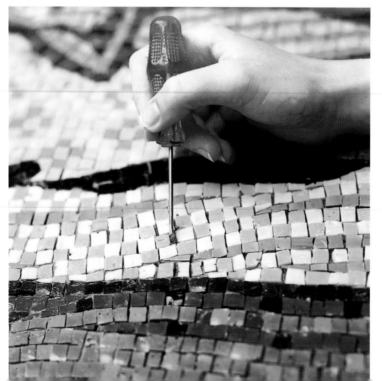

9 Wet the paper, leave until the glue is dissolved (about 15 minutes), and carefully peel back. You will find with this method that some adhesive inevitably comes up between the joints. This can be scraped out with a small screwdriver and is easier to do neatly when the adhesive has started to go off (after about three or four hours). The adhesive will dry pale and if it is visible between the joints, particularly in areas of dark colors, you can darken it with a little linseed oil applied with a small brush.

The highly reflective quality of smalti and their uneven surface mean that they will look very different in different lights. Smalti panels need to be hung with care because the image can be obliterated by too much reflected light. Traditionally this material is used in churches, often without any direct lighting, and the ideal but slightly impractical solution is candlelight.

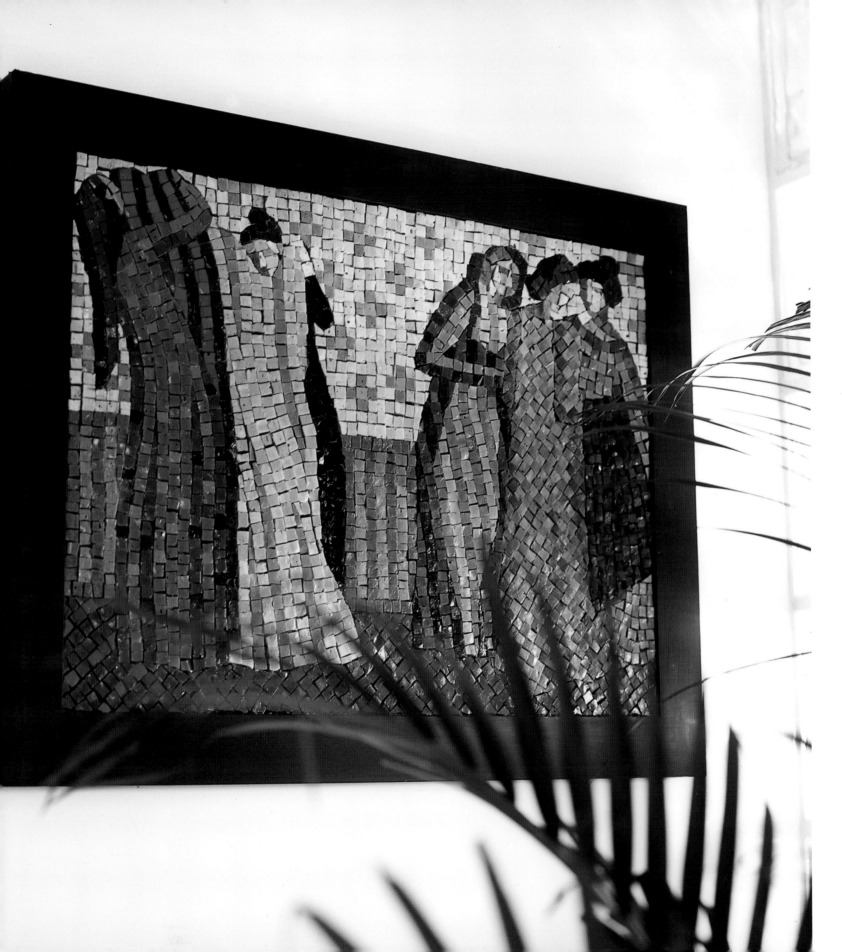

Cityscape floor panel

Inspiration

LE TRE ARTI, 1933

GINO SEVERINI

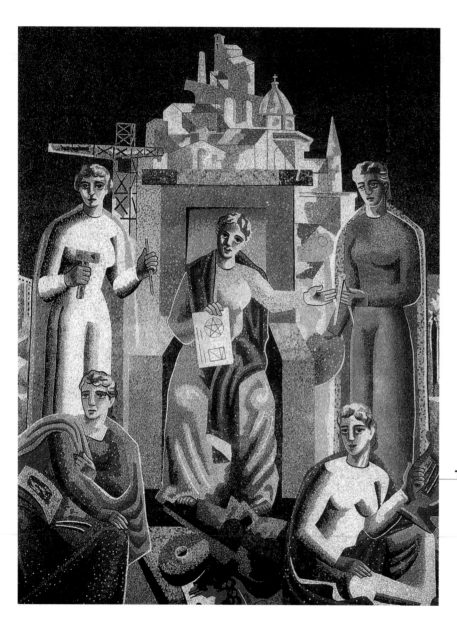

equipment

- pencil
- felt-tip pen
- tile nippers
- paintbrush
- craft knife

materials

- drawing paper
- brown paper
- unglazed ceramic tiles
- water-soluble glue

The mosaic that inspired this project was designed by Gino Severini for the fifth Triennial Exhibition in Milan in 1933. It was one of a series of mosaics by different artists including a magnificent marble mosaic floor, all installed in the Palazzo dell'Arte. Severini's mosaics are beautifully executed and have a relaxed, unforced style that allows the mosaic material to express itself rather than mimicking painterly effects. He uses lively mixes of color, sometimes including flashes of gold, and a nondirectional method of laying that gives the surface a satisfying overall cohesion. It is a technique that can be used to create subtle shading of one tone into another but can also accommodate areas of graphic

method

1 Make a drawing of your design (or see template on page 159). Although inspired by Severini's mosaic, other source materials have also been used. Photographs of 20th-century buildings have been photocopied and studied for the different patterns made by the openings in the walls. The finished drawing must be enlarged and reversed onto brown paper. This can be done either by gridding it up or on a photocopier (see Projects 1 and 4).

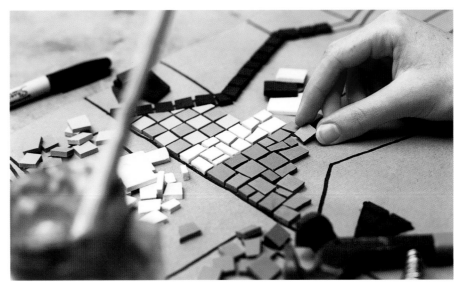

flatness. The degree of stylization allows Severini to use black and white outlines where necessary to give clarity and heightened definition. The buildings are dramatically simplified in this way, using a combination of lines and blocks of color.

In this project mixed unglazed ceramic colors have been used to create subtle and interesting effects. The buildings are highly stylized and arranged to create a balanced composition rather than a particular scene. This panel has been finished off with a border of whole-tile mosaic in a selection of colors from the main design and it could be set into a larger area of plain tiling, or fixed to a window sill as shown.

2 The ceramic tiles are cut with tile nippers and stuck to the brown paper with water-soluble glue. In this design black and white lines of quarter tiles run through areas of color. These areas are made up of a mix of different but related colors to give a lively, flickering effect. In some areas the colors are laid in a regular chequered pattern while in others the pieces are more varied in size and laid more randomly.

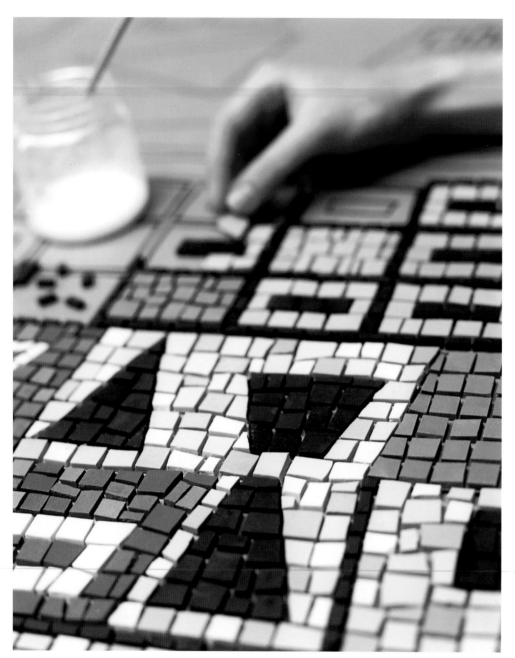

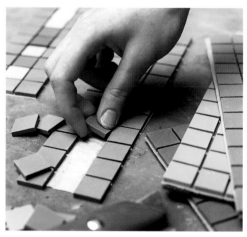

4 This panel has been finished off with a border made up of whole tiles. The ceramic tiles come on paper-faced sheets, and this is a simple way to make decorative borders. The sheets are cut into strips of the required width using a craft knife and some of the tiles are peeled off the backing paper. You can dampen the back of the sheets with water so they peel off more easily.

3 The technique of laying random-sized pieces in a nondirectional arrangement is a very useful way of filling in small areas of background. Pieces can be cut to fill the required gaps conveniently without breaking up any overall directional rhythm, and the finished effect looks effortless and natural.

5 Water-soluble glue is then painted onto the paper and a row of colored tiles stuck down. These strips can then be arranged around the perimeter of the cut-piece mosaic, which has been made to a sheet-module size.

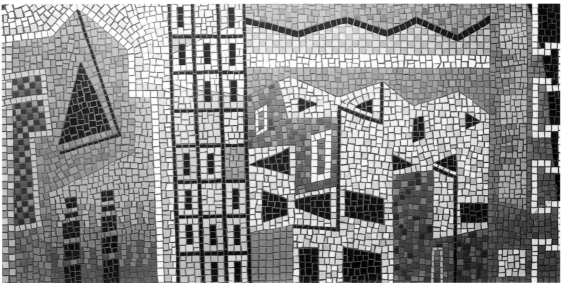

Unglazed ceramic is an excellent material for floor mosaics because it is both easy to work with and hard-wearing. Panels for floors can either be fixed to boards or directly to a concrete sub base. Fireplace hearths and entrance steps are ideal locations because they are discreet areas that do not have to align exactly with surrounding finishes.

Decorative wall tiles

inspiration

MARILYN MONROE, 1962

ANDY WARHOL

These wall tiles are inspired by Pop Art and in particular the work of Andy Warhol. The example illustrated shows multiple portraits of Marilyn Monroe simplified into areas of plain, vibrant color. These flat images derive from the screen-printing techniques used on advertisements and packaging, and were hijacked by Warhol in the production of his pictures. The idea of repeating identical images also mimics mechanical reproduction and undermines the traditional idea of artists as craftsmen making unique, one-off works. His chosen subjects—whether famous brands or celebrities—were also resolutely modern and untraditional. The notion of celebrity was particularly interesting to Warhol, and one of his greatest achievements was the manufacture of his own celebrity. He was surrounded by glamorous superstars of the day, and became as famous for his lifestyle as for his artworks. Warhol, however, had started his artistic career as a gifted decorative illustrator, and his flair for color and the formal qualities of composition and image-making are still visible in his mature work.

These little tiles are designed to be set into areas of plain tiling. They take a single image and repeat it in different colorways. Glazed ceramic is used to make the flat color areas of the lips, while the backgrounds are made of small vitreous glass mosaic pieces that are laid to follow the outline of the lips. The grout lines enliven the field of otherwise plain color and the selection of cool colors for the lips and hot colors for the backgrounds adds a touch of appropriate perversity.

equipment

- pencil
- scissors
- tile nippers
- paintbrush
- rubber gloves
- plasterer's small tool
- notched trowel

materials

- tracing paper
- brown paper
- glazed ceramic tiles
- vitreous glass mosaic tiles
- water-soluble glue
- black grout
- three ceramic wall tiles
- cement-based adhesive

66

method

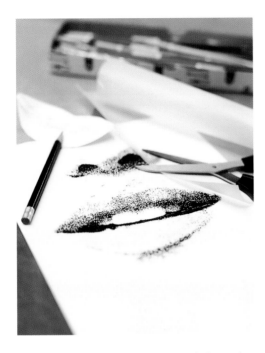

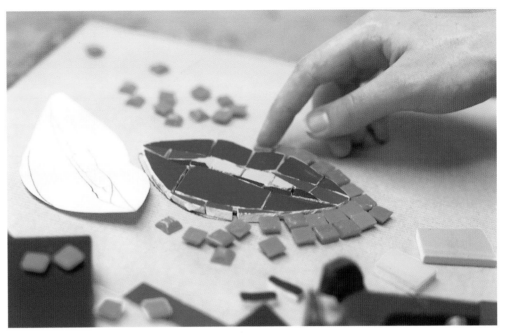

1 Enlarge your original to the desired size and trace the outline onto brown paper cut to the size of the finished piece (or see template on page 159).

2 Work out a selection of colors. If you are going to do a series of mosaics choose all the different colorways at the beginning so that you can be sure that they will all work well together. Cut the glazed tiles with tile nippers and lay them loose the right way up so you can see how they look.

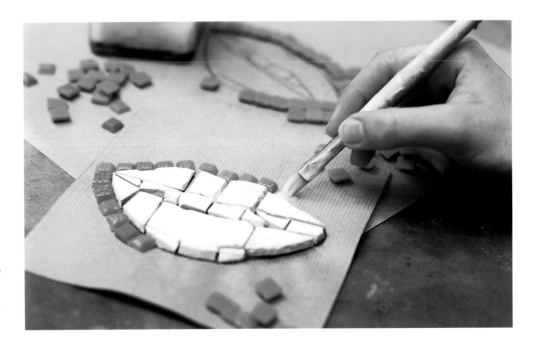

3 Carefully transpose the tiles, piece by piece, and stick them with water-soluble glue upside down to the drawn outline on the brown paper. Start to stick the background following the outline of the lips.

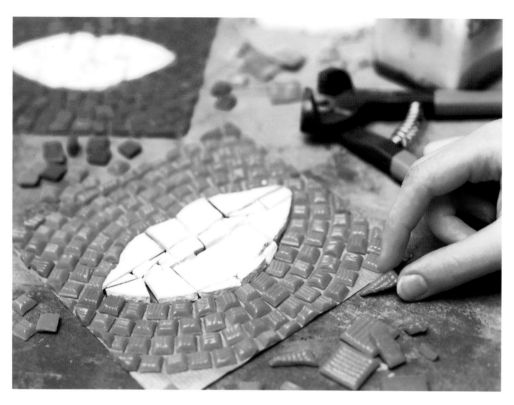

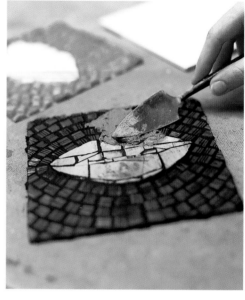

4 As you come to the edge of the tile you will have to cut the mosaic pieces to fit. Try to avoid very small pieces by cutting edge triangles from half tiles.

5 Wear rubber gloves to pre-grout the tiles. Fix the tiles in accordance with the indirect method (see page 44). Because the glazed ceramic is very slightly thicker than the vitreous glass, it is a good idea to build up the glass to the same level with a thin layer of cement-based adhesive applied to the back of the mosaic with a plasterer's small tool.

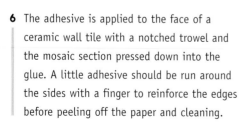

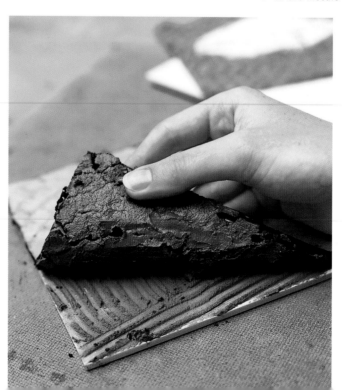

6 The adhesive is applied to the face of a ceramic wall tile with a notched trowel and the mosaic section pressed down into the glue. A little adhesive should be run around the sides with a finger to reinforce the edges before peeling off the paper and cleaning.

The idea of using small mosaic panels set into areas of larger tiles works well in kitchens and bathrooms. You can either fix the mosaics to a thin tile as described here and set them in with thicker wall tiles, or you can leave the occasional tile out and fix the mosaic panels directly to the wall.

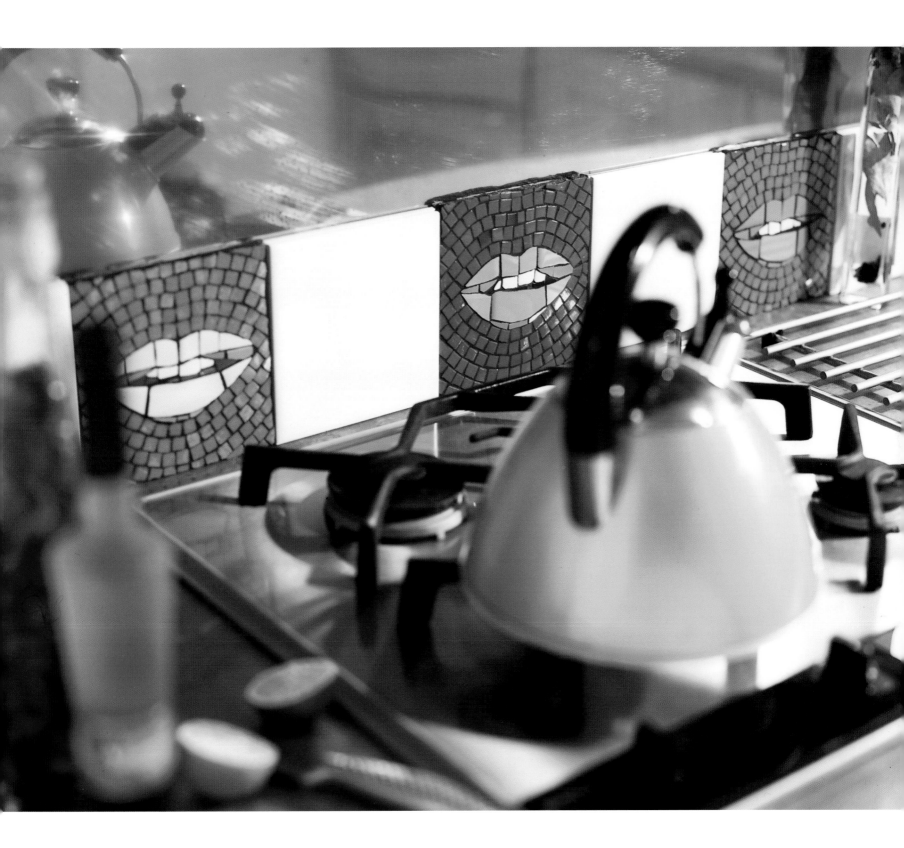

Goldfish splashback

Inspiration

BOCAL DE POISSONS ROUGES, 1914
HENRI MATISSE

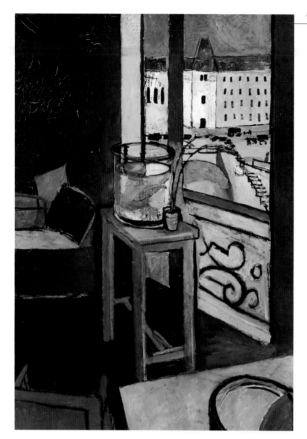

This splashback is inspired by a series of paintings by Henri Matisse. Painted in the second decade of the 20th century, these pictures demonstrate Matisse's overriding interest in form, color, and harmony. Increasingly throughout his career Matisse would paint the interior of his own studio, where drapes and props could be moved around to suit his experiments in composition and color. Although his work remained representational, and it is always possible to identify the objects depicted, the paintings are not really about the hermetic world of the artist's studio. Matisse was liberated from the demands of literal meaning and his paintings are about painting, rendering color and form with line and paint to create an independent and harmonious image. The simple and often repeated interior scenes of windows, tables, and goldfish allow him to concentrate on formal concerns and his admitted aim was to create decorative pictures.

The design for the splashback is a composite of various elements from Matisse's paintings. Large, relatively flat areas of color are characteristic of Matisse's paintings and this can be a problem when working in mosaic. The solution offered here is to take inspiration from the collages he produced late in life. When he was too infirm to continue painting he was able to keep working by cutting shapes out of paper painted in different colors. The forms he chose were easy to cut and elegant in their simplicity. In this project, glazed ceramic wall tiles have been used and cut into similar simple forms. Joints in areas of background color have been avoided and a black grout has been used to emulate Matisse's characteristic black outlines. This is balanced by the careful use of areas of black in the background. The design is constrained by the practical limitations on shapes that can be cut from single pieces of tile—the indented leaf forms often used in the collages would be impossible—but these demands of the medium can be used to add interest to the effect. The background of the fishbowl, for instance, is made up of several differently colored pieces, which helps to give the impression of reflected light on water and glass.

equipment

- pencil and colored pencils
- charcoal
- black felt-tip pen
- scissors
- impermanent felt-tip pen
- tile cutters
- snapper
- tile nippers
- paintbrush
- craft knife
- notched trowel

materials

- drawing paper
- tracing paper
- brown paper
- polyethylene sheet
- nylon mesh 16 x 23 in (40 x 60 cm)
- ceramic tiles in various colors
- aliphatic glue
- mineral fiberboard 16 x 23 in (40 x 60 cm)
- cement-based adhesive
- black grout

method

1 Start by working out your design on a color drawing and trace the outlines onto a piece of tracing paper (or see template on page 158).

2 You can enlarge the image by drawing a grid onto the tracing and then making a grid of the same number of squares on a piece of brown paper cut to the size of the finished piece. Using a piece of charcoal you can copy the image square by square, marking off the points on the grid lines where the outlines intersect. Go over the charcoal lines with a black felt-tip pen so that the image is clearly visible.

3 Cut a piece of clear polyethylene sheeting slightly larger than the finished piece and place it over the brown paper drawing. Then place the mesh on top. The polyethylene prevents the tiles from sticking to the paper.

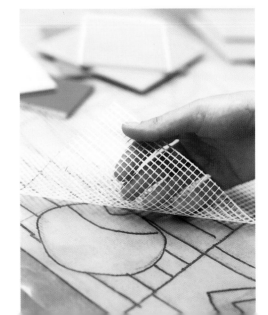

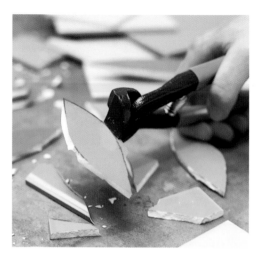

4 Long strips and leaf shapes can be cut from the ceramic tiles using the tile cutter. Draw the shape on the tile with an impermanent felt-tip pen and then follow the line with the scoring wheel, pressing quite hard.

5 Place the snapper up across the score line and press. This will break the tile along the score line.

6 The tile may not break perfectly along the line but the edge can be tidied up with the tile nippers.

7 As you work you can lay the pieces on the mesh and use a pen to mark the line of the desired cut. Short cuts can be made with the tile nippers and long, straight lines can be made with the scoring wheel and snapper.

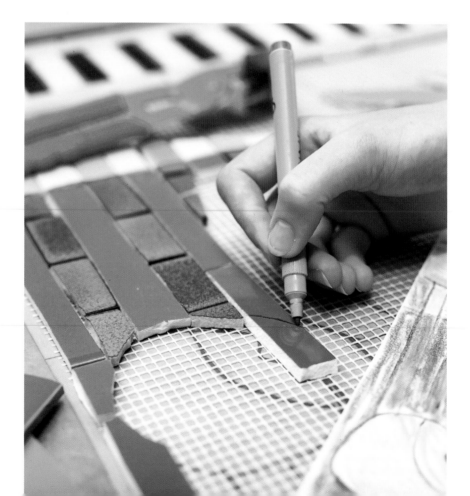

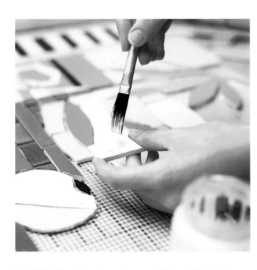

8 Stick the tiles down by applying a blob of aliphatic glue on the back of the tile with a small brush and then position on the mesh.

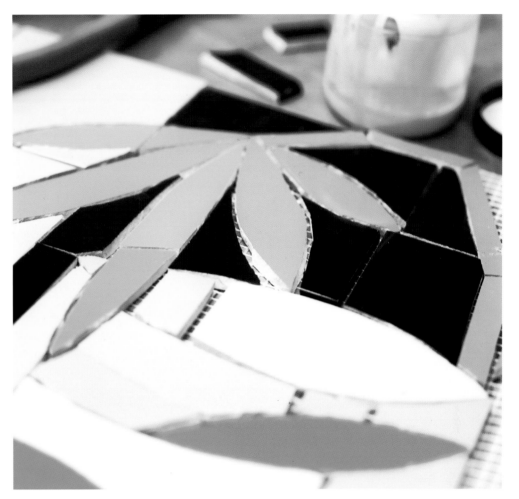

9 Try to make up the design using single pieces of each color where possible. Joints in the black areas, however, will be concealed by the black grout.

10 You may find it easier to fix the finished piece in smaller sections. The mesh can be cut along a joint in the tiles with a sharp craft knife.

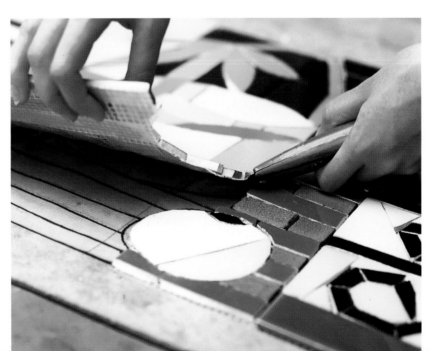

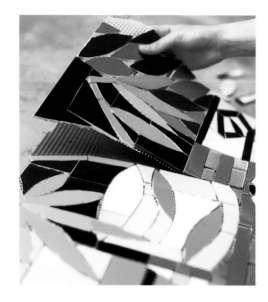

11 Cement-based adhesive should be applied to the fixing surface with a notched trowel. In this case the mosaic is being fixed to a mineral fiberboard, which is suitable for use in potentially wet areas. Tiles in each corner have been removed so that holes can be drilled and the panel fixed with screws to a wall. When the panel is in place the tiles can be fixed back in position, concealing the screw heads. The mosaic can then be grouted with a black grout to emphasize the joint lines.

Working with glazed bathroom tiles is an effective and economical way of making mosaic. Decorative areas could easily be set into areas of plain tiling allowing whole rooms to be designed in a single harmonious scheme.

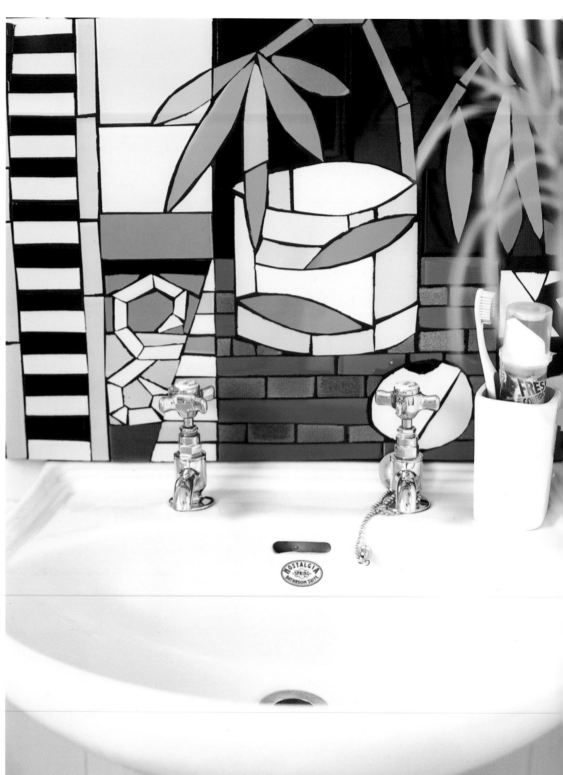

Horse paving slab

inspiration
FORO ITALICO, 1930s

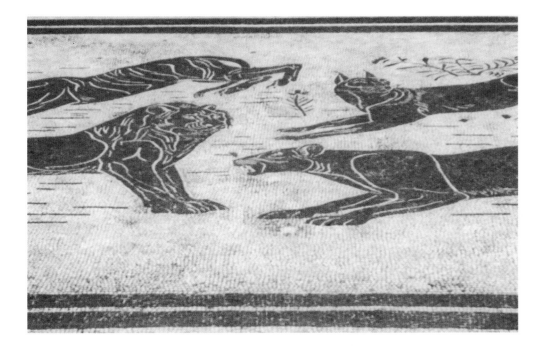

equipment

- pencil
- black crayon
- drawing paper
- brown paper
- tracing paper
- tile nippers
- water-soluble glue
- paintbrush
- gray grout
- cement-based adhesive
- notched trowel
- grouting float

materials

- black and white unglazed ceramic tiles $3/4$ x $3/4$ in (2 x 2 cm) (approx 200 tiles of each color)
- concrete paving slab 16 x 16 in (40 x 40 cm)

This paving slab is inspired by the great black and white mosaic pavements at the Foro Italico in Rome. This is a sports complex built in the 1930s under Mussolini's rule to celebrate the combined virtues of athleticism and fascism. A monumental neo-classicism was the style chosen for this endeavor, and the complex is built on an epic scale and peopled by gigantic statues of heroic young men. The pavements are executed in black and white marble and are clearly inspired by the extensive remains of Roman mosaics at Ostia, the ancient port of Rome. Here also the mosaics are strictly monotone but this gives them a strong graphic effect, with the high contrast helping the images and patterns to be read clearly against their surroundings. This is a good solution in busy urban areas where the pavement design will be competing with a huge variety of other visual information, from advertising hoardings to pedestrians partially obscuring the pictures. It can also be a good solution in more domestic situations, for instance in the garden where there will be a lot of competition from colorful plants and flowers. A black and white design will stand out clearly and make a distinct statement.

Simple and striking designs such as this need to be executed with some care because their simplicity can easily be spoiled by clumsy cutting and laying. The eye will be quickly drawn to awkward junctions and small pieces because of the absence of distracting detail. The grout lines and directions of laying are an important part of the finished piece.

1 Work out your design on a drawing (or see template on page 157). If you make the drawing a size proportional to the finished piece, i.e., each half or quarter size, it is easier to work out what size will represent the individual mosaic pieces. This project is made of $1/3$-in (1-cm) tiles represented by $1/4$ in ($1/2$ cm) at a half scale and $1/8$ in (2.5 cm) at a quarter scale. Designing to the size of the tesserae will avoid a lot of complex cutting and help to make the finished piece look elegant and convincing.

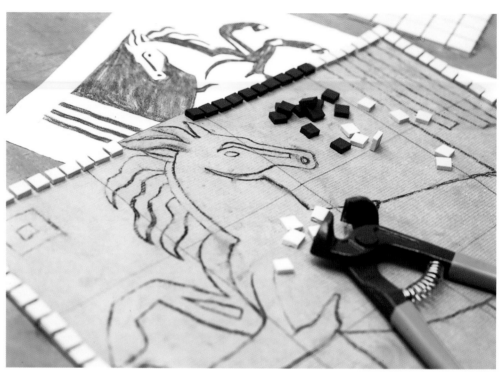

2 To make the mosaic using the indirect method you must enlarge and reverse the image onto brown paper. This can be done by photocopying or making a grid of the drawing and using a light box or tracing paper (see Projects 1 and 4). Cut the tiles to size using the tile nippers. Start by laying a row of tiles around the border and glue them down with water-soluble glue. Having whole tiles around the perimeter will be stronger than letting the design run right to the edge and ending up with some small cut pieces. Leave the fourth side of the border until later so that you can easily sweep fragments of mosaic off the paper as you work.

3 With designs showing animals and people it is always a good idea to start with the eyes and head because this will establish the character of the whole piece.

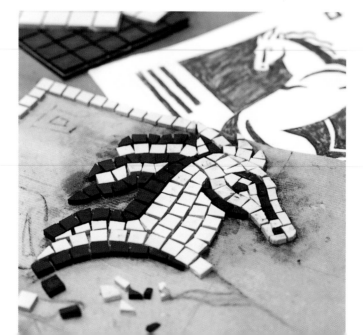

highlight

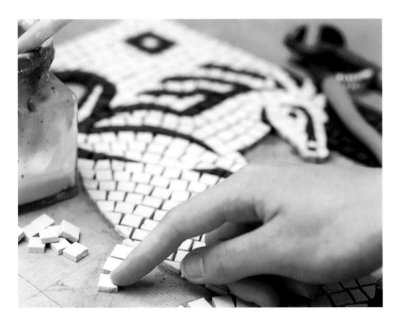

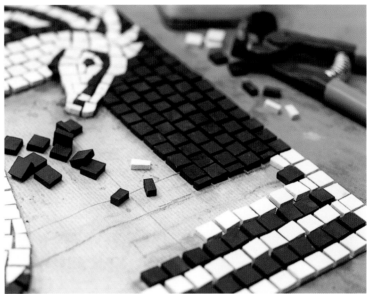

4 Across the horse's body the tiles have been laid to curving lines to create a sense of three-dimensional form.

6 You can avoid using very small pieces by cutting some shapes from half tiles and making one slightly larger piece instead of a quarter plus a tiny triangle.

5 In contrast the background is laid in straight lines with staggered joints formed by starting alternate lines with half tiles. This gives a sense of either horizontal or vertical direction with the black areas behind the head laid horizontally and the white areas laid in vertical lines. This is emphasized by the contrasting lines set into the plain areas.

7 The piece is fixed using the indirect method (see page 44). Once the back has been pre-grouted, cement-based adhesive is spread directly on to the concrete paving slab using a notched trowel. Run a little extra adhesive around the sides of the mosaic to strengthen the bond of the vulnerable border tiles.

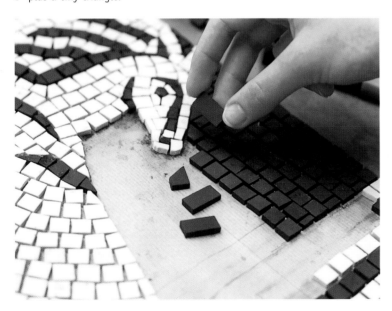

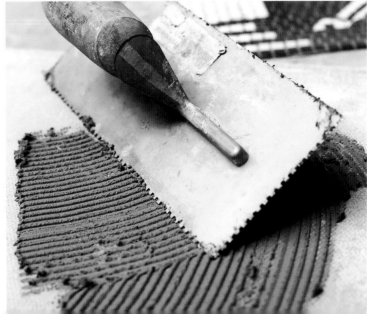

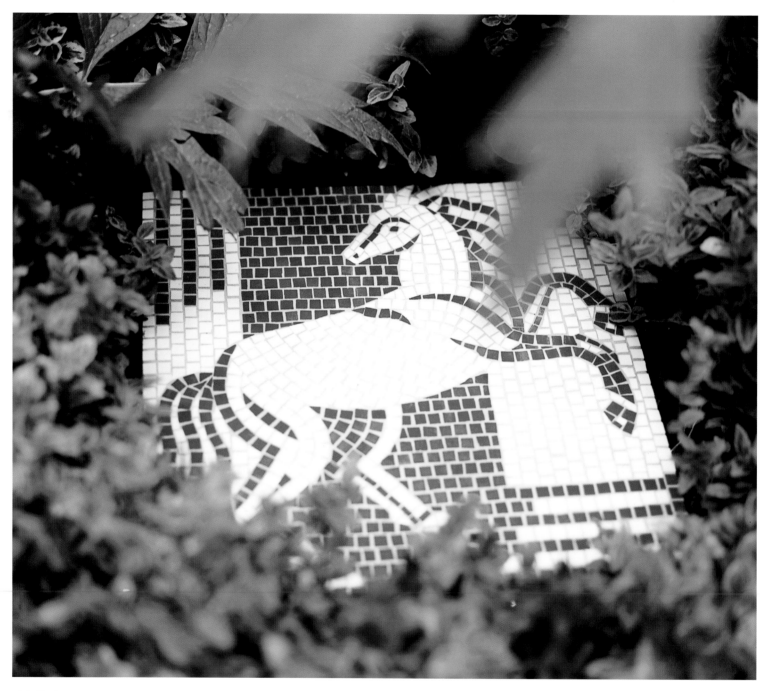

This little paving stone could be set in with plain slabs to form a
patio, or placed in a flowerbed or lawn to make a stepping stone.
Another idea and would be to design a slab incorporating a house
name or number to set into a front path.

Digital landscape:
Sole Bay

inspiration
PEARBLOSSOM HIGHWAY, 1986
DAVID HOCKNEY

The modern world is full of inspirations for this project—newspaper photographs, LED screens, pixelated computer images. Artists like Chuck Close and David Hockney have used these effects in their work. The piece by Hockney illustrated is a large desert landscape made up from a collage of separate photographs. Because it is made up of multiple images it has an instantly mosaic effect and it also exploits the brain's ability to read composite images as a single picture. Hockney has always been interested in the artistic potential of new or unusual technologies, working with faxes, photocopies, and Polaroid photographs. This piece is an exploration of photographic realism and is particularly concerned with the curious subject of perspective. Since the Renaissance the illusion of three-dimensional space on the picture plane has been created with the aid of the laws of perspective whereby all parallel lines stretching away from the viewer are constructed as converging into a single point on the horizon called the vanishing point. This view of the world is faithfully reproduced by the lens of a camera and we tend to accept it as "real," a description of how the outside world actually is. Because the camera produces these images so easily artists of the modern period have explored alternative, and more subjective, constructions and renderings of the world. In this example Hockney uses photography itself to make an image that undermines our belief in the single vanishing point. Each of the individual photographs is taken from a different position and therefore has a different vanishing point, but the resulting image is interpreted by the eye and brain without any difficulty. The same idea of incorporating multiple vanishing points was traditionally used in Oriental scroll paintings, allowing the creation of images many feet long without any distortion. The constraints of the laws of perspective assume a static observer who can move neither their head nor their eyes. In reality we read the world by constantly changing our focus and viewpoint and making a composite from many different bits of information. It is this sophisticated system of interpretation that allows us to read Hockney's photographs as a comprehensible landscape.

In this project the viewer is required to work even harder to interpret the image, which has been reduced to a grid of colored and gray scale squares. As with all pixelated images, the picture will be clearer when viewed from a greater distance. The image of a seascape has been chosen because it has a basic and familiar structure to help the brain's interpretation. Human faces have the best recognition factors but some very common and simple images can also work. Although based on photographs, the image has to be dramatically changed and the easy realism of the single vanishing point is irrelevant, the picture having been put together from a composite of several separate photographs. To avoid confusion between the real colors and the available palette of mosaic tiles the project has been designed from a black and white image.

method

equipment

- mosaic setting tray
- ruler and pencil
- paintbrush
- felt-tip pen
- notched trowel
- grouting float
- sponge

materials

- color and black-and-white photographs
- vitreous glass mosaic tiles
- sheet of acetate
- brown paper squares
- water-soluble PVA
- hardboard squares 14 x 14 in (35 x 35 cm)
- cement-based adhesive
- framed MDF board, internal dimensions 64 x 26 in (162 x 66 cm)
- gray grout

1 Choose a photograph of a subject that will be easily recognizable. In this project a landscape has been chosen because this is a familiar arrangement of elements around the distinctive line of the horizon. The idea of horizontality has been emphasized by combining a series of different photographs of the same stormy scene to make a single long image.

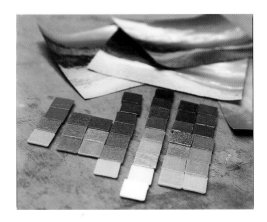

2 Work out the gradation of grays (or gray scale) from black to white. Referring to the color images you can then select ranges of blues, greens, and browns to match the different gray tones. The colors do not have to match the photograph exactly; you are looking for a combination of mosaic colors that is lively and appealing.

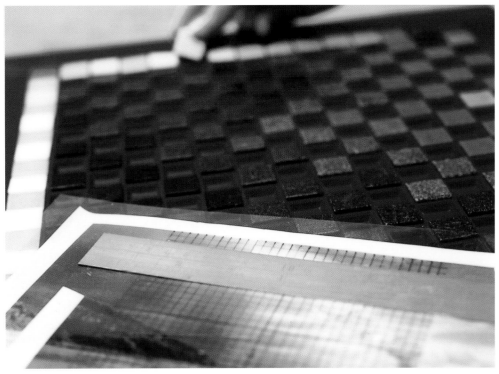

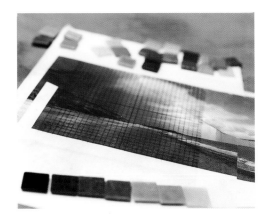

3 In order to concentrate on the tonal relationships in the image it is easier to work from a black and white version. Work out a grid size that will allow enough information to be communicated and that will result in a finished panel of appropriate size. Have the grid photocopied onto a sheet of acetate so that you can clearly see the image beneath.

4 Laying tiles in a grid pattern is best done in a mosaic setting tray or jig, both of which are available to buy or rent. This piece has a border, which is laid into the tray first. The ruler is placed along the first row of the gridded image and the corresponding rows in the setting tray filled with tiles of appropriate tones. Fill in the alternate squares with tiles from the gray scale, moving the ruler down the image and working across, row by row.

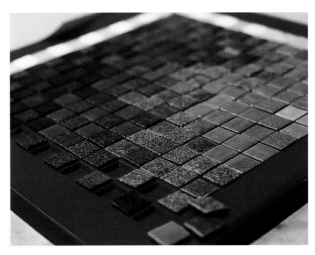

5 When the tonal progression is clear you can add in the colored tiles of matching tones referring to the color original to identify areas of land, sea, and sky. The alternating gray and colored tiles give the surface a harmonious overall pattern, which helps to avoid unnatural jagged lines between different colors and tones.

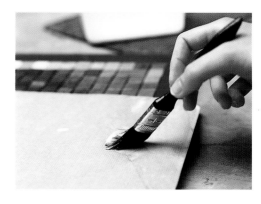

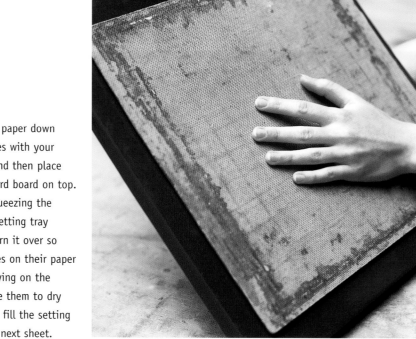

6 When the setting tray is full take a brown paper square and paint on a 50/50 solution of a water-soluble PVA and water with a medium-size paintbrush. Make sure the glue goes right to the edges of the paper. Place the glue face-down onto the tiles. The paper should be smaller than the tiled area so that half of the edge tiles are uncovered and can be lined up accurately when fixing.

7 Smooth the paper down over the tiles with your fingertips and then place the hardboard board on top. Carefully squeezing the board and setting tray together, turn it over so that the tiles on their paper facing are lying on the board. Leave them to dry and start to fill the setting tray for the next sheet.

8 When the sheets are dry you can number and arrow them on the back so that you will be able to see in which sequence to fix them. After completing all the sheets you can lay them out paper-down and see the image in reverse. At this stage you can peel off colors and make alterations. When you are happy with the sheets you can start fixing. Comb the cement-based adhesive onto the board using a notched trowel, and lay sheets down without pre-grouting, pressing them firmly into the adhesive.

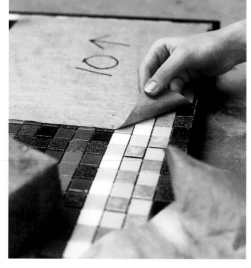

9 If you make sure the joints line through from sheet to sheet you can leave the paper on until the adhesive has dried. This will prevent the tiles shifting out of alignment as you peel.

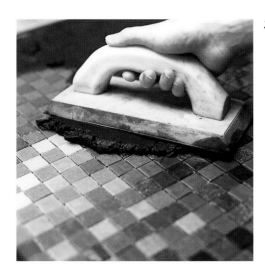

10 The final stage is to grout the piece. For a mosaic of this size it is best to use a flat-bed grouting float to work the grout into the joints. Use the side of the float to scrape off as much excess grout as possible and then sponge clean.

In pieces using this pixelated technique the larger you can make the finished work the clearer the image will be. The only drawback is that it can be difficult to find suitably enormous walls.

gallery

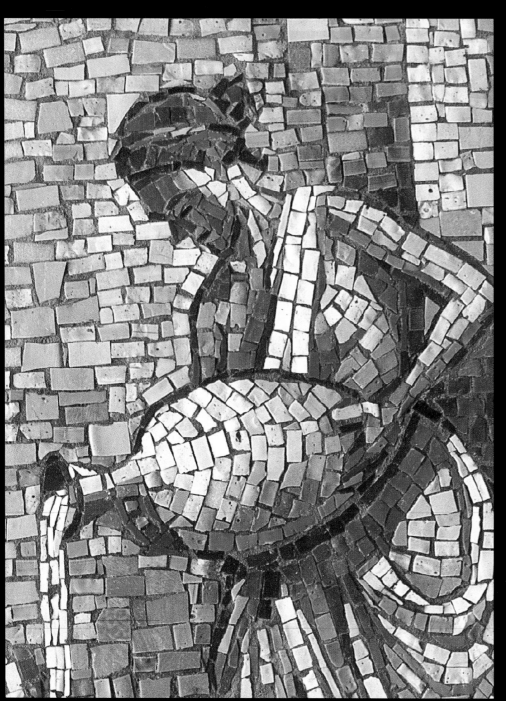

◄ **Melbourne Mural Studio, *Hyatt on the Park Mosaic*, 1999.**
This panel is made of smalti and demonstrates the subtle colors available in this material and the interesting variations in the size of the pieces.

▶ **Melbourne Mural Studio, *Steam Room Mosaics*, 1989.**
Vitreous glass and unglazed ceramic have been combined in this wall mural. A dark grout has been used to unite the deep blues and greens of the background.

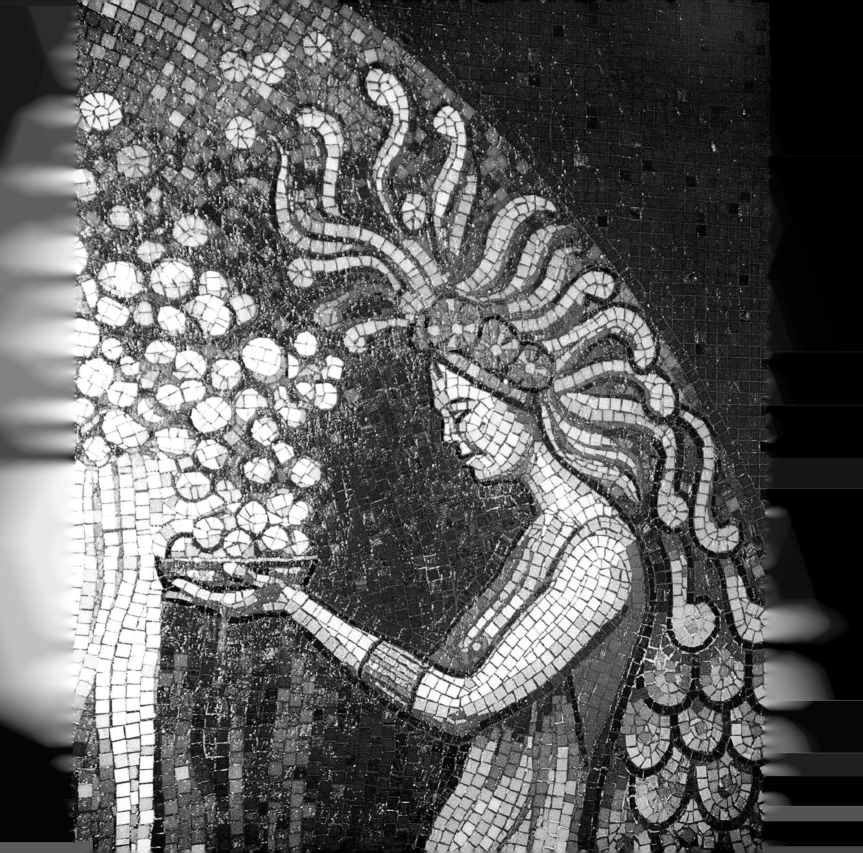

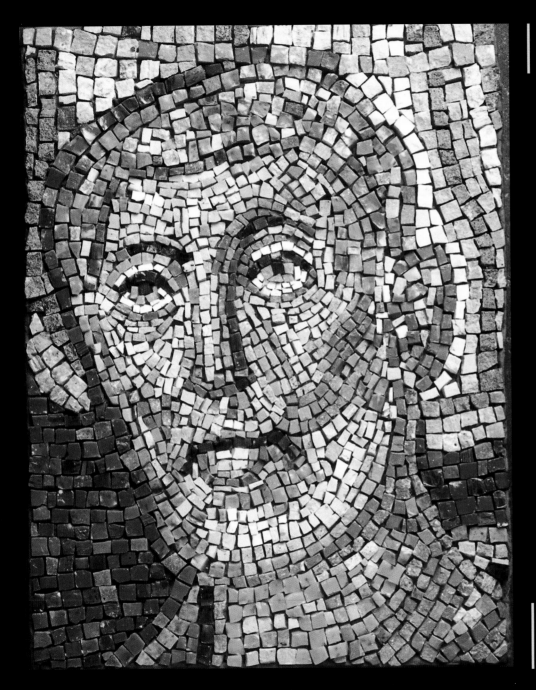

▶ **Melbourne Mural Studio,** *Major Mitchell Parrots,* **1991.**
This circular panel is made of smalti and the brilliant colors suit the tropical scene.

◀ **Helen Bodycombe,** *St. Peter,* **2000.**
This panel, made of marble and smalti, has a disctincly modern feel to it though it is a straight copy of a portrait of St. Peter in the Neonian Baptistry in Ravenna, Italy.

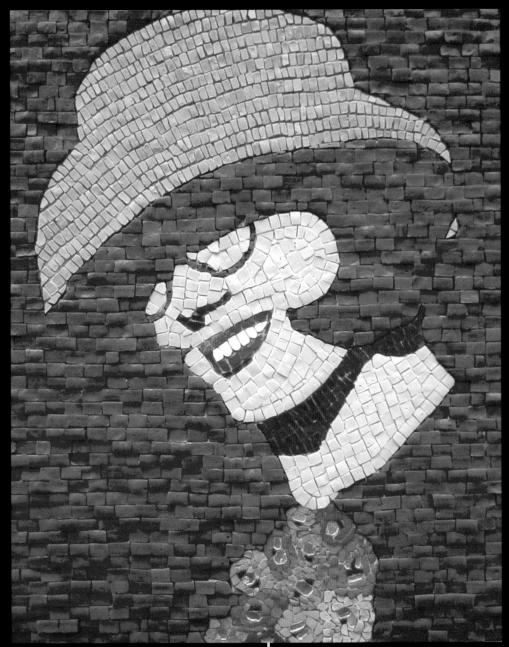

◀ **Marcelo de Melo, *Good Wine*, 2002.**
This colorful mosaic is made of china and vitreous glass on plywood. A good sense of perspective is achieved, and the work has a painting-like quality.

▲ **Marcelo de Melo, Fiona Heath and the Wedding Hat, 2001.**
Smalti on plywood. This mosaic was showcased at the "youth mosaic biennial 'citta di Ravenna' 2002".

▲ **Mosaika Art & Design, *Bruce Lee Portrait*, 2001.**
This portrait of Bruce Lee is taken from a photograph and achieves a highly realistic effect using fractured pieces.

abstraction

THE REJECTION OF REALISM IN THE 20TH CENTURY LED SOME ARTISTS TO ABANDON REPRESENTATION ALTOGETHER AND TO CONCENTRATE SOLELY ON THE FORMAL EFFECTS OF LINE, SHAPE, AND COLOR. MANY OF THESE ABSTRACT EXPERIMENTS WERE ATTEMPTS TO CREATE A NEW EXPRESSIVE LANGUAGE OF ALMOST MYSTICAL SIGNIFICANCE. OTHERS WERE MORE CONCERNED WITH PERCEPTION AND THE PHYSICAL MECHANISM OF INTERPRETING IMAGES FROM VISUAL STIMULI. THESE IDEAS ARE FULL OF INSPIRATION FOR INTERPRETATION IN MOSAIC WITH ITS RICH RANGE OF COLOR AND TEXTURE. CLASSICAL AND BYZANTINE MOSAIC WAS AS MUCH CONCERNED WITH PATTERN AND DECORATIVE EFFECTS AS WITH REPRESENTATION, AND THIS TRADITION CAN BE EXPLORED AND RESEARCHED IN THE MODERN IDIOM.

The early 20th century was a time of profound social and political change. Technological advances and the growth of cities had radically transformed the physical environment, and powerful new ideas from thinkers such as Sigmund Freud and Karl Marx now came to transform the psychological landscape. Under the old regimes successful artists had mostly depicted religious and historical themes, painted to public commissions, and produced portraits and landscapes to decorate bourgeois homes. Many artists across Europe, however, also believed that it was their creative role to respond honestly to their surroundings and were trying to find ways to communicate their experience of the modern world.

The most radical artistic experiments took place in Russia. After the revolution that had overthrown the Tsar there was a huge optimism that all the old ways could be overthrown and replaced with a totally new kind of society and culture. It was in this spirit that total abstraction was first proposed by the Suprematist artist Kasimir Malevich in 1913. His chosen form was the square because it does not appear in nature, and his most radical work was a white square tilted against a white ground. Although the painting appears to be a perfect expression of formal minimalism, for Malevich it was filled with mystical significance. He had aimed to destroy all references to the art of the past but he also wished, through this new language, to express his feelings about the great mysteries of the universe. He believed passionately in the importance of art and the independence of individual artists to counterbalance the regimenting power of the state. These ideas were challenged by Constructivist artists such as El Lissitzky and Vladimir Tatlin, who continued to work in a totally abstract style but claimed to have no interest in art itself. Painting and drawing were merely ways of exploring ideas that could be used in the design and production of functional objects and they all worked in many different media. Tatlin, for example, designed theater sets, gliders, and workers' overalls. These artists did not think that fine art was a superior activity but, equally, they were not interested in forms of production that were not industrial. Their inspiration was entirely political, and they wanted to use their skills to help build an egalitarian society by inspiring people with a vision of a new world and designing things that could be mass-produced for the benefit of all.

Other Europeans, such as the architect Walter Gropius in Germany, shared this optimistic faith in the potential of the machine age, although his enthusiasm was to some extent tempered by the experience of World War I and the devastation wrought by tanks and guns. In 1919 he founded the Bauhaus in Weimar, a school of art and design that had a far-reaching influence on the development of all art and design in the 20th century. At the Bauhaus, practical, craft-based skills were taught in workshops, while theory and design were taught by artists who were called Masters of Form. These classes, particularly the basic course for new students, were originally designed to find ways of analyzing the art of the past by reducing it to the simple components of color, form, and line. Exercises were devised to manipulate and understand these fundamentals and elaborate theories evolved to guide their use. Abstraction was not the primary purpose of these exercises, but the new principles that were articulated in them opened up a vast realm of possibilities, an undiscovered country that could be mapped through a combination of observation and intuition. Johannes Itten was the first tutor of the basic course and he used the simple forms of the square, circle, and triangle to explore and experiment with effects of contrast and tension. He used dynamic opposites, darkness and lightness of tone, warmth and coldness, complementary colors to give weight and balance to the forms. Project 9 (see page 108) is inspired by one of these exercices. His students produced fascinating and lively abstract works but his teachings were underpinned by complex mystical beliefs derived from a religious teacher called Mazdazman. Itten believed that forms had emotional significance and also particular colors; the square represented peace, death, black, dark, and red; the triangle was vehemence, life, white, and yellow; the circle was uniformity, infinity, and blue.

The Russian painter Wassily Kandinsky, who joined the Bauhaus in 1922, had similar theories about the spiritual meanings of abstract form and color. For him blue was shy and passive and tasted of fresh figs, while green was self-sufficient and bourgeois. All colors had temperatures and so did lines: verticals were warm and horizontals cold. Kandinsky presented these statements to the students as self-evident truths but his colleague the painter Paul Klee was more personal and hesitant in his approach. Klee started with the simplest form, the point, and with the line which is the point in motion. He then introduced tone, which added weight to the simple measurements of line. Finally the students were allowed to use color, which Klee regarded as the most important element because it added

a property he described as quality. The subject of his compositions was always balance, and he frequently referred to musical analogies such as rhythm and harmony. His writings, based on his explorations within his own work as a painter, are often deeply impenetrable. He appears nonetheless to have been an inspiring teacher because of his enthusiasm and perhaps also because he believed that instinctive and imaginative forces ultimately overrode any codified system of rules. Projects 7 and 8 (see pages 98 and 103) are based on his paintings.

The Bauhaus workshops covered a wide variety of crafts, including metalwork, ceramics, mural painting, and tapestry but not mosaic, which was a skill identified with Italy and itinerant Italian craftsmen. However, some of the woven designs produced by Gunta Stölzl, and certain exercises of the basic course, have a strong relationship with mosaic design. Paul Klee's paintings, with their use of repetitive simple elements and sophisticated colors, provide a great deal of potential inspiration for mosaic pieces.

In the later years of the Bauhaus, when mystical and craft-based ideas had been overturned by a more severe functionalism, Josef Albers joined the staff under the new director, Lázló Moholy-Nagy. His approach was far more practical and direct than that of Klee, Kandinsky, or Itten. His particular interest lay in the properties and potentials of different materials, for instance the structural uses of paper. Particularly influential in the field of architecture, where engineering was becoming the mainspring of design, it was an approach that also related to other developments in the visual arts. The Cubists in France had been experimenting with incorporating found materials into their pictures; Georges Braque often used scraps of printed paper, and Picasso applied a woven chair-back to one of his canvases. The German artist Kurt Schwitters had been experimenting with collages and reliefs made of packaging. The underlying idea was that objects in the physical world have their own character and interest, and the artist can understand and help to express these properties by making the material itself a subject.

This is an idea that has relevance for mosaic since found objects can be easily incorporated into mosaic pieces. A good example is the work made by Hans Unger in 1963 for Penguin Books in Harmondsworth that has type blocks of lettering and logos set amongst glass mosaic, which is the inspiration for Project 10 (see page 112).

▲ **Gunta Stölzl, *Gobelin*, 1926–7.**
Apart from its development of theoretical modernist ideas, some of the most interesting work to come out of the Bauhaus was produced by Gunta Stolz in the textile workshops. True to the Arts and Crafts philosophy of the early Bauhaus, craft skills were used to create innovative design of pure form and color.

▲ **Kurt Schwitters, *Magic*, c. 1936–40.**
Schwitters believed that any material or object could be made into art and that the art and object were interchangeable, described by his own made-up word, "merz." His constructions came to be conceived on a grand scale, filling an entire home in Hanover called the Merzbau, which was the first art installation (1923–36).

The Nazis disapproved of the Bauhaus because it advocated a style that was not specifically German, and in 1933 it was closed down. Its reputation had already spread throughout the rest of Europe and America, particularly because of its opposition to Nazi ideas, and when the staff fled to exile they found themselves welcomed with open arms. Their teachings and the international modern esthetic they championed became identified with the forces of freedom, and after World War II the International Style was cleansed of its early Utopian socialism and became the accepted expression of the free world. Walter Gropius and Mies van der Rohe were commissioned by

American corporations and institutions to design new buildings, such as the Massachusetts Institute of Technology and the Seagram Building in New York. The austere modernism of the Europeans was softened by the domestic traditions of the Chicago School and Frank Lloyd Wright, who had incorporated elements of decoration in their modern buildings. During the 1950s and 1960s a number of large-scale mosaic murals were commissioned to add color and interest to otherwise severe modernist buildings. The painter Lee Krasner, for instance, created a huge mosaic for 2 Broadway, in New York.

A particularly American form of painting called Abstract Expressionism came to dominate the visual arts in the 1940s and 1950s. Artists such as Jackson Pollock (Krasner's husband), Barnett Newman, and Mark Rothko worked on enormous nonrepresentational canvases. Their aim was to break free from the structured formality of Cubism to produce work that was an emotional and physical statement. The paint itself was part of the subject, as was the physical activity of painting on such a large scale, but the material and technique were not an end in themselves. The paintings were inspired by Jungian ideas, and the artists believed them to be expressions of a deep subconscious, echoing the early mysticism of Malevich. Associated with this movement was an artist called Jeanne Reynal, who had worked as an assistant to Boris Anrep in London and who used mosaic as a medium of expression by throwing fragments of ceramic and glass at a plaster surface in order to create a random and spontaneous effect. At this time there were earnest discussions about the relative virtues of abstract and representational art, with the champions of abstraction believing it to be a purer form of expression that would eventually replace outmoded representation altogether.

In reality, abstraction and representation have continued to co-exist. The rough and emotional works of the Abstract Expressionists were followed by more controlled paintings of color and form known as hard-edged abstraction. Painters such as Kenneth Nolan and Frank Stella adopted techniques used by house painters to produce very flat surfaces with neat edges that aimed to remove all meanings except the clear formal relationships between color, line, and form, thus producing works that were close in spirit to the Bauhaus exercises. Josef Albers, who was now working in America, produced a series of paintings called *Homage to the Square*, which explored color relationships and how a color can be changed by the color it is seen

▲ Bridget Riley, *Hesitate*, 1964.
Op Art marked a return to an interest in illusionism but in a strictly non-representational form. Here, Riley uses carefully calibrated variations of shape and tone to create the powerful impression of a deep fold in the surface of the canvas.

▶ Joseph Albers, *Homage to the Square*, 1961.
Albers produced a huge series of paintings based on illusions created by subtle juxtaposition of color and was very influential on other American hard-line abstractionists.

affinity with mosaic, being made up of multiple elements of squares and circles. Project 11 (see page 116) is based on his ideas.

These experiments with form and color had only finite possibilities, however, and artists began to return to the outside world for inspiration. Most of these new experiments were representational but there were exceptions. The work of Eduardo Paolozzi evolved from Pop Art in the 1960s in its interest in flat graphic representation, but its subject matter is not drawn from the pop culture that attracted his contemporaries. A constant theme in his work is a kind of pattern based on electrical circuit boards and machine parts, as if he is more interested in the inner workings of things than in their surface. These elements are present in the series of mosaics he designed for Tottenham Court Road Underground Station in London. They are executed in both vitreous glass and smalti but the designs against their plain white background retain the feel of drawings on paper. Project 12 (see page 120) derives from his use of simple geometric patterns.

next to. These works raised the issue of the influence of the eye and brain on our perception of color, a notion pursued by the Op artists Victor Vasarely and Bridget Riley. They used form and tone to confuse the eye and create illusions of depth and movement on the flat picture plane. Even gradations of tone suggest three-dimensional shapes projecting from, or receding into, the canvas, while black and white lines closely spaced cause the eye to jump about, imitating movement in the lines themselves. Vasarely's works, in particular, have a clear

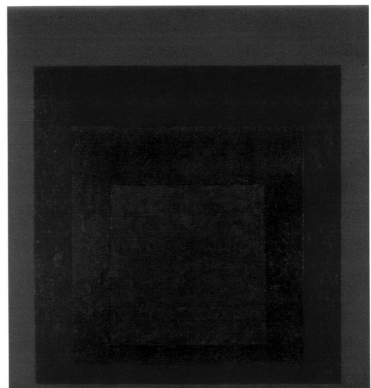

Other artists pursued the logic of pure abstraction and the end of meaning through works that exhibited less and less human intervention. Minimalists, such as Carl Andre and Donald Judd, were rejecting the ideas of self-expression held by the previous generation in favor of what they believed to be a rational, almost mathematical way of seeing. They were inspired by the practicality and rigor of the Constructivists but they did not share their broader political concerns. Instead their work is defined by its rejection of the characteristics associated with other art. There is no artistic craftsmanship involved; if pieces needed to be specially made they would be ordered from factories or commercial workshops. Repetition of modular elements is a favorite technique employed to illustrate rationality and order, and the use of color is largely prohibited. Carl Andre's notorious bricks, *Equivalent VIII*, were derided by the general public when bought by the Tate Gallery in London in 1972, and it seems that the works do convey a depressing nothingness despite the higher intentions of the artists.

To escape from the cul-de-sac of formalism, artists shifted the emphasis from the completed work to the idea behind it and the process of its creation. Even less physical input was required in Conceptual Art than in Minimalism and this is often reflected in the limited response evoked in the observer. Some artists, however, did explore ways of producing physical works that were new and interesting. The Italian Alighiero Boetti designed patterns based on the simple mathematical idea of alternating ratios of white and black squares in a repeating module of 100 squares. Within this rule the number of black and white squares was prescribed but their distribution was left open to esthetic impulse. The resulting series of patterns were then woven into beautiful tapestries by craftswomen in Afghanistan, a country the artist had made his second home. Some of Boetti's watercolor paintings were also converted into mosaic by craftsmen in Ravenna, Italy. Although his work is suffused with conceptual ideas about the role of the artist and mathematical and theoretical formulations, the finished works also retain an obvious delight in material properties.

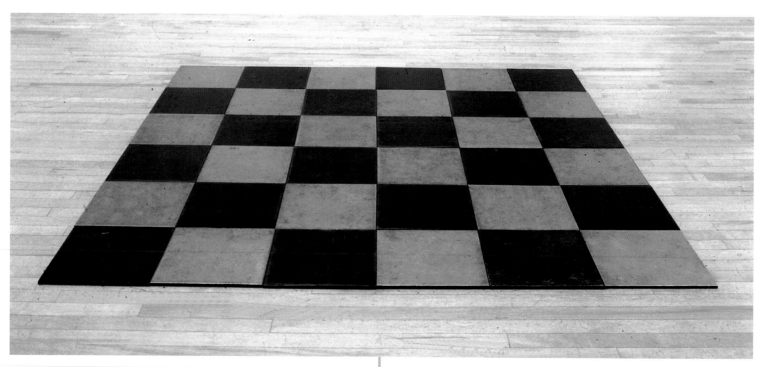

▲ **Carl Andre,** *Steel Zinc Plain,* **1969.**
Judged on purely visual criteria, Andre's work appears to be like a large-scale and simple-minded mosaic, or a restrained but attractive floor finish. Minimalist works, however, are intended by the artists to be assessed on the purity of the concept rather than the mere appearance of the work.

Describing color

Color is very difficult to describe accurately in words but there are a few terms, used repeatedly in this book, that help to explain how different colors appear to us. Every color has three attributes:
Hue describes which color we are seeing, whether it is green, red, yellow, or blue, or sometimes a combination, such as a bluey-green or a greeny-gray.
Tone refers to how light or dark the color is, whether it is closer to black or white or whether it is a mid-tone, somewhere in-between.

Intensity or Brightness describes how strongly we experience a color and may be due to its purity, as in primary colors, or the amount of pigment or colorant in the color. In mosaic, the reds and oranges and yellows have a predictable intensity but there are also other colors such as lime greens and royal blues that have a surprising depth and intensity. They can be used to great effect but can also accidentally overpower their dowdier neighbors.

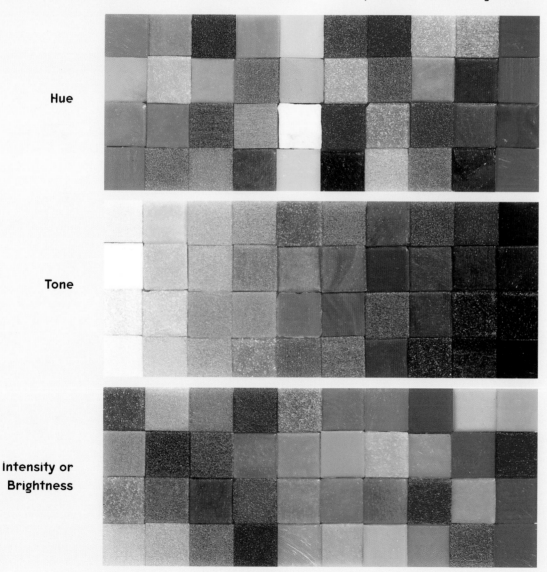

Hue

Tone

Intensity or Brightness

Pattern mirror

inspiration
STRUCTURAL I, 1924
PAUL KLEE

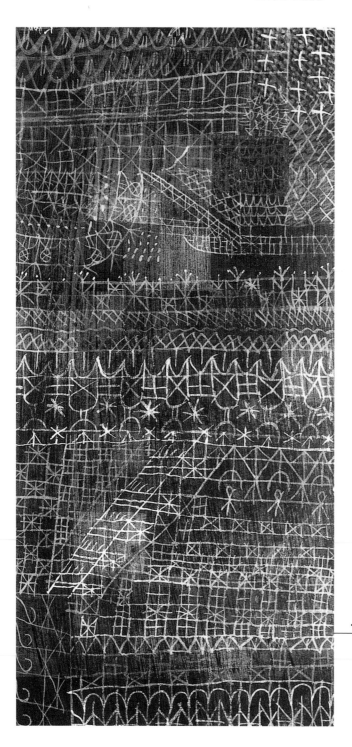

equipment

- tile nippers
- double-wheeled nippers
- scissors
- paintbrush
- small screwdriver
- sponge
- notched trowel
- plasterer's small tool or palette knife

materials

- colored pencils
- drawing paper
- vitreous glass mosaic tiles—2 reds, 4 greens, purple
- unglazed ceramic—black, 2 greens, 2 browns, terra-cotta
- brown paper
- water-soluble glue
- MDF backing board 20 x 20 in (50 x 50 cm) (preferably with narrow wooden frame)
- mirror 10 x 4 in (25 x 10 cm)
- silicone glue
- masking tape
- cement-based adhesive
- black grout

The inspiration for this piece is a painting by Paul Klee called *Structural I*. This is one of a series of works where the artist uses a delicate filigree of lines over a background of modulating colors. In this example the lines are pale against a dark background and are drawn on with white and cream chalks. On other occasions Klee used a dark line against a pale ground, sometimes drawn in ink and

method

sometimes scratched through the top surface of paint. In all cases the lines are quite freely and loosely drawn, almost like doodles, and the lines themselves have a slight unevenness of width and tone. The backgrounds are also rich in texture and variety of tone, and it is these particular qualities which give the paintings their character and visual interest.

The idea of a network of fine lines over a field of color has a clear relationship with the appearance of grout lines in a mosaic and it is this connection that inspired the design for the mirror. There is no attempt to reproduce the exact effects in the painting because these are so closely related to the techniques used and it is impossible to translate successfully from one medium to another by simple copying. Using a completely different set of materials and skills will change the character of the piece and it is important to realize this when working from a source of inspiration in another medium. In this example the idea has been to create different patterns in the grout lines by cutting the tiles into shapes that make repeating designs. The tiles are set quite far apart so that the grout lines will read clearly, and the cutting is quite rough so that there is variety in the width of the lines and the shapes of the pieces. Each line of pattern is made out of three or four different colors to give an extra liveliness to the effect, including some bright reds and greens. These have been added because when a mosaic is grouted with dark grout the overall piece becomes darker and less intense and highlights of strong color help to counterbalance this effect.

1 Make a colored drawing to help you select the colors for each row. The effect of blending from reds to greens has been achieved by gradually introducing greens into the reds before replacing them completely. Browns and purples have also been used as intermediary colors. All the colors are of a mid-tone because very light or dark colors would jump out and confuse the effect. A mixture of glass and ceramic has been used to widen the range of subtle colors and to give a variety of matte and shiny surfaces. Black ceramic has been used for the border because the grout joints will disappear against it and form a strong contrast to the fractured areas of pattern.

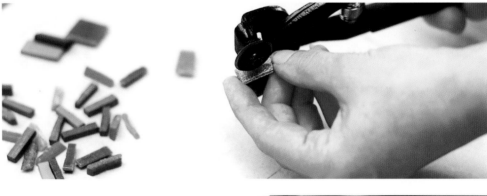

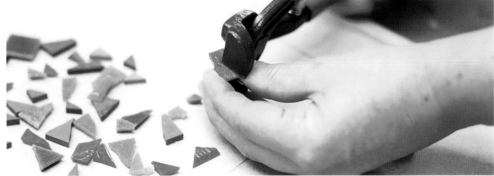

2 Experiment with cutting different shapes. From the basic square tile a range of triangles and strips can be cut with the tile nippers. Some cuts will be easier using the back of the nippers. Some shapes, particularly the thin glass strips, will be easier with a double-wheeled nipper. All these pieces can then be arranged into different patterns to use in rows across the mosaic.

3 This project is made using the indirect method and you need to cut out brown paper to fit the areas to be worked in mosaic. It will be easier to make up the mosaic in four separate sections, the two side panels and two thin strips for the top and bottom.

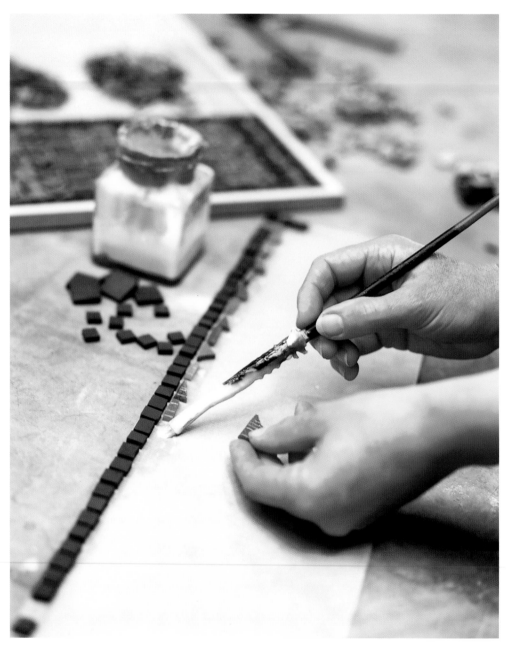

4 Stick the mosaic pieces to the brown paper with water-soluble glue applied with a paintbrush. Apply small areas at a time and of an even thickness because too much glue will make the paper wrinkle. Start with the black border and then lay out a vertical line to establish your spacings.

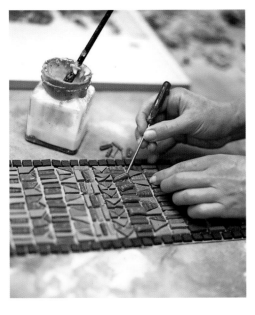

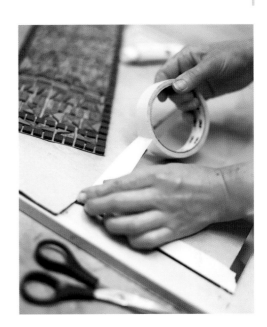

6 When you are making a mirror it is a good idea to fix the mirror to the board before fixing the mosaic. The mosaic can be easily altered if it does not quite fit but the mirror is a fixed size. Silicone glue is a flexible adhesive that allows for the thermal movement of glass and does not affect the silvering of the mirror. It should be applied in two continuous vertical strips to the back of the mirror, which should then be carefully positioned on the board and pressed into place. The face of the mirror should then be protected with masking tape and brown paper to avoid scratching.

5 If you are unhappy with some of the colors or shapes when the panel is completed you can easily make alterations at this stage. A small screwdriver is a good tool for prying off the odd piece, and larger areas can be removed by damping the back of the paper with a sponge and leaving it for five minutes while the glue dissolves. The ease with which alterations can be made is one of the great advantages of the indirect method.

7 The technique for fixing the mosaic sections is the indirect method (see page 44). After pre-grouting, you will need to apply the cement-based adhesive to the areas above and below the mirror with a plasterer's small tool or a palette knife. A notched trowel can be used for the larger areas. Once the mosaic has been transferred to the board, grout the face and wipe clean.

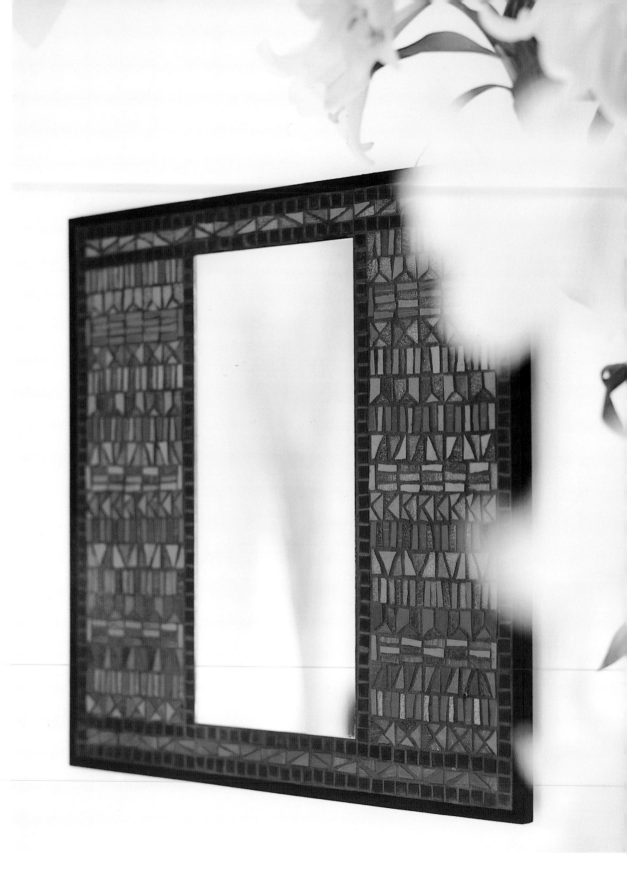

Many variations on this approach would be possible. A much more restricted color range would make the grout patterns more dominant, particularly if the tiles were paler than those used in the project. Similarly, darker tiles could be used in conjunction with a paler grout color. Cutting up larger tiles would give a greater variety of sizes and a broader range of patterns. Paul Klee based the course he taught at the Bauhaus on his own experiments with painting, strongly believing in, and encouraging experimentation. There is no better way of exploring ideas than to play around with materials and try out different things.

Gene panel

inspiration

AD PARNASSUM (DETAIL), 1932
PAUL KLEE

This little panel is a composition inspired by another painting by Paul Klee called *Ad Parnassum*. This too is one of a series of similar works where Klee used an almost regular pattern of individual brush strokes against a background divided up into blocks of different color. The tiny dabs of color create a shimmering effect across the surface, sometimes standing out strongly against a contrasting background color, and sometimes blending into the point of disappearance. Sometimes the dots are made up of two colors, with a paler color overpainting a darker or more intense one. Both of these colors have a different relationship with the background color, giving an added level of complexity. This pairing effect is reminiscent of the strange images created by some techniques of DNA analysis—hence the title of the piece. The washes of color that form the background blocks are not uniform in density and this creates another set of slight variations across the surface which adds to the liveliness of the overall composition. Equally, there is no uniformity in the shape of the overlying dabs because they are formed by the natural action of the paintbrush. This sense that the inherent qualities of paint and brush are being allowed to express themselves is very important in Klee's work and gives his paintings a relaxed and effortless quality.

These painterly effects cannot properly be reproduced in mosaic, but the idea of repetitive elements against different backgrounds can be explored using glass tesserae and different grout colors. In this project the grout colors have been restricted to the readily available black, gray, and white, and the glass colors have been chosen to work with these backgrounds. Each glass color is paired with a dark gray or black to give a consistent rhythm across the whole piece, and the colors are divided up into different blocks that overlap the blocks of grout color. Within these blocks, the colors are arranged in different sequences of ascending or descending tones, either vertically or horizontally, and these variations set up contrasting rhythms that counterpoint the overall rhythm of the dark pieces. It is hard to describe this design without turning to musical terms and analogies, and it is often a useful way of thinking about how to create interesting effects that combine to achieve a sense of harmony. Klee himself was very musical and conceived much of his work in this way.

method

equipment

- tile nippers
- surgical gloves
- sponge
- small screwdriver
- craft knife
- grout spreader

materials

- pencil and colored pencils
- drawing paper
- tracing paper
- vitreous glass mosaic tiles (approximately 80 dark gray and black and 80 assorted colors)
- MDF backing board 16 x 16 in (40 x 40cm) (preferably with narrow wooden frame)
- felt-tip pens
- PVA glue or wood glue
- paint for frame
- cardboard strips
- poster-mounting putty
- black, gray, and white grout
- masking tape

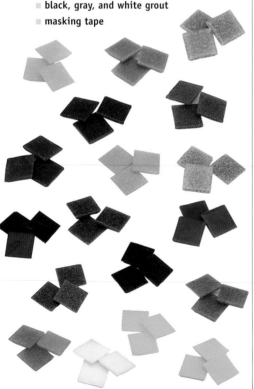

1 A large part of the effect of this project is created by the grout colors, and you will not be able to see the grout effect until the final stage, so it is important to do some advance planning. A good way of doing this is to make tracing paper overlays to try out different color combinations and patterns. You need to make a base sketch showing the grid of tiles and then an overlay colored in with the areas of black, gray, and white, arranged in a balanced pattern, representing the grout areas. On another overlay you can set up a pattern for the blocks of color which relates to the pattern of the grout blocks but does not match them exactly, so that there will be overlapping areas of similar tile colours across different "background" colors. The color blocks can then can be colored in different ways and overlaid on the black, gray, and white drawing to give an idea of the final effect.

2 From the rough color drawing you can select a palette of tiles. In this project there are four color groupings: whites and grays, mid-blues and olives, light blues and olives, and yellows. There is also a range of dark grays and blacks. All the tiles need to be quartered using the tile nippers, but they can be cut quite roughly because some variation in shape and size will add character to the piece.

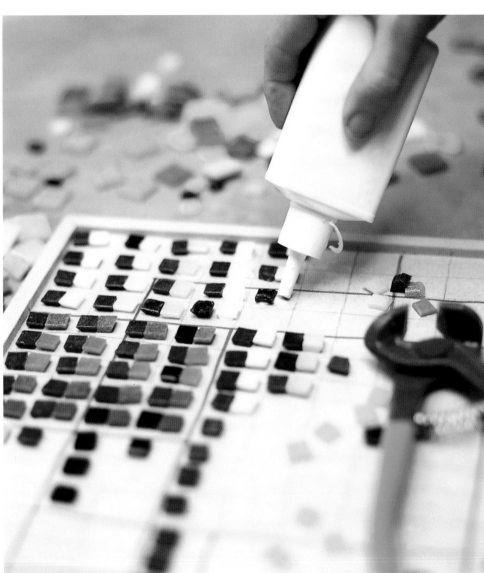

3 Before sticking the tiles down you will need to mark up the board so that you know when to change color. Lay out the tiles in pairs across the top of the board and singly down the side. From these spacings you can draw up a grid; freehand lines will give the piece an attractive irregularity. Referring to your design overlays, you can then mark on the grout and color blocks in different felt-tip pens.

4 Following the color block guide lines you can now stick down the tiles. Because this is an interior piece, PVA or wood glue is a suitable adhesive and can be squeezed directly from the bottle as required.

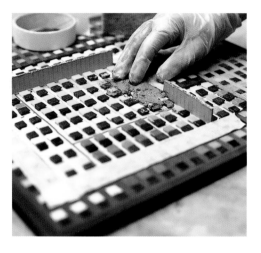

6 The grout will tend to adhere to the cardboard and before it dries you should run a craft knife down the edge of the cardboard and remove the strips. When the black grout is dry (after 3 to 4 hours) move on to the gray areas. Place cardboard barriers against the white areas and protect the black grout with masking tape. The gray grout should be applied as before and the barriers carefully removed.

5 When all the tiles are stuck down and the adhesive is dry (PVA will usually take 1 to 2 hours) the frame should be painted before grouting. Use cardboard strips held in place with poster-mounting putty to form barriers between the different grout colors and start with the black areas. Because the areas are quite small you will probably find it easiest to apply the grout with your fingers (protected by surgical gloves) and to use a small piece of sponge to clean off the surface. You may need to scrape away excess grout along the barriers with a small screwdriver.

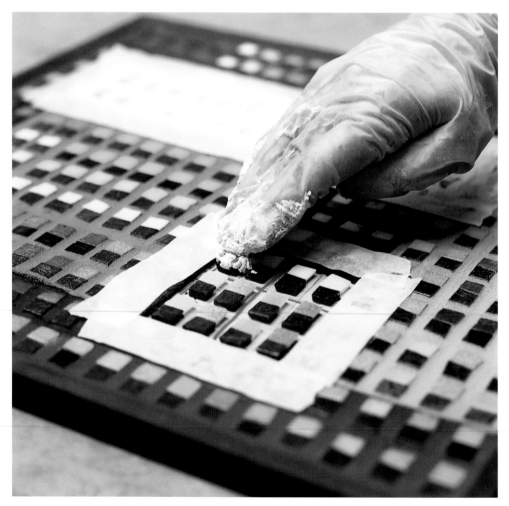

7 When dry the edges can be protected with masking tape and the white grout can then be applied to the remaining areas.

8 When all the grout is dry and the tape removed there may be some slightly uneven junctions that create a jarring effect. These can be tidied up using a small screwdriver to scrape away excess grout.

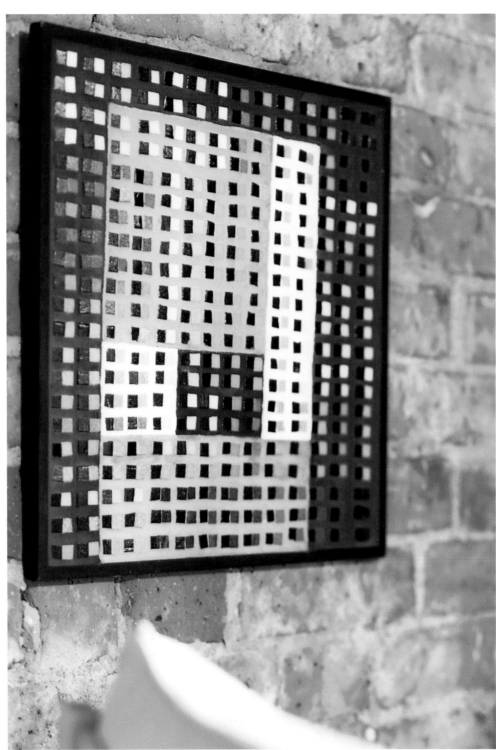

Many other experiments could be made along these lines, for instance using white instead of black tiles as the constantly repeating element, or a combination of the two to create another layer of rhythm. A wide range of new possibilities would be opened up by using colored grouts—small quantities of acrylic paint can be added to grout, and stronger effects can be achieved with proprietary colored grouts.

Tonal composition

Inspiration

MIDAS AND BACCHUS, c. 1630

NICOLAS POUSSIN

equipment

■ ruler
■ pencil
■ hammer

materials

■ vitreous glass mosaic tiles
■ MDF board 12 x 16¹⁄₂ in
 (30 x 42 cm)
■ PVA glue
■ copper strip
■ silicone glue
■ copper hardboard pins

Johannes Itten was the tutor of the basic course at the Bauhaus, and he devised an exercise for his students that produced paintings that looked very much like mosaics. He taught them how to make a geometrical analysis of the tonal values in an Old Master painting which in the original exercise was *The Duchess of Alba*, by Goya. The picture was divided up into a grid and each square was filled in with an appropriate shade of gray to match the tone of the color in the original painting. In this way, all the details of form and color were removed and the compositional structure of the picture is revealed. The resulting image was beautifully balanced and, as well as demonstrating Goya's skill, was in itself an interesting and harmonious abstract composition. At the time when these exercises were being used, in the 1920s and 1930s, their primary purpose was as an aid to understanding the techniques of representational painting. Seen now, however, in the context of the intervening decades of pure abstraction, it is easy to read them as works in their own right.

The gridded structure obviously lends itself to working in mosaic and the initial purpose of this project was to apply this approach of tonal analysis to a different painting, Nicolas Poussin's *Midas and Bacchus* (above). From this gray-scale version, a new abstract color composition was then made that retained the harmony of the original image but without any of the representational detail.

method

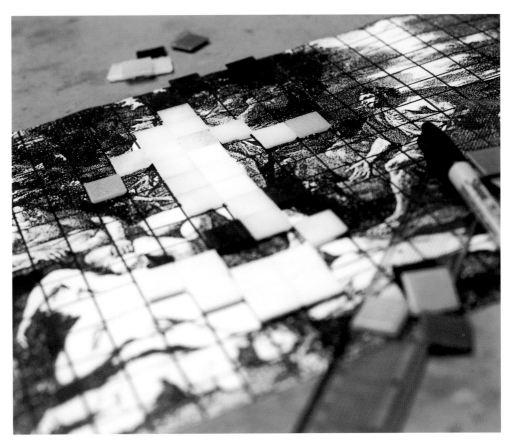

1 From the available mosaic colors select tiles that evenly change from black through gray to white. Try to make sure that the difference in tone between all the individual tiles is the same—you may need to leave out some that are too close together because they may draw attention to other areas where the differences are greater. Next to this gray scale you can work out color scales that have similar tonal values.

2 Choose a painting by an Old Master. Very complicated compositions with many figures could be undertaken but you would have to work to a large scale. Try to select a painting where there are strong areas of dark and light with a strong structure. Make a black and white photocopy of the painting. It does not need to be of fine quality because you are not interested in the details— a rather poor copy may help to simplify and clarify the tonal relationships. Divide the copy into a grid of squares of a size that will reflect the important changes in tone across the painting and then enlarge the image so that the squares are the size of the tiles (3/4 in / 2 cm). Starting with very dark and very light areas, lay the gray-scale tiles on top of the photocopy and gradually fill in the areas in between. Keep standing back and blurring your eyes to compare the effect with the original painting, and make sure that the structure is emerging. When you are happy with your arrangement, you can lift them off one by one and stick them down in rows with PVA glue to the MDF board.

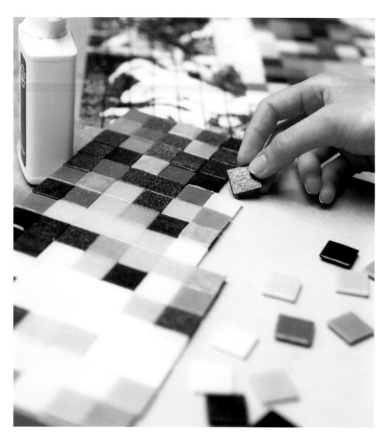

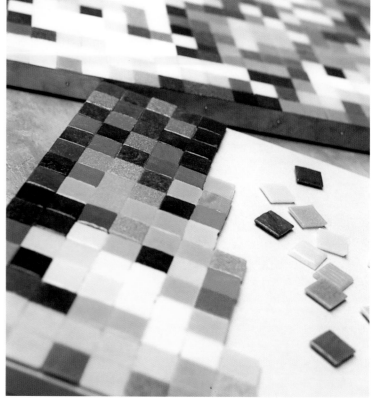

3 From this monochrome version, and referring to the color scales made in Step 1, you can then start a new panel substituting colors for the grays.

4 You can refer back to the original painting, not necessarily to copy the colors but to establish groups of different hues. For instance, all the bodies have been rendered in the same hue—flesh tones in the painting and blues in the panel. The small areas of intense color in the painting have also been reflected with particularly bright tiles.

5 These abstract compositions have been finished off with simple copper frames. Flexible copper strip is bent round the board and glued in place with silicone. Copper-headed hardboard pins hammered in at 2-inch (5-cm) intervals will hold it in place while the glue dries off.

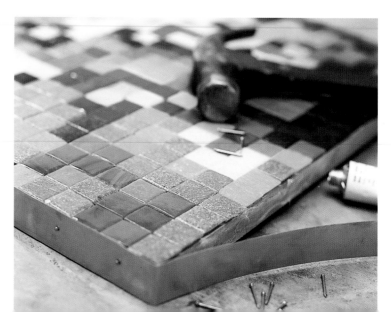

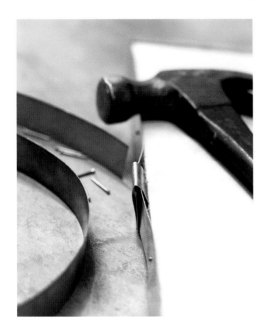

6 The overlapping ends can be covered with a piece of copper strip bent over both edges.

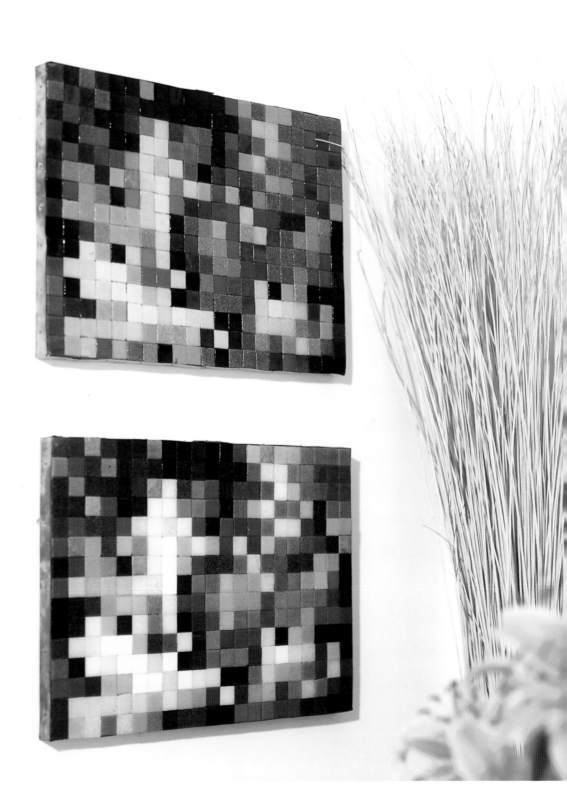

The finished piece does not obviously resemble its source but its relationship to Poussin's painting gives it an extra level of interest. It would be rewarding to repeat the exercise with a number of works by the same artist using the same palette. This would show the different ways in which a particular painter manipulates the picture space and would also create a series of themes and variations ordered around this simple system of analysis.

Circular
letter mirror

Inspiration

PENGUIN BOOKS MOSAIC, 1963
HANS UNGER &
EBERHARD SCHULZE

nonrepresentational composition allows the familiar characters to be seen as abstract visual symbols rather than read as letters or words. This project also incorporates printer's type blocks. Recent advances in printing technology mean that these can often be found in thrift shops at bargain prices. They are beautiful objects, incorporating very finely detailed metalwork, and it is a pleasure to find a use for them that will bring out their visual qualities and save them from the oblivion of history. This particular design is based on type blocks bought in Brick Lane Market in East London. Their metallic surfaces, sometimes stained with red and black ink, have been combined

This mirror is made using a rich variety of different materials. It was inspired by a mosaic made in the 1960s by Hans Unger and Eberhard Schulze for the headquarters of Penguin Books in Harmondsworth, Middlesex. This is a large wall mosaic made of a combination of smalti, ceramic tiles, and natural slate laid in an apparently free and flowing arrangement reminiscent of painterly brush strokes. The pieces are of different sizes and thicknesses and the surface is therefore strongly textured. It is an approach that allows the materials to express their individual properties of color and reflectivity and was popular in the mid-20th century when the Bauhaus-inspired idea of "truth to materials" was a preoccupation of many artists. This example is given added interest by the inclusion of printing blocks and linotype pages from the Penguin press. The highly worked metal elements with their intricate surface detail form a dramatic contrast with the plainer surrounding materials. Their inclusion in a

with a variety of marble, smalti, and vitreous glass pieces. The color palette has been restricted to include primarily blacks, grays, and whites, which enables the eye to concentrate on the interest provided by the textures and surfaces of the different materials. The blocks themselves are deeper than the other materials and, rather than build up the mosaic around them, this dramatic discrepancy in level has been exploited as one of the characteristics of the finished piece. Further variations in level have been created by using the marble and smalti elements on different sides so that all the concentric rings are made of pieces that are of alternating heights. The different unit sizes mean that the rows all have a slightly different rhythm and therefore do not synchronize with each other, which adds to the variety and liveliness of the effect. The alternating patterns of towers and canyons resemble a miniature city on the banks of a perfectly circular lake.

method

equipment

- ruler
- pencil
- screwdriver
- long-handled tile nippers
- plasterer's small tool or palette knife

materials

- circular framed MDF board
 16 in (40 cm) diameter
- circular mirror 8 in (20 cm) diameter
- silicone glue
- D-rings and picture wire
- paper
- masking tape
- metal printing blocks
- polished and unpolished marble cubes
- white and slate-blue smalti
- gray vitreous glass
- cement-based adhesive

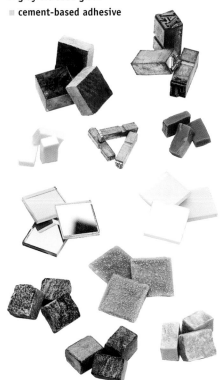

1 Draw lines at right angles through the center of the board and mark off the diameter of the mirror to ensure it is in the middle.

2 Place the mirror on a piece of paper and draw round it. Cut out this circle of paper and stick it to the face of the mirror with a couple of pieces of folded-over masking tape to protect the surface. Stick the mirror to the board with lines of silicone glue.

3 Before starting to stick the mosaic, it is a good idea to fix hangers and picture wire to the back. The finished piece will be awkward to turn over and could be damaged if you leave this until the end.

4 The printing blocks are the inspiration for this piece, and the other materials have been chosen to complement them. Natural stone is both heavy and hard and therefore has a relationship with the steel blocks. It needs to be cut with long-handled nippers for better leverage. Cutting open the unpolished cubes reveals a more strongly colored face as well as providing a different thickness. Glass shares both the hardness of stone and metal as well as their shiny, reflective qualities.

5 Work out a pattern of alternating materials by laying them loosely in the frame. Some elements, such as the type blocks and pieces of hard stone, will be of a fixed size and so other rows will have to be made up of cut pieces so that the design will fit neatly between the frame and the mirror.

6 The inside and outside rows will be the most visible so start sticking them down and then work toward the middle. Spread a small area of cement-based adhesive on the surface of the board with a plasterer's small tool or palette knife. The adhesive bed will show through between the tiles but it will be a neutral gray color and will merge with the shadows between the taller pieces.

7 When you have about one-sixth left to do it is worth laying the pieces in without any adhesive so that you can adjust the spacings or cut one or two special sizes so that all the rows meet up correctly. If you do have to make adjustments you can stagger them across the rows so that all the slight peculiarities do not occur in the same area and look unsightly.

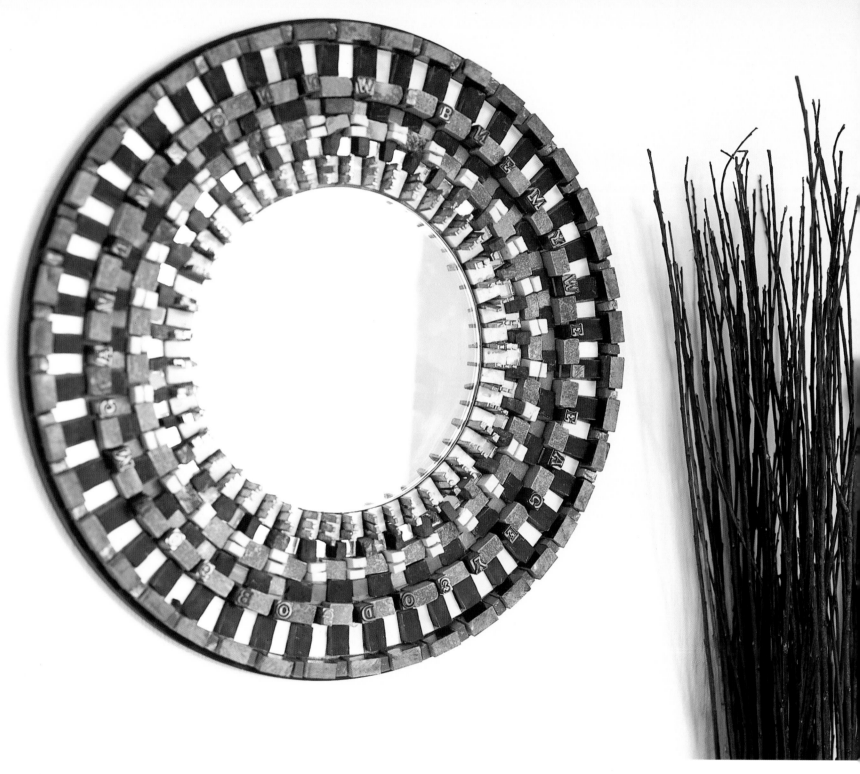

All kinds of variations on this project are possible depending on the materials available to you. If you had enough type blocks you could use them without other materials and perhaps even write words and sentences (in reverse!) to give another level of interest. The piece would tend to be rather heavy so would need to be small. Old-fashioned typewriter keys are very attractive and could be used as a source of letters, and modern computer keyboards that are about to be discarded could be successfully recycled in this way.

Op Art coffee table

Inspiration
ARNY, 1967–68
VICTOR VASARELY

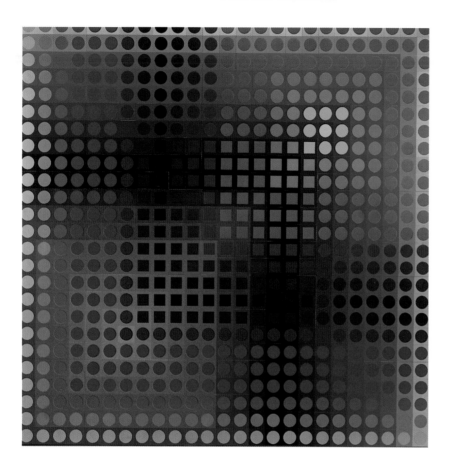

equipment
- colored pencils
- paintbrush
- screwdriver

materials
- squared paper
- vitreous glass mosaic tiles
 (882 tiles of 28 different colors)
- 13 shades of blue from darkest
 to palest plus charcoal gray
- 12 shades of browns and olive
 greens plus white and black
- framed MDF board, internal
 dimensions 33 x $16\frac{1}{2}$ in
 (84 x 42 cm)
- paint for frame
- silicone glue
- screw-on table legs with
 fixing plates and screws

The inspiration for this tabletop is the work of the Hungarian painter Victor Vasarely. Working in the 1950s and '60s, he was fascinated by the illusions of depth and form that could be created on the canvas. He used a repertoire of simple shapes—squares, circles, and triangles— and by careful manipulation of tones and contrast created dynamic optical effects. All realistic painting is based on the knowledge that progressions of color from dark to light can be used to give the impression of shading on a curved form and thus the illusion of three dimensions. This technique is exploited by Vasarely to create his Op Art paintings. The gradating tones are often heightened in effect by contrast with an overlaying pattern of forms in a constant tone, usually black or white. Within a single painting, foreground and background may swap roles between constancy of tone and gradation, so that the repeating forms may appear as holes in a flat plane or as solids floating in space.

These paintings have an attractively retro look about them now, partly because these simple effects were widely used in decorative arts of the 1960s, particularly in textile and wallpaper designs. They make an excellent source of mosaic ideas because they feature simple, repeating modules to which the squares of mosaic lend themselves readily. They rely on wide tonal ranges of color and these can be found in vitreous glass mosaic tiles. Coffee tables are in themselves retro items so this seemed a suitable object to make in this style.

The tabletop is a loose interpretation of Op Art ideas, adapted to the medium of mosaic. For the tonal effects to work dramatically, the piece is made with the tiles butted close up to each other, thus avoiding the need for grout joints that would interfere with the direct color relationships and dilute the effect.

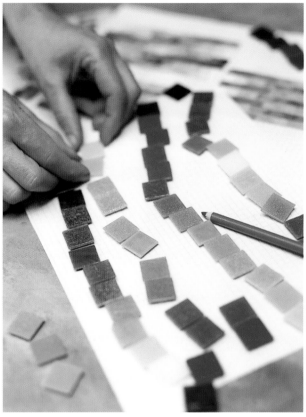

1 It is often easier to experiment on a drawing before selecting your colors. For designs made of whole tiles, such as this one, working on squared paper is a good shortcut and allows you to try out a lot of different ideas quickly and easily. Always remember that these are working drawings and part of the design process rather than works in their own right that must be beautifully finished. Often a very quick sketch will be enough to clarify your ideas.

2 Because colored pencils will never be a perfect match for all the mosaic colors, the selection of tiles can only be made by experimenting with samples and assembling an appropriate range. For this project the tonal range, from light to dark, is of paramount importance. The manufacturing constraints of vitreous glass mean that there are wider ranges in some colors than others; there are more blues than anything else, quite a lot of greens, grays, purples, and browns, a few reds and oranges, and very few yellows and pinks. Taking into account these limitations, the colors selected here are blues and olives and browns. The true tonal ranges, that is variations of a single hue, have been enlarged by the addition of colors from similar hues, for instance there are lavender-blues in the generally turquoise blue range and olive-greens in the browns. This makes the color combinations less obvious and more interesting.

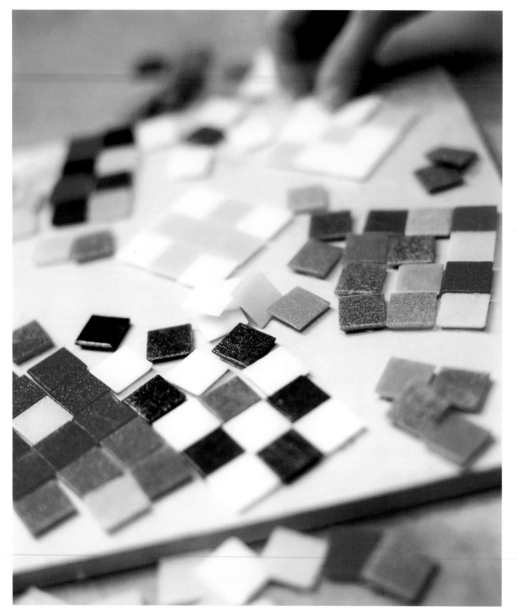

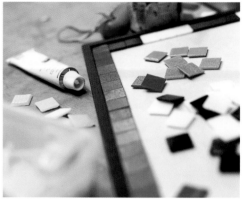

4 When you are sure of your colors it is a good idea to paint the frame. When the paint is dry you can start by sticking down a row of tiles along the edge of the pattern in both directions to be sure that they fit comfortably.

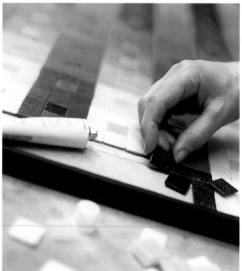

3 Even though the module in the final table will be three tiles square, it is possible to play around with single tiles to try out different patterns. With two tonal ranges there will be areas of extreme contrast where the palest tiles abut the darkest, and areas without any contrast at all where the mid-tones abut. For this project the areas of maximum contrast are at the ends of the table, with the blues and browns merging in the middle. In each nine-tile square there is a single tile of the same tone from the other color range; the juxtaposition of colors that are close in tone but of different hues can be very subtle and pleasing.

5 Because this piece is tightly jointed, silicone glue has been used to give extra flexibility. A small amount is squeezed directly onto the board along the line to be laid, and the tiles gently pushed into the glue. Because this is a tabletop the tiles must lie flat.

Depending on the temperature, the silicone will dry in 1 to 2 hours and the tabletop can then be turned over and the legs fitted. Proprietary fixing plates are available that are screwed into the table base and into which the legs themselves can be screwed. Remember to use screws that are no longer than the thickness of the table base or else you will dislodge the mosaic on the face.

By concentrating on optical effects you can make sophisticated designs without needing any cutting and laying experience or skill. A good range of grays is available in vitreous glass, and an interesting alternative project would be to design a striking monochrome panel.

Translucent hanging panels

inspiration

TOTTENHAM COURT ROAD
UNDERGROUND STATION, 1984
EDUARDO PAOLOZZI

equipment

- tile nippers
- protective eyewear
- double-wheeled nippers
- small spreader

materials

- mosaic tiles: 3 black ceramic circles and 8 ¾ x ¾- in (2 x 2-cm) squares
- translucent vitreous glass tiles: 12 white, 20 gray, 5 blue, 6 light green, 6 aqua
- 3 clear glass marbles
- brown paper
- water-soluble glue
- translucent silicone glue
- clear glass panel 10 x 4 in (25 x 10 cm)
- thin wire for hanging

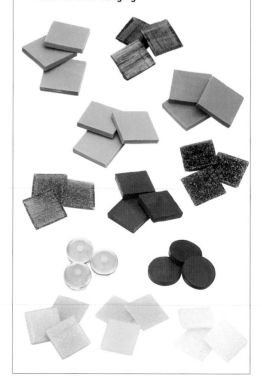

Eduardo Paolozzi's designs for Tottenham Court Road Underground Station in London represent one of the largest areas of decorative 20th-century mosaic in England. Although largely abstract, modern themes such as computer circuitry and fast food lie behind the designs. They are executed in an interesting mixture of vitreous glass and smalti although constrained by the practical necessity of providing a flat and easily cleanable surface. The designs incorporate many differently sized elements and color combinations, all of which act as a useful catalog of mosaic techniques and effects for the traveling mosaicist. As with many mosaics designed by artists for execution by others, there are areas where you can see that it has been difficult to interpret the design successfully. Some shapes lend themselves to mosaic more easily than others but artists do not necessarily take this into consideration. For the mosaic designer, Tottenham Court Road Station contains many examples of both elegant and awkward laying. One of the most successful areas is made up entirely of whole black and white tiles laid in complex patterns. Elsewhere there are some attractive color mixes and combinations even though the overall color effect is rather loud and bombastic.

The little glass panels made for this project are inspired by the strong vertical designs at the top of the main escalator. The strong contrast of the colors against the white background is similar to the contrast that can be achieved by mixing translucent and opaque mosaics on glass panels. When hung against a window, with the light shining through, the accents of opaque ceramic tile will be dramatically dark against the translucent glass tiles.

method

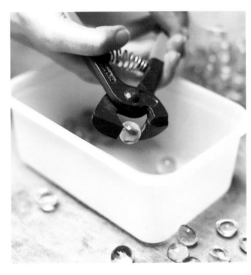

2 The marbles need to be cut in half to give a flat surface to stick down to the panel. This can be done using ordinary tile nippers but you MUST wear eye protection to avoid injury because the marbles can fly fast and unpredictably away from you. It will help if you hold the marble in the nippers over a box and you may need several attempts because some will chip rather than shear.

1 When selecting the glass tiles for this project you must check to see how translucent they are by holding them up to the light or in front of a light bulb. With the paler colors it is usually quite obvious if they are translucent or not but some darker colors can be surprisingly different when lit from behind. Some colors will be completely opaque and therefore not suitable, and sometimes tiles of the same color will vary hugely in translucency and will need to be checked individually.

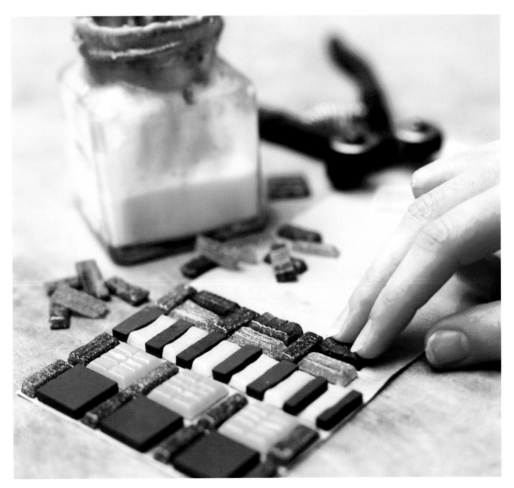

3 It would be possible to use the direct method for this project but silicone is messy to work with and if any gets on the face of the tiles it is difficult to remove. The indirect method therefore produces a neater result. The tiles need to be cut into appropriate sizes—the thin strips will be easier to cut with the double-wheeled nippers—and then stuck to the paper with the water-soluble glue. Leave the top row with the marbles to be fixed directly.

4 Because this is a translucent panel you must use a translucent silicone glue, and with this technique you can also use silicone as a grout. You have to work quite quickly as silicone skins over when exposed to the air in 5 to 10 minutes. First pre-grout the piece by spreading silicone glue with a small spreader all over the back of the mosaic and pressing it into the joints with the spreader.

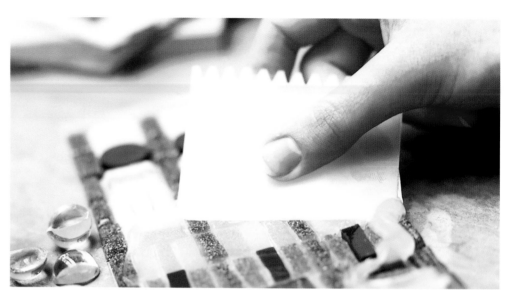

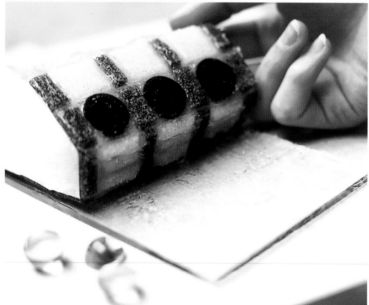

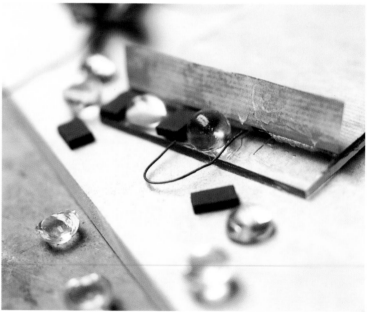

5 Squeeze lines of silicone about 2 inches (5 cm) apart down the glass panel and then spread it evenly across the whole area with the spreader. Turn the pre-grouted mosaic over on to the silicone-coated glass and press down all over to try to eliminate air bubbles. Remove any excess silicone around the edges with the spreader.

6 Make a hanger for the panel by cutting a length of thin wire about 4 inches (10 cm) long and bending it into a U shape. Position the hanger at the top of the panel so that its ends will be covered by the opaque ceramic pieces. Stick the top row of ceramic and marbles directly to the exposed silicone, adding a little more glue if the marble backs are uneven. Finally dampen the paper with a wet sponge to discourage the silicone from sticking to the paper.

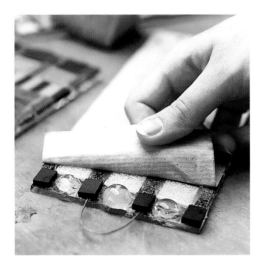

7 Leave the paper on the face until the silicone has dried (overnight). Wet with a sponge and leave for 5 minutes while the water penetrates and the glue dissolves, and then peel off the paper.

Colored opaque materials can be used instead of the black ceramic. This would create a more dramatic difference in the appearance of the piece between night and day, and between back- and front-lighting. Another variation is to make the piece using the direct method and grout it with an opaque cement-based grout. Against the light this will create dark lines similar to the leaded joints in stained glass. Remember that you cannot pre-grout with conventional grout when using silicone because it will not stick to wet surfaces.

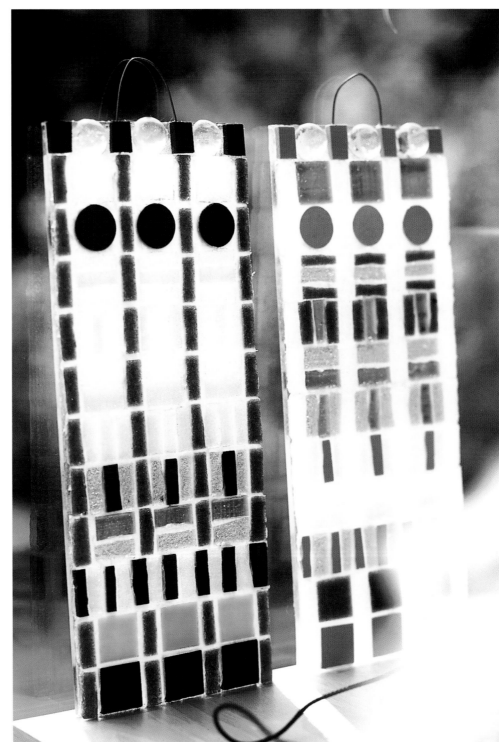

gallery

▲ Mosaika Art & Design, *Pop Dots*, 2001.
This simple design is rendered more lively by its transformation into a mosaic made of various shapes and sizes.

▲ Mosaika Art & Design, *Dora Maar Reinterpreted*, 2001.
This panel is made of ceramic and based on Picasso's painting of Dora Maar. The fractured laying of the figure is contrasted with the more regular background.

▲ **Helen Bodycombe,** *Movimento nelle Foglie*, **2001.**
This flowing abstract design handles variations in the
tone with sensitivity to create an overall effect of
movement and grace.

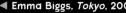

▲ Emma Biggs, *Tokyo*, 2000.
This vitreous glass wall panel achieves its dramatic
effect through the careful juxtaposition of colors
within the simple overall structure of vertical stripes.

126

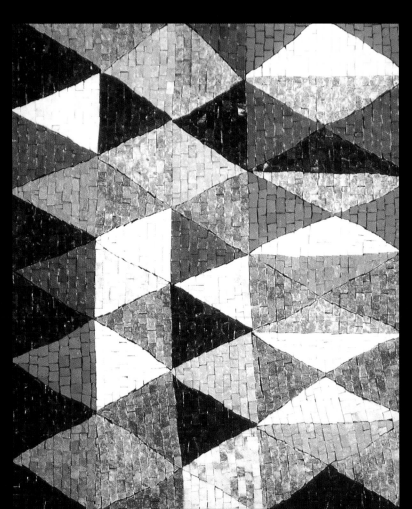

◀ Emma Biggs, *Diamonds*, 1998.
Made of river marble, the texture of natural stone
gives this piece an interesting surface. The matte
color of the black stone contrasts with the glittering
crystaline texture of the paler marble colors.

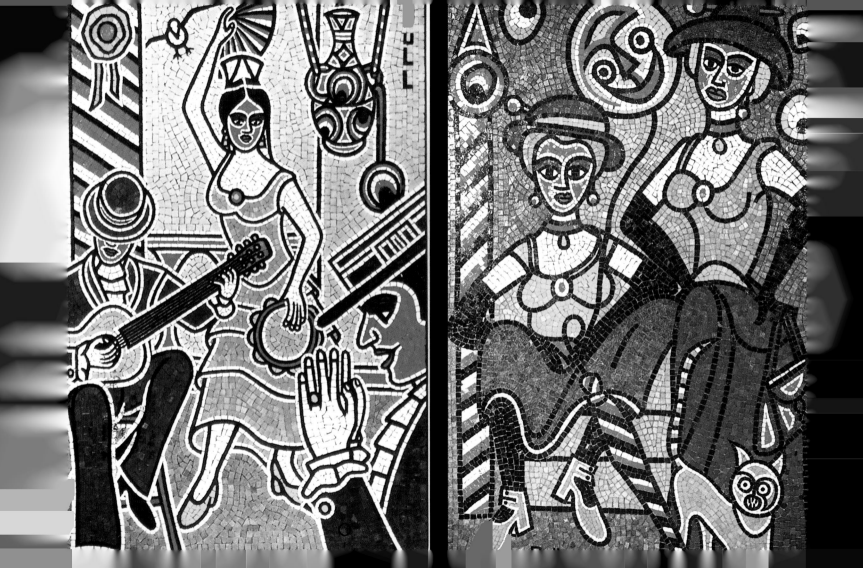

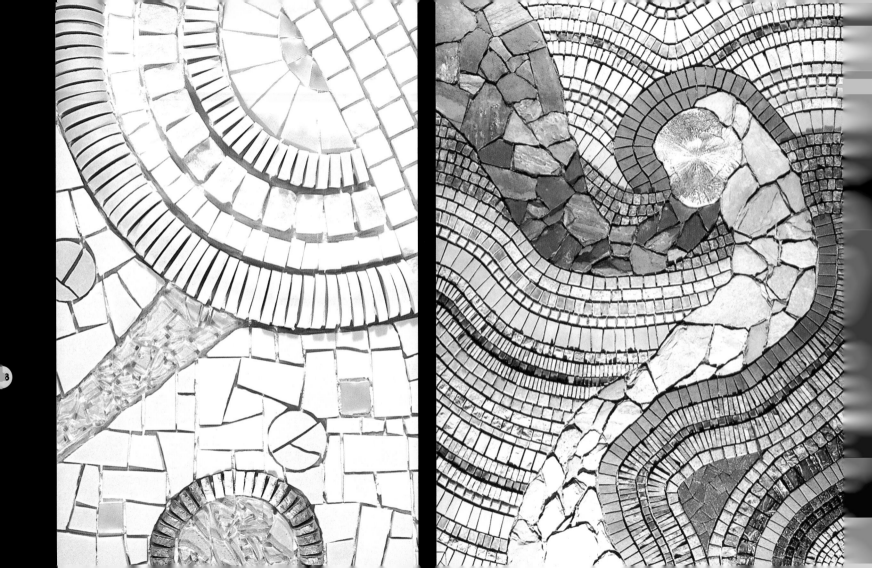

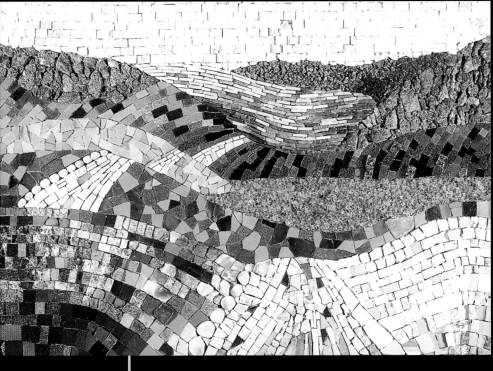

▲ **Sonia King. *Hill Country*, 1999.**
In this stylized landscape, a wide variety of different materials are used to represent the receding hills and there is a satisfying balance between representation and abstraction. Made of marble, glass, ceramic, stone, shells, and more.

▼ **Sonia King, *Ice Land*, 2000.**
This piece made of marble, glass, onyx, smalti, and ceramic has a very rich surface, using very small fragments of different materials to create a composition of flowing organic forms.

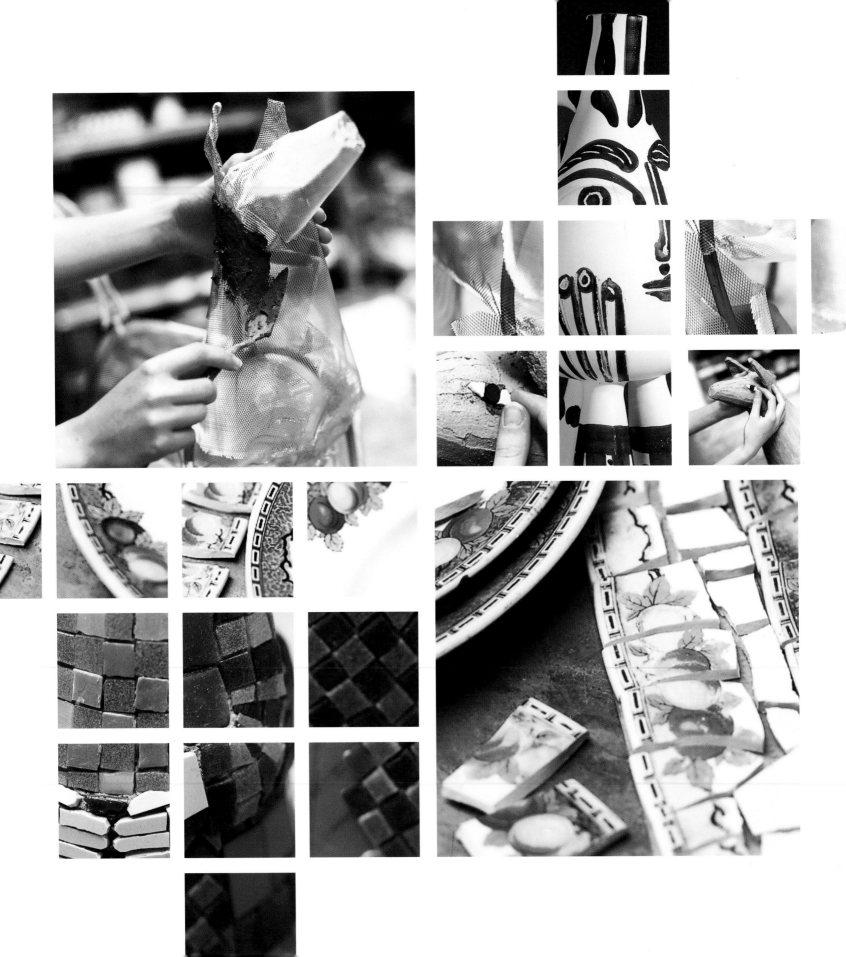

sculpture
and objects

SCULPTURE WAS TRANSFORMED BY THE REVOLUTION OF MODERNISM AS PROFOUNDLY AS WAS PAINTING, WITH SOME 20TH-CENTURY SCULPTORS EXPLORING THE STYLIZATION OF REPRESENTATIONAL FORM AND OTHERS OPTING FOR PURE ABSTRACTION. TECHNICAL INNOVATIONS HAVE ALSO INFLUENCED THE DEVELOPMENT OF SCULPTURE, INTRODUCING NEW MATERIALS AND NEW POSSIBILITIES OF SCALE. THE BOUNDARIES BETWEEN ART, ARCHITECTURE, AND SCULPTURE HAVE BECOME INCREASINGLY BLURRED, AND IT IS PARTLY DUE TO THIS PHENOMENON THAT MOSAIC HAS BEEN USED FOR THE FIRST TIME AS A COVERING FOR SCULPTURES AND 3-D OBJECTS. TRADITIONALLY, MOSAIC WAS EXCLUSIVELY USED AS A MEDIUM OF ARCHITECTURAL DECORATION, BUT THE INNOVATIVE ORGANIC WORK OF THE CATALAN ARCHITECT, ANTONIO GAUDÍ, WAS A FUSION OF ARCHITECTURE AND SCULPTURE, AND IT WAS HIS PIONEERING USE OF MOSAIC THAT HAS INSPIRED THE APPLICATION OF MOSAIC TO 3-D FORM.

131

Up until the end of the 19th century, sculpture, perhaps even more than painting, had been dominated by the legacy of the ancient civilizations of Greece and Rome. Since the rediscovery and reassessment of the great classical statues, such as the Laocoon, uncovered in Rome in 1506, almost all sculpture had been imitative of the classical style. It had provided a profound source of inspiration for Renaissance and Baroque sculptors, and increasing interest in archeology in the 18th century meant that new examples were constantly being discovered.

There was extreme pressure from historians and the exhibiting salons to follow the pure classical style, and by the middle of the 19th century the human form had been idealized into a cold and stiff object. The Italian sculptor Antonio Canova was hugely successful in his time, producing works of great skill and perfection but without any emotion or movement. It was particularly difficult for young sculptors to be innovative in their work because their materials were so much more costly than mere paints and canvas. Someone would have to cover the costs of bronze or stone, and the public institutions and private collectors who bought sculpture were still convinced that Classicism was the only true style.

The first sculptor to begin to challenge this view was Auguste Rodin. Himself deeply grounded in Classicism, he found inspiration for his new style through a careful study of the sculpture of antiquity. He noticed that a certain roughness of surface could add to the vitality of the form, reflecting light in a more expressive way. This led him to radical experiments with the manipulation of his materials, allowing the natural surfaces and textures to express themselves as well as the figurative subjects. His famous sculpture of the novelist Honoré de Balzac shows the figure emerging out of an almost abstract form, and his *Gates of Hell* are animated by hundreds of figures merging into and out of the bronze surface. Although modern in their free use of material and concentration on movement and feeling, they also have close associations with the sculpture of the past—Michelangelo's slaves emerging from blocks of stone and the bronze doors by Lorenzo Ghiberti for the Baptistry in Florence.

▶ **Antonio Gaudí and Josep Maria Jujol, Casa Battlo, Barcelona.**
Gaudí's imagination was as much sculptural as architectural, and he designed roofscapes and chimney pots as dramatic sculptural forms. Mosaic was the perfect medium to cover these complex shapes and give them an extra dimension of applied decoration and color.

By the end of the 19th century, however, the stranglehold of Classicism was loosening its grip on both sculpture and architecture throughout Europe. Art Nouveau in France and Jugendstil in Germany were movements taking inspiration from the organic forms of nature rather than the models of history. Buildings are not easily made out of curved, asymmetric surfaces, and it is probably no accident that this style was fashionable at a time when the European bourgeois class was enjoying a period of great prosperity funded both by domestic manufacturing and the exploitation of empires. Many of the artifacts created in this style, such as the Paris Métro signs, are a fusion of applied decoration and form, and it is hard to say whether they are buildings or sculptures, or something else altogether. The greatest example of this fusing of architecture, sculpture, and decoration is in the work of Antonio Gaudí in Barcelona. In collaboration with the designer Josep Maria Jujol, he created a series of strange apartment buildings with complex curving façades and elaborately decorated chimney pots. His masterpiece, the Church of the Sagrada Familia, was

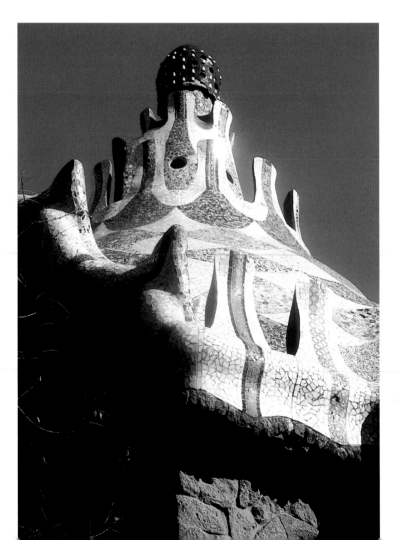

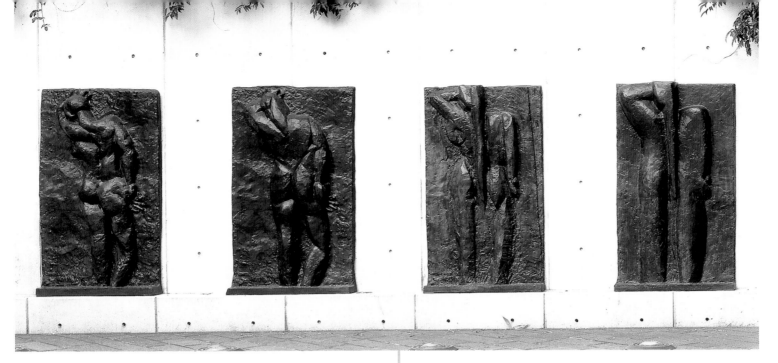

▲ **Henri Matisse, *Backs I to IV*, 1909–30.**
These reliefs were made over a period of 20 years and each new panel was made from a plaster cast of the previous one, amended by adding clay or carving away the plaster. They illustrate a progression away from realistic modelling toward the more stylized effects of direct carving inspired by African sculpture.

begun by others as a neo-Gothic design, but became a giant organic construction, still unfinished, of stone, brick, and ceramic that appears to be growing out of the ground, more like an alien vegetable than a building. In Parc Güell he collaborated with Jujol to make a long, serpentine bench covered with characteristic broken-ceramic mosaic. This is the inspiration for Project 13, Catalan Flowerpot (see page 138).

Only a very few of what might be called sculptural buildings have been created since then. The German architect Erich Mendelsohn created an extraordinary structure in the Einstein Observatory in Potsdam that looks like an illustration from an adventure comic. Le Corbusier's chapel at Ronchamp is much more like a sculpture than a building, with its curling roof and sloping walls, occasionally punctured by openings filled with colored glass. Another example is Frank Lloyd Wright's Guggenheim Museum in New York, which expresses its pure spiral form and hardly looks like a building at all. Although these buildings are very original and inventive in form, they differ dramatically from Gaudí's work in that they do not contain decoration of any kind, either inside or out. The idea of decoration was incompatible with pure Modernism, and this insistence on unadorned form is evident in the development of sculpture as well as architecture.

When sculptors were liberated from the constraints of the classical tradition they were able to look elsewhere for inspiration. We have seen that Rodin was able to respond to the properties of his raw materials of clay, plaster, and bronze. His Italian contemporary,

Medardo Rosso, took this fascination with plastic and fluid materials further by working in wax and producing extraordinary, half-formed, ghostlike figures. Other sculptors turned to the artifacts of other civilizations to help free themselves from the constraining realism of the West. Egyptian, Assyrian, Cycladic, Polynesian, and many other different cultures were all studied with enthusiasm. Gauguin and the Romanian sculptor Constantin Brancusi produced sculptures that looked like pagan idols, using the exaggerations and simplifications that give such objects their visual power. They made objects of mysterious and mesmerizing symbolism but whether they are intended to be worshiped, and what God they represent, is less clear.

Rather than borrow meaning from elsewhere, sculptors sought inspiration in modern materials and the new forms these suggested. Foremost among these sculptors was the Russian Naum Gabo, who came up with the revolutionary idea of constructivist sculpture. His "constructions" were assemblies of different flat materials in different planes, sometimes creating recognizable human forms but often making abstract compositions. While the Expressionist buildings discussed earlier looked like sculptures, these sculptures were very architectural in inspiration and some of them were intended as models

for visionary buildings. Fascinated by transparency as an ingredient in his constructions, Gabo used glass and clear plastic as well as metal and plastic thread.

Some artists continued to use traditional materials and to be interested in the human figure as subject matter. Matisse, for instance, used bronze to pursue his experiments in the simplification of the female form. This series of female back views illustrates the shifting balance between subject, material, and form. Henry Moore's sculptures follow the same tradition, using the natural characteristics of his material to make figures that are part human, and part rock formation and landscape. The process of simplification distills a kind of essential meaning, making these representations of the idea of female form rather than evocations of living individual people. Picasso, by contrast, experimented with new materials, his pieces revealing a playful individuality. Following on from Marcel Duchamp's idea of exhibiting manufactured objects as art works, Picasso made some sculptures by combining everyday objects to make new, recognizable likenesses. He famously combined a bicycle saddle and handlebars to create a bull's head. He also made many ceramic sculptures where form and line are combined to make lively hybrid figures and animals. Project 14, Flowerpot Figure (see page 142), is inspired by these works.

This idea of being able to use any and all materials in making a sculpture led one artist to experiment with mosaic. This was the Argentine Julio Fontana who, early in his career, made a female head covered in gold and colored glass mosaic. He went on to produce many ceramic sculptures and the slashed canvases for which he is famous.

▲ **Pablo Picasso, *Bull's Head*, 1942.**
This is one of Picasso's most elegant and minimal sculptures, entirely constructed from found objects. It represents, however, a very different tradition from Duchamp's ready-mades as here the work is transformed by the artist's arrangement and the bicycle components metamorphize into a bull.

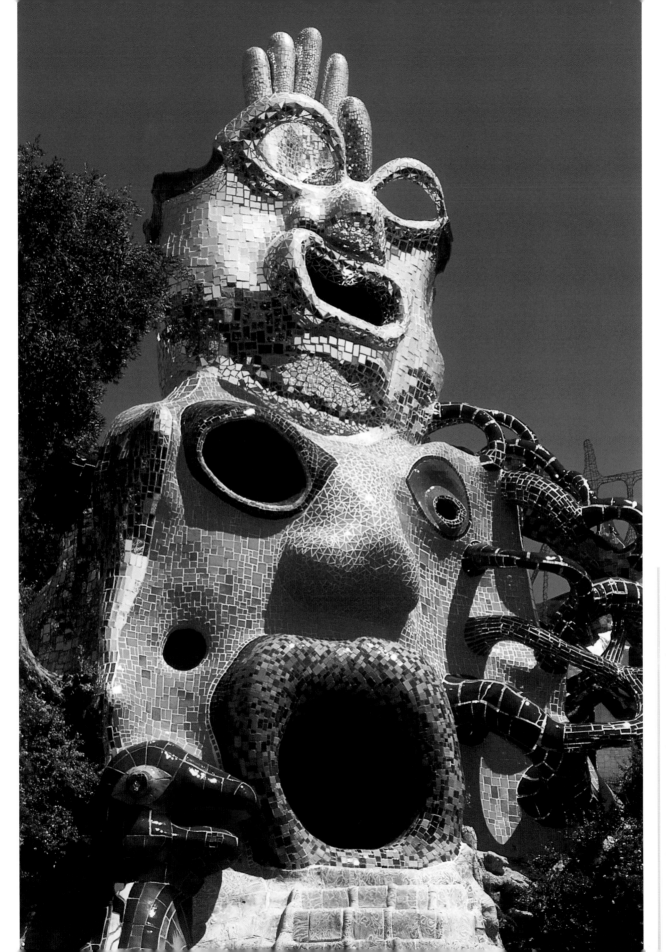

◄ **Niki de Saint Phalle, Tarot Garden, Tuscany.**
These sculptures are huge in scale, towering over the surrounding countryside, and highly colored, often incorporating mirror as well as glazed ceramic and glass. Clearly inspired by Gaudí and Jujol, the garden is also influenced by the 16th-century Mannerist Parco dei Mostri at Bomarzo in Lazio with its giant moss-covered stone creatures in a garden setting.

The tendency in the middle of the 20th century was away from representation and toward abstraction. Sculptors such as David Smith used sections of cast and welded metal to make huge constructions that were about weight, balance, and material qualities. Their enormous size gave them a monumental quality and they made successful public art objects amongst the skyscrapers of modern cities, often featuring in plazas and outside new office developments. The idea of using industrial components introduced a separation between the conception of a sculpture and its manufacture. This separation was pushed even further by minimalist sculptors such as Tony Smith and Donald Judd, who contributed no more than a series of written dimensions that were then made up by industrial processes into finished works. More recently Richard Serra has been designing huge lumps of metal for fabrication and installation by others, usually in public spaces. These are conceived as site-specific interventions in an urban space. Indeed, one of Serra's enormous pieces, installed in New York's Federal Plaza, intervened so effectively in blocking off the habitual routes of local people that it was eventually removed in response to popular outcry.

In the 1960s the influence of Pop Art did encourage some artists to return to representational sculpture. Claes Oldenburg made giant versions of everyday objects out of fabric filled with soft stuffing. The prodigiously inventive artist Niki de Saint Phalle, who had begun life as a fashion model, started to make large painted female figures out of papier-mâché. Stylized in form and covered with bright patterns, they were designed as symbolic "Nanas," figures embodying female fertility. In 1978 she embarked on the great work of her life, the Tarot Garden near Grosseto in Tuscany. Her partner, the sculptor Jean Tinguely, assisted her in beginning to create a series of enormous welded structures. With a large team of helpers, over the next 20 years she covered these structures with cement and resin and then with brightly colored ceramic mosaic. She had been hugely impressed by the work of Gaudí and Jujol in Barcelona and she used their mosaic technique to decorate the series of figures inspired by the tarot cards.

The use of applied color is a recurring theme in 20th-century sculpture. Degas's famous dancer, with her real fabric skirt, was originally given a painted face. Some of Barbara Hepworth's wooden pieces had areas of painted color, as did the expressive portrait busts of Marino Marini. The steel sections and plates found in the work of

Alexander Calder and Anthony Caro were often color-coated in bright primary colors. Niki de Saint Phalle, however, is alone in using mosaic as a durable and colorful way of embellishing complex and curving three-dimensional forms.

Scale has become one of the preoccupations of Western sculpture, with artists increasingly choosing not to make large single pieces but whole environments and installations—sculptures you can walk inside. In 1987 Thomas Schutte exhibited an ice-cream stall with adjoining toilet. Exhibiting objects as themselves has avoided the old tension between representation and abstraction. Damien Hirst's pickled shark is not a representation of a shark or an investigation of its three-dimensional form; it is actually a shark. It has, however, got a fancy title (*The Physical Impossibility of Death in the Mind of Someone Living*), which demonstrates that Hirst is fulfiling the role designated to artists in our society as having deep philosophical thoughts. Contemporary sculptors think about things, and possibly arrange things, but they do not make things very much any more.

There is a group who are excited by raw materials and who cannot resist the impulse to create sculptural objects with their own hands, but they operate on the margins of society, far away from the art world. Sometimes called outsider artists, these people are motivated by the inner necessity to make things that express their own personal vision. They often find it hard to communicate in more conventional ways and live quite isolated lives, concentrating on their creative passions. Mosaic, usually made out of fragments of broken china, is very often a part of their work because it is a cheap and colorful way of decorating their sculptures. There may also be something about the slow and laborious process of mosaic-making which appeals to their obsessive natures, symbolizing the possibility of creating order out of chaos through sheer mental concentration and physical effort. It is a phenomenon that is found all over the world; in France there is Raymond Isidor's Pique-assiette near Chartres that features beautiful elevations of Gothic cathedrals made out of broken china and pebbles. In America, Fred Smith has constructed his Wisconsin concrete park near Phillips on Highway 13 that contains more than 200 concrete figures and animals adorned with broken glass and depicting an eclectic range of scenes from Ben Hur to Iwo Jima. In South Africa there is the Owl House created by Helen Martins at Neue Bethesda, containing 65 cement owls

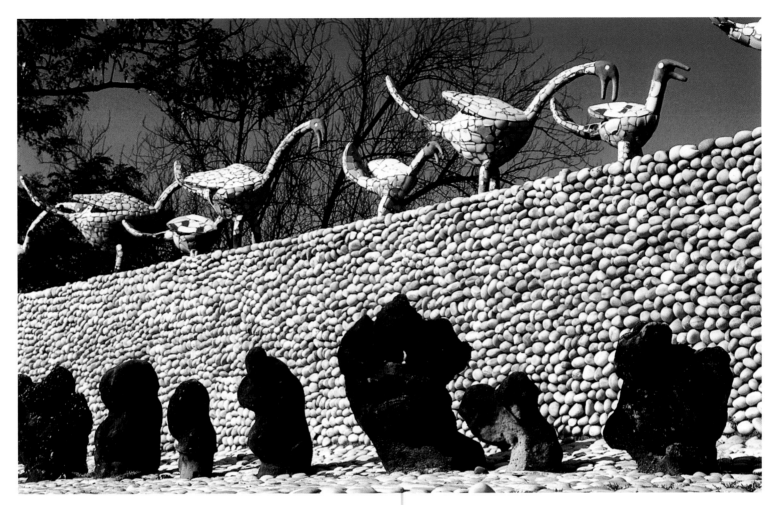

▲ **Nek Chand, *Birds*, Rock Garden, Chandigarh, India.**
Nek Chand's work often uses many versions of the same form. Because they are all hand-made and based on primitive technology, the repeated sculptures are all slightly different and this variety creates an animated and lively effect. Here, two different series of birds are placed in alternate sequence.

accompanied by camels and wise men. The largest and perhaps most interesting of all is the Rock Garden in Chandigarh, India. This has been made by Nek Chand who gathered all his materials together from garbage dumps and roadside dumpsters while working as a road inspector. He selected a secluded site hidden in the green belt around the city and began secretly to make armies of figures and animals, working at night. In 1976, however, his garden was discovered by the authorities. As the news spread people began to visit the garden, so, after much deliberation, the authorities yielded to popular pressure and Nek Chand was given a grant and some paid assistants to help complete his great scheme. Project 15, Garden Animal Sculpture (see page 147), is based on one of his marching animals. He is now working on phase three of his garden, which contains structures at a much larger scale including giant swings and an aquarium. It is ironic that this extraordinary work should have sprung up in the shadow of Chandigarh, the city designed by the European arch modernist, Le Corbusier, whose highly theoretical approach to design could not be more different from Nek Chand's untrained and instinctive way of working. However, as well as being the coldly rational master planner of Chandigarh, Le Corbusier also designed the chapel of Notre-Dame-du-Haut at Ronchamp. The expressive sculptural power of this romantic building is derived from the modernist principles of pure form and truth to materials, which are not entirely unrelated to the emotional impact of the Rock Garden figures.

Catalan flowerpot

Inspiration

BENCH, PARC GÜELL, BARCELONA

ANTONIO GAUDÍ AND
JOSEP MARIA JUJOL

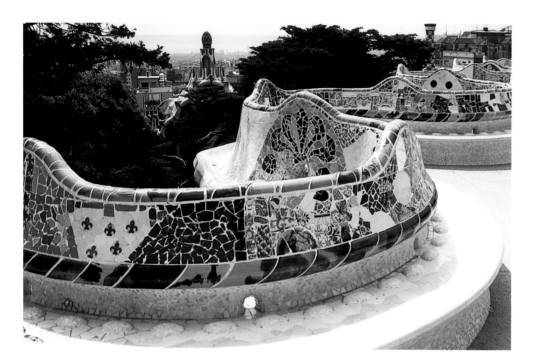

equipment

- paintbrush
- tile nippers
- charcoal
- plasterer's small tool
- surgical gloves
- sponge

materials

- PVA glue
- terra-cotta pot
- old china plates
- brown paper
- cement-based adhesive
- gray grout

This flowerpot, decorated with broken china, is inspired by the work of Antonio Gaudí and Josep Maria Jujol in Barcelona. Gaudí was an architect who developed a distinctively flamboyant organic style in the late 19th century, and Jujol was a designer with whom he collaborated. Most of the mosaic decoration on Gaudí's buildings is by Jujol. Both men were influenced by the Art Nouveau style that was flourishing in the rest of Europe but they were also inspired by Catalan folk traditions, with their elaborate decorations and widespread use of glazed ceramic tiles. The development of broken-tile mosaic was largely a practical response to the difficulty of applying decoration to the complex curved forms of Gaudí's architecture. The small pieces can follow smoothly the curving surfaces, and a random pattern of broken shards creates a harmonious overall design that does not have to follow particular lines of laying.

This flowerpot is a relatively simple shape because it is cylindrical and therefore only curves in one direction. It has been decorated with pieces from decorated plates. This is a good way to give extra life to pieces of china that have sentimental value but have been chipped or broken. These plates belong to my mother and a simple project has saved them from the trash can. Looking closely at Jujol's mosaics, we can see that they are very carefully made with all the pieces interlocking neatly. One way of ensuring that the mosaic has this quality is to cut up the china with nippers and lay it back in its original sequence so that the pattern still reads as a fractured version of the original.

method

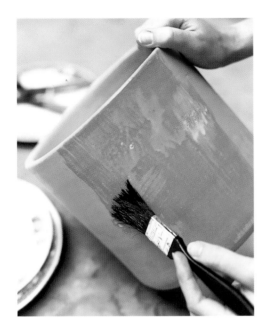

1 Mix up a solution of half PVA glue and half
 water and apply to the outside of the
 terra-cotta pot with a paintbrush. This will
 seal the porous ceramic and prevent the
 cement from drying out too quickly.

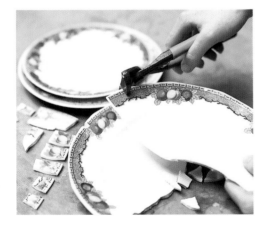

2 Cut up the old plates with tile nippers. Do not
 be tempted to smash the plates with a
 hammer: you will obtain neater-shaped pieces
 by using the nippers.

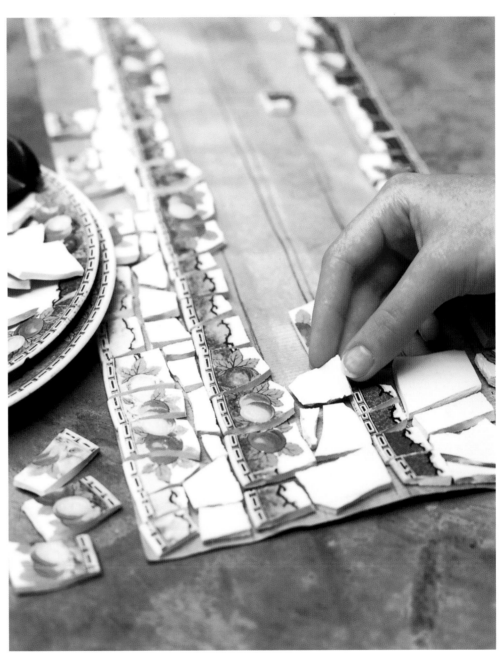

3 The idea of this project is that the pattern should still read as it did in the original plates so it
 is important to lay out the pieces as you cut them to ensure that they remain in the right
 sequence. You can wrap a piece of brown paper around the pot and cut it to the size of the
 surface area. By laying pieces out on the paper before you start you can check that you have
 enough material and that the pattern will work out.

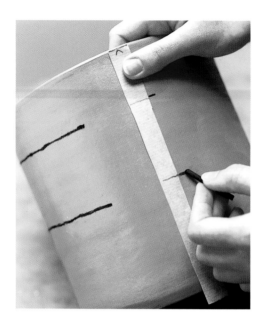

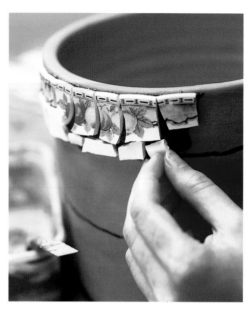

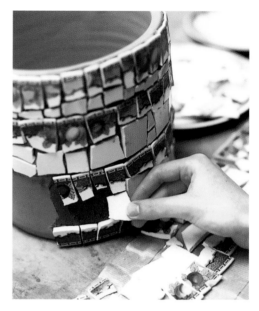

4 By measuring off the spacing between the rows on the piece of paper you can mark some guidelines onto the surface of the pot with a piece of charcoal.

5 Start sticking the top row by applying a small area of cement-based adhesive to the pot with a plasterer's small tool.

6 The fragments of china will not be completely flat or of equal thickness but you can add extra adhesive to the back of the individual pieces to help make the surface as smooth and as level as possible.

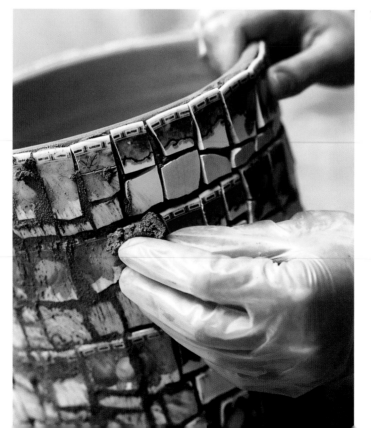

7 When all the pieces are stuck down and the adhesive is dry you can grout the piece. Rub the grout into the joints with your hand protected by a surgical glove. Wipe off the excess with a sponge and finally polish with a dry rag.

The gray grout provides a strong contrast with the white china, and the grout joints make a decorative pattern that complements the pattern on the china. Another approach would be to use only plain colors and make the grout joints into interesting patterns all the way around the pot.

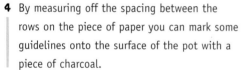

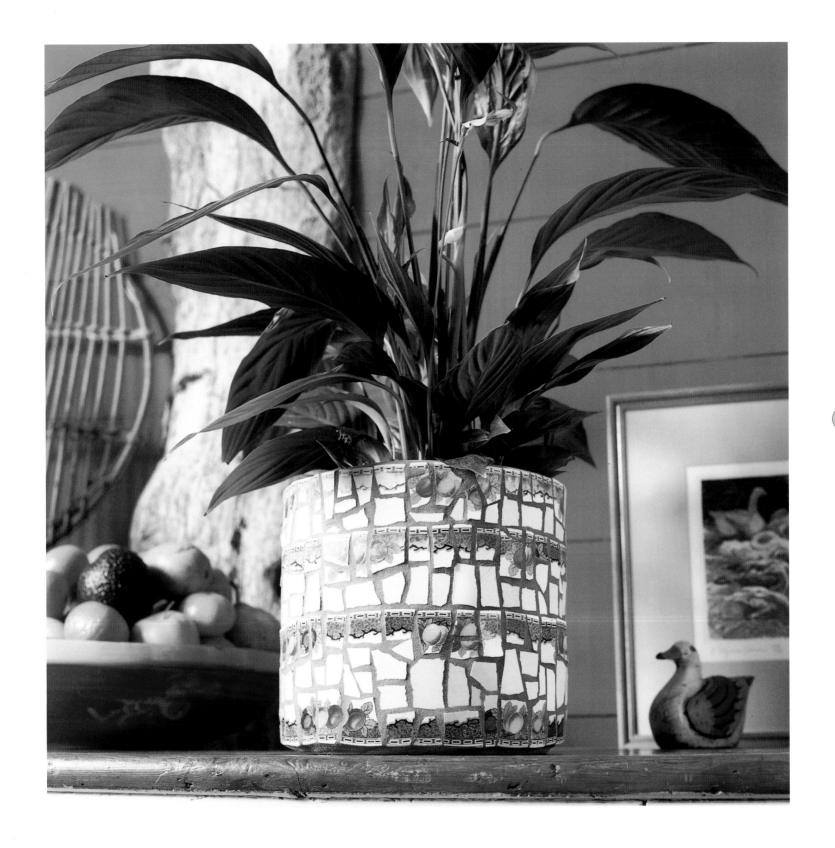

Flowerpot figure

Inspiration

PITCHER DEPICTING TWO FACES, 1947–71
PABLO PICASSO

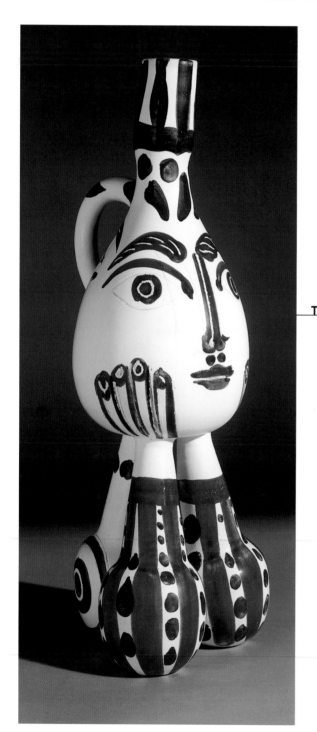

equipment

- paintbrush
- charcoal
- plasterer's small tool
- tile nippers
- felt-tip pen
- surgical gloves

This piece takes its inspiration from some of Picasso's sculptural works. One of the things that interested him about three-dimensional form was how the shapes of some inanimate objects could be reminiscent of human figures and animals. Many of his ceramic works are half pots or jugs and half representational sculptures of figures and creatures. The piece shown is a strange hybrid object that takes a simple ceramic form and connects it with a female head by the simple lines drawn on the surface. This draws attention to the formal qualities of the head and hands by showing how they can be simplified into an almost spherical shape, and at the same time animates the object and gives it character and personality.

Picasso is exploring the very human habit of reading faces and figures into the world around us; children in particular often see faces in cloud and rock formations, or assemble random objects (usually food on a plate) into expressive faces. In this project the body of the figure has been made from two up-ended flowerpots stacked on top of each other. The form created evokes a woman dressed in long stiff skirts, and so the applied mosaic decoration is in a series of different patterns reminiscent of textiles and weaving. The rims of the flowerpots have been exploited to create the lower arms and a fringed border for the skirts. To make a convincing and appropriate head it was important to find an everyday object that was not only right in size but also that would provide a neck. The answer was a little perfume bottle with a long, thin top. Working directly onto silicone to make the head did not allow much time for deliberation or complexity because the glue skins over so quickly. The resulting face has a simplicity that complements the stylized and flattened forms.

method

materials

- 2 flowerpots: 1 small, 1 large
- cement-based adhesive
- PVA glue
- vitreous glass mosaic tiles
- black and white unglazed ceramic tiles
- 1 small perfume bottle
- silicone glue
- black and gray grout

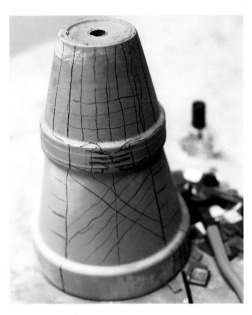

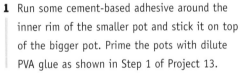

1 Run some cement-based adhesive around the inner rim of the smaller pot and stick it on top of the bigger pot. Prime the pots with dilute PVA glue as shown in Step 1 of Project 13.

2 Mark a center line down the pot with charcoal and draw on the hands, arms, and the criss-cross pattern of the front of the dress.

3 Apply some cement-based adhesive with the plasterer's small tool to build up the upper arms. They should line through with the flowerpot rim that forms the lower arms. Let this harden (at least two hours).

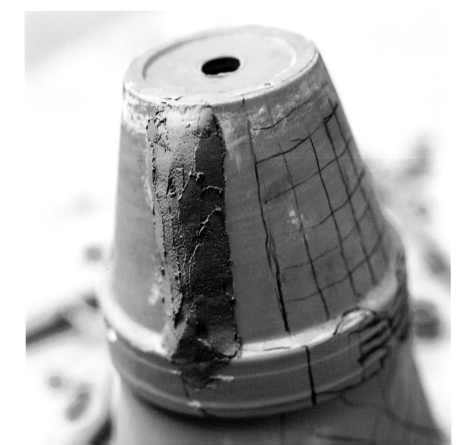

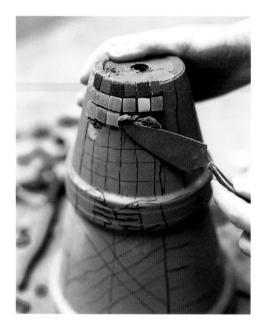

4 With the tile nippers, quarter the vitreous glass tiles. Apply a thin layer of cement-based adhesive with the plasterer's small tool to a small area and start to stick down the tiles that form the front of the dress.

5 Fix the small pieces of unglazed ceramic that are the hands and fingers so that they overlap the dress front and read as separate elements. The arms are covered in quartered tiles so the pieces can follow the curve of the cement base. The back of the figure is covered in alternate stripes of reds and greens in whole vitreous tiles.

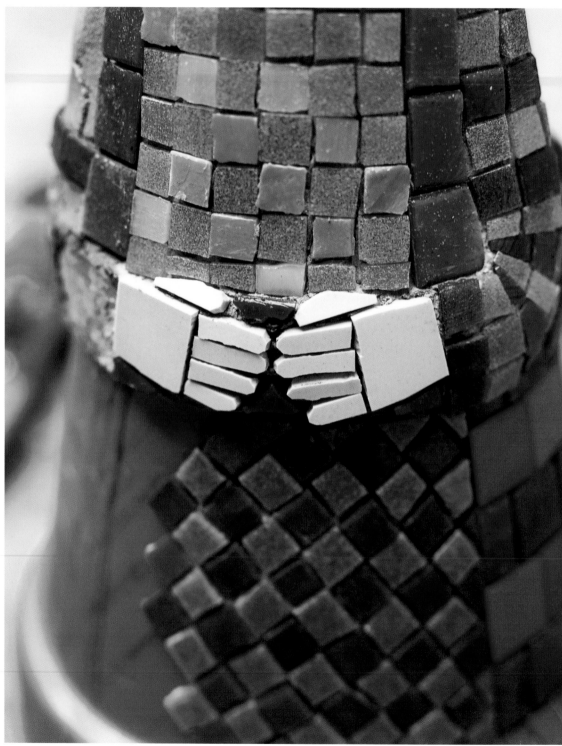

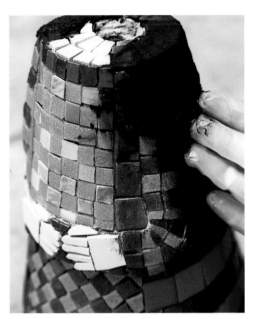

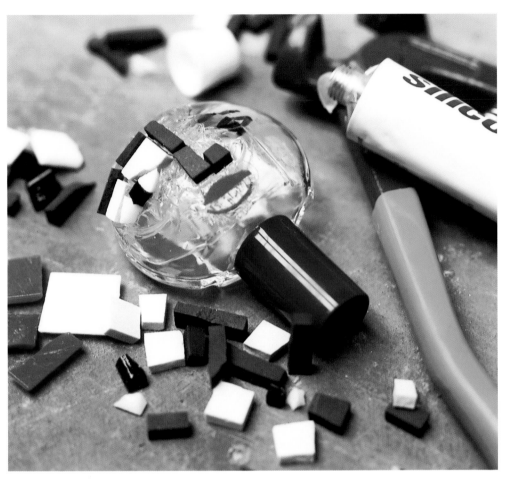

7 Grout the rest of the body with black grout, using your fingers protected in surgical gloves. Sponge it clean, paying particular attention to the ridges at the flowerpot rims where grout will collect and may need to be scraped out with the small tool.

6 It is easier to make the head before fixing it to the body. Draw the features on the glass with a felt-tip pen and cut some small pieces of glass tiles for the eyes and lips. Pre-cut some quarters of white ceramic and some little strips of black ceramic and then cover the face area with silicone glue. The glue will dry quite quickly so do not attempt anything too elaborate. Cut some more strips of black ceramic to make the hair and stick them to the top and back of the head. Finally, cover the neck in white quarters and also the quadrant of the top of the flowerpot where the neck meets the body.

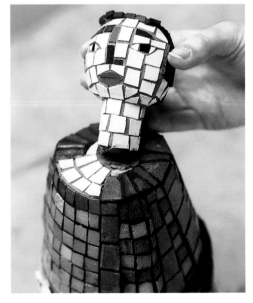

8 The face and neck should be grouted in gray and the hair in black. Use your hand protected by a surgical glove to do this. Use a small piece of sponge to clean off the grout without spreading it on to the wrong area. When it is dry you can apply a large lump of cement-based adhesive to the bottom of the neck to stick the head firmly to the body.

All kinds of everyday objects could be assembled and transformed in this way. Pottery jugs and vessels are often anthropomorphic, as are bottles and glass jars. The figures created are hybrids of the three-dimensional form and flat decoration so the found objects would not have to be too human in shape. Very stylized figures could be made from lengths of pipe or concrete fence posts.

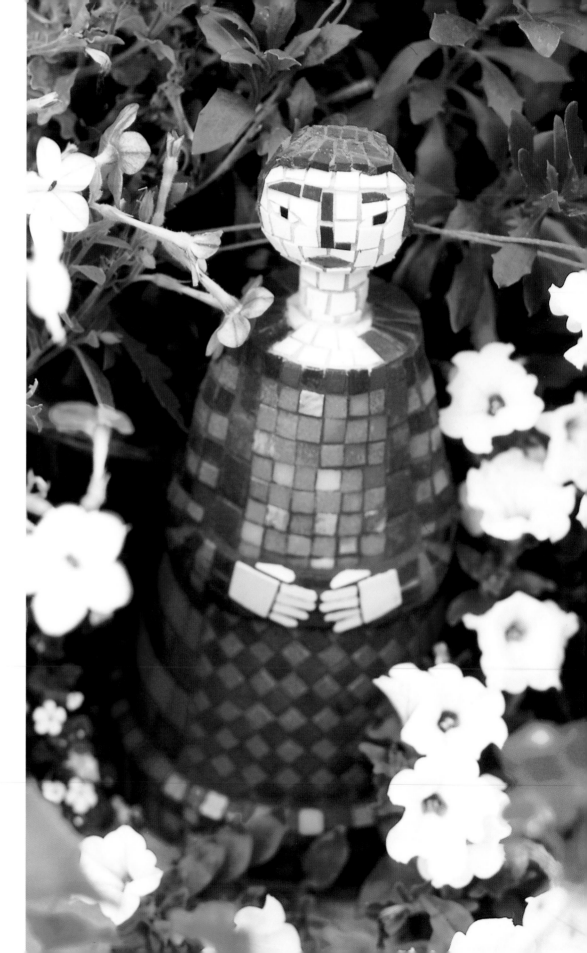

Garden animal sculpture

inspiration
ROCK GARDEN, CHANDIGARH
NEK CHAND

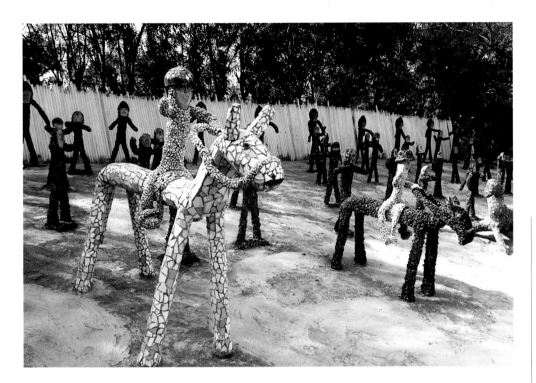

equipment
- hacksaw
- scissors
- wire cutters
- plasterer's small tool
- surform
- tile nippers
- surgical gloves
- sponge

materials
- pencil
- drawing paper
- copper tube $\frac{1}{3}$ in (1 cm) diameter
- aluminum insect mesh
- galvanized steel wire
- silicone glue
- cement-based adhesive
- charcoal
- unglazed ceramic mosaic tiles: pearl, black, and white
- gray grout

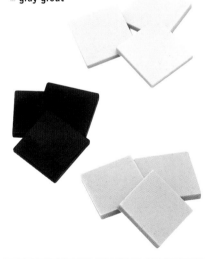

Nek Chand's sculptures in the rock garden, Chandigarh, are the inspiration for this project. His figures and animals are made from cement applied to metal frameworks. Some are left unadorned but others are covered in broken china, bangles, and glass. The strange power of the rock garden is created by the repetition of almost identical sculptures placed in evenly spaced rows, marching toward some unknown purpose. The individual pieces also have a compelling strangeness, their designs suggesting a combination of the living things they represent and the simple methods by which they are made. They embody the childlike and primitive qualities that so influenced the early modern masters in the West as they tried to break free from the traditions of a realistic representation.

The finished state of the dog made here clearly reveals the nature of its construction. The conical nose and barrel-shaped body are characteristic shapes easily formed out of aluminum mesh. The absurd curving tail, directly borrowed from Nek Chand's work, is more like a bent pipe than a dog's tail. Nevertheless the materials are combined to create an object that is also quite authentically doglike. This simple construction technique makes exact symmetry difficult to achieve but this adds to the liveliness of the finished piece. It has been covered with long triangles of unglazed ceramic to convey the impression of dog hair. The pieces can be laid quite randomly but the directions altered to allow the curving surfaces to be covered in a uniform way without ugly junctions.

method

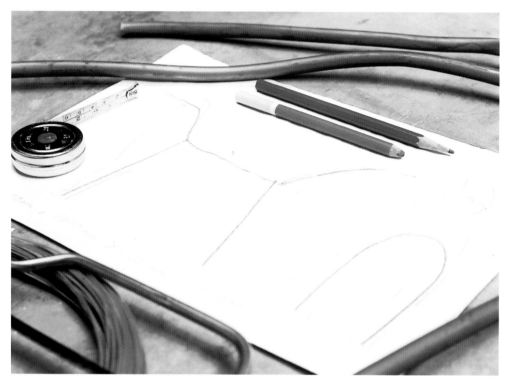

1 Before starting to make the animal, work out on a drawing roughly how you want it to look. It can be useful to draw a side view and a front view. If you draw the dog to scale you can mark on the underlying framework and work out how long the pieces of copper tubing will need to be.

2 Thin copper tubing can be easily bent by hand and cut with a small hacksaw. Make two hoops for the front and back legs and a long piece to run from the end of the nose, down the neck, and along the back and the tail. The legs can be attached to the spine with pieces of galvanized wire wound tightly around the junctions.

3 Measuring off the scale drawing you can work out some rough sizes to cut out of the aluminum mesh. You will need separate pieces for the body, neck, nose, tail, each ear and each leg, with four small extra pieces to form the paws. The mesh can be cut with an old pair of scissors and bent into shape. It can be fixed into position using little twists of wire and blobs of silicone glue. Creases in the mesh will add to its strength and can be concealed later under the cement skin. You do not have to make a completely rigid structure at this stage because fragile junctions will be held in place by the cement-based adhesive.

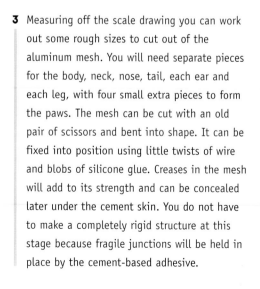

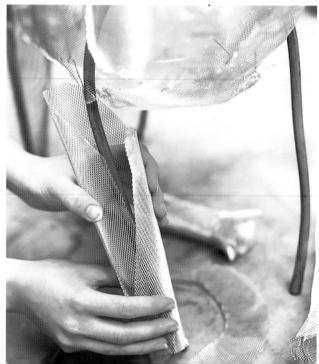

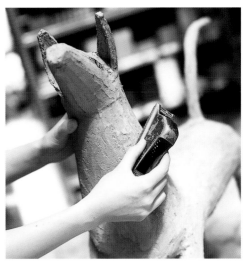

5 When you are happy with the overall shape you can smooth down the surface with a surform, which will scrape off the worst of the lumps.

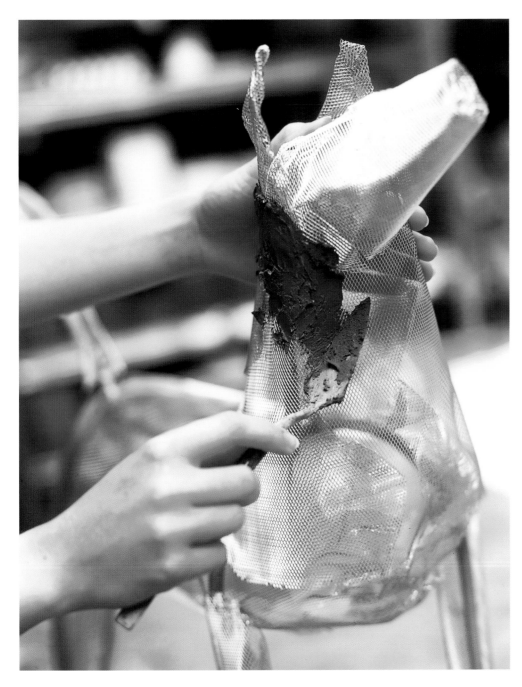

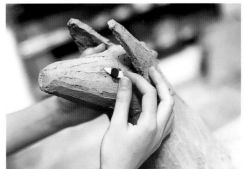

6 Draw on the position of the eye with a piece of charcoal, making sure it looks right from all angles and mark on the other eye at the same time to ensure symmetry. Apply a small area of cement-based adhesive with the plasterer's small tool and stick on the pieces. In some areas, for instance at the top of the ears, you may need to build up a greater thickness of adhesive to bed the pieces securely. Try not to let the adhesive come up between the joints.

4 The adhesive should be pressed into the mesh using a plasterer's small tool. It should be spread in a layer that is at least ¼-inch (½-cm) thick but it can be thicker in places where necessary to improve the overall shape. When wet the adhesive is very heavy and you may need to build up some areas in layers, letting the adhesive dry out overnight before adding the next thickness.

7 The triangular pieces are laid in the direction of the dog's fur but care has been taken not to set up a regular system, applying a more random approach that can accommodate changes of direction when necessary. For instance as the triangles reach the sharp curve under the neck between the front legs, they are tilted away from the vertical so that they can cover the shape more easily.

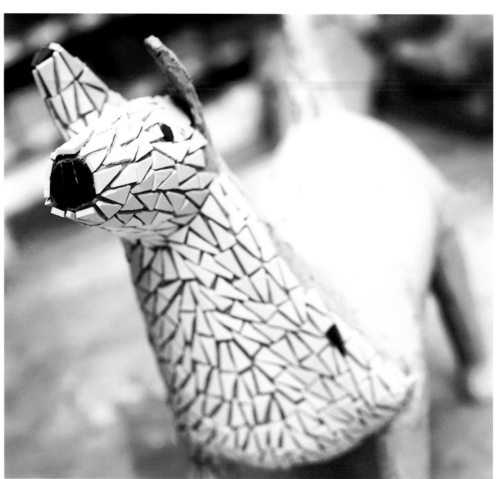

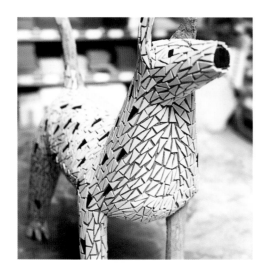

8 The same is true where the tiles laid across the back are tilted toward the horizontal where they meet the curve of the belly. The underside is laid lengthwise, that is, parallel to the spine.

9 When the dog is covered all over and the adhesive dry, it can be grouted. This is best done by rubbing the grout into the joints with your hand (protected by a surgical glove). The excess grout should be sponged off immediately and the surface given a final clean with a dry cloth.

Nek Chand's work is particularly striking because he makes so many versions of the same sculpture. Having made one dog, it might be tempting to make several more to stand in rows guarding your garden or patio.

gallery

▲ **Claire Milner, *Treasure Box*.**
Decorative treasure box made of vitreous glass.

◀ **Helen Bodycombe, *Bondi Pennant and Chorus Line*.**
Clearly inspired by Gaudi's Parc Güell, this colorful bench is decorated in vitreous glass in a lively combination of flowers, lettering, and carpet-like patterns.

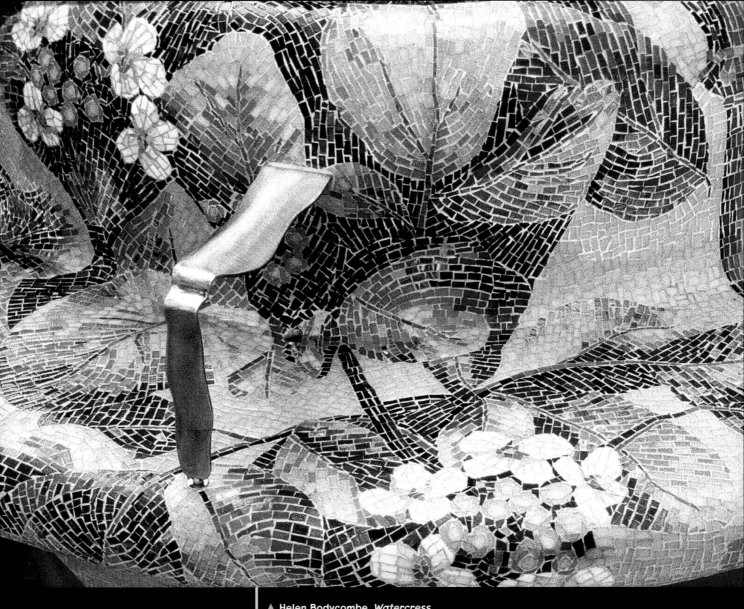

▲ **Helen Bodycombe,** *Watercress.*
Detail of a bench made with vitreous glass showing how
the swirling mosaic design is complemented by the metal
work of the arm rests.

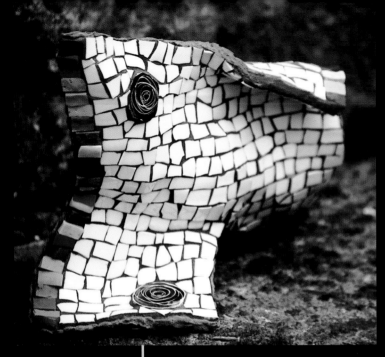

▲ Marcelo de Melo, *Running Rug*, 2001.
This sculptural piece exploits the ability of mosaic to cover irregular curves, and breaks all the rules of good mosaic practice by exposing vulnerable edges, but this adds to the originality and interest of the piece.

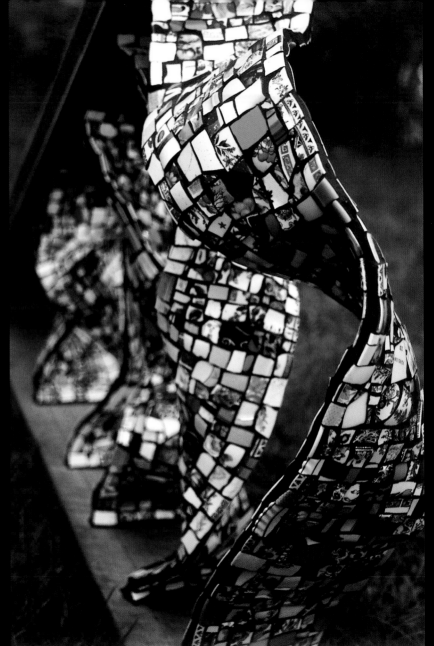

Further reading

Ancient Mosaics, Roger Ling (Thames and Hudson, 1998)
Art Since 1960, Michael Archer (Thames and Hudson, 1997)
The Arts and Crafts Movement, Gillian Naylor (Studio Vista, 1971)
The Culture of Craft, edited by Peter Dormer (Manchester University Press, 1997)
From Bauhaus to Our House, Tom Wolfe (Abacus, 1981)
Gaudí, Rainer Zerbst (Taschen, 1991)
Modern Art and Modernism, edited by Francis Frascina and Charles Harrison (Paul Chapman Publishing, 1982)
Modern European Art, Alan Bowness (Thames and Hudson, 1972)
Mosaico, Scuola Mosaicisti del Friuli (Longo Editore, 2000)
Omega and After, Isabella Anscombe (Thames and Hudson, 1981)
Paul Klee, The Nature of Creation (Hayward Gallery, 2002)
Photomosaics by Robert Silvers (Henry Holt and co., 1997)
Realism, Linda Nochlin (Penguin Books, 1971)
The Sources of Modern Architecture and Design, Nikolaus Pevsner (Thames and Hudson, 1968)

Suppliers

Australia

Academy Tiles
20 Herbert Street, Artarmon
NSW 2064
Tel: 61 2 9436 3566

Ceramic and Craft Centre
52 Wecker Road, Mansfield
Queensland 3722
Tel: 61 7 3343 7377
There are branches throughout the country

Canada

Interstyle Ceramic and Glass Ltd.
8051 Enterprise Street,
Burnaby B.C. V5A 1V5
Toll free telephone and
fax: 1 800 667 1566
www.interstyle.bc.ca

Oddly Enough Mosaic Supplies
Edmonton, Alberta
Tel: 1 780 463 5113

United States

Diamond Tech International
5600-C Airport Boulevard
Tampa, Florida 33634
Tel: 1 813 806 2923
Toll Free: 1 800 937 9593
www.dticrafts.com

Di Mosaico
Coronado Island
San Diego, California
Tel: 1 619 778 8007
www.dimosaico.com

The Cavallini Co., Inc.
3410 Fredericksburg Road, San Antonio,
Texas 78201 3847
Tel: 1 210 733 8161

Happycraftn's Mosaic Supplies
5130 Indian Drive
Hartford, WI 53027
Tel: 1 262 644 9928
www.happycraftnsmosaicsupplies.com

United Kingdom

Edgar Udny & Company Limited
314 Balham High Road
London SW17 7AA
Tel: 44 20 8767 8181

Mosaic Workshop
Unit B, 443-449 Holloway Road
London N7 6LJ
Tel: 44 20 7272 2446

Studio Arts
50 North Road
Lancaster LA1 1LT
Tel: 44 1524 68014
enquiries@studioarts.co.uk

Useful supplier websites

www.users.dircon.co.uk/~asm/suppliers
www.mosaicworks.com
www.mosaicworkshop.com

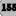

Picture credits

Alte Pinakothek: 108; **Birmingham Museum and Art Gallery:** 16r; **Bridgeman Art Library:** 11, 12, 26; 16l, 48b, 49, 50, 51, 52, 95b, 133, 142; **Centre d'Études Alexandrines:** 9; **Christies:** 17; **Conran Design Associates:** 25; **Deidi von Schaewen:** 14, 23, 132, 135, 137, 147; **Gallerie Hopkins-Thomas-Custot:** 57; **London's Transport Museum:** 20l, 120; **Penguin Books:** 112; **Réunion des Musées Nationaux: /** Gérard Blot: 22, /J.G. Berizzi: 53, /CNAC/MNAM: 70, 116, /Béatrice Hatala: 134; **Robert Silvers:** 27; **Scala Group:** 10l&r; **Tate Picture Library:** 55, 94, 95t, 96; **Trevor Caley:** 24; **University of Pennsylvania Museum, Philadelphia:** 8l; **University of Texas/Timothy Moore:** 75; **V&A: Picture Library:** 13r; **Vatican Museums:** 8r; **VIEW: /**Andrew Holt: 138; **Wedgwood Museum:** 20r.

Templates

▲ **Project 1**
Enlarge on a photocopier by 340%

▶ **Project 5**
Enlarge on a photocopier by 270%

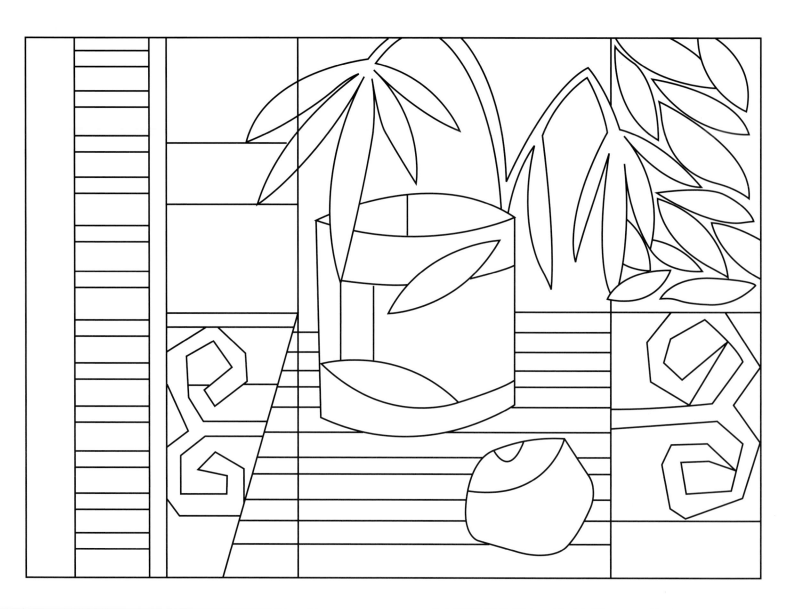

▲ **Project 4**
Enlarge on a photocopier by 345%

▲ **Project 2**
Enlarge on a photocopier to the desired size

◀ **Project 3**
Enlarge on a photocopier so that the design is
2 inches (5 cm) smaller than the size of the tile

index